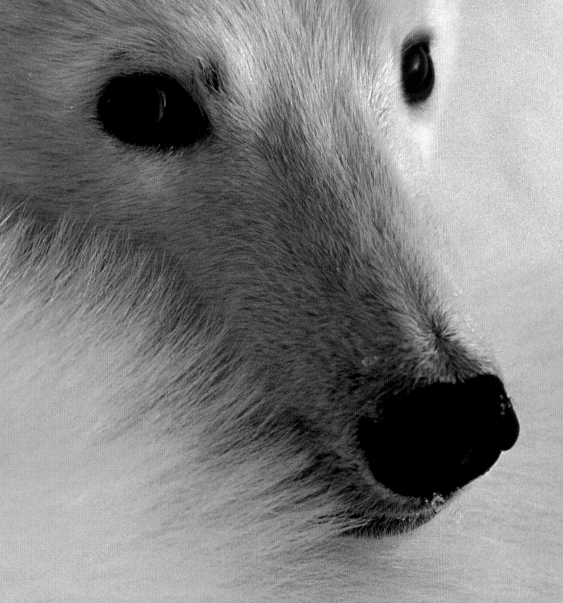

BEAR

A Celebration of Power and Beauty

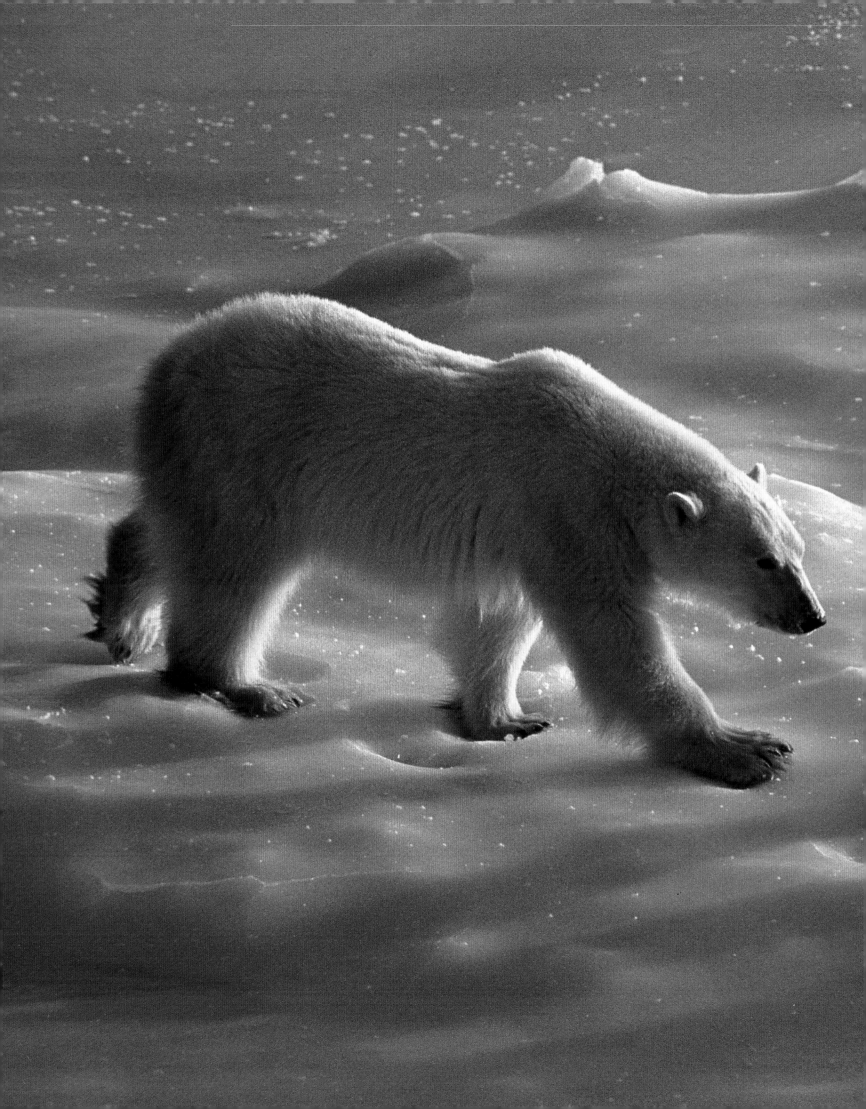

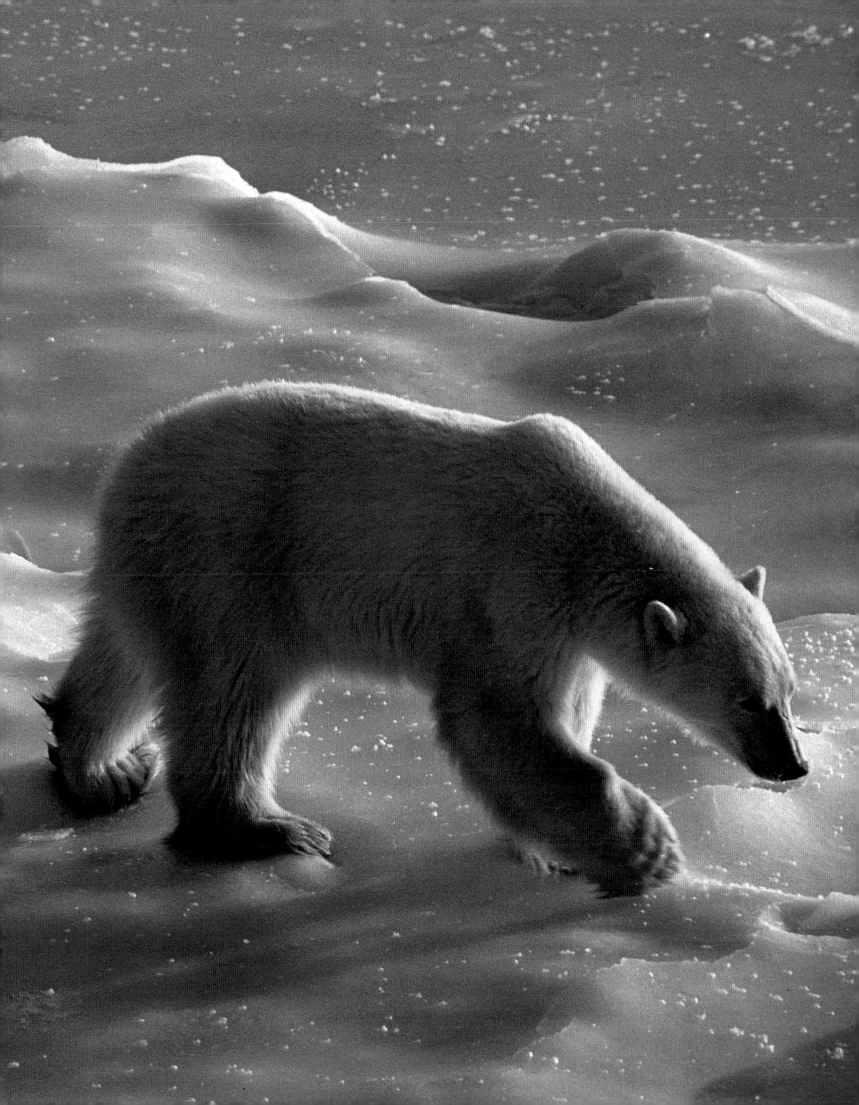

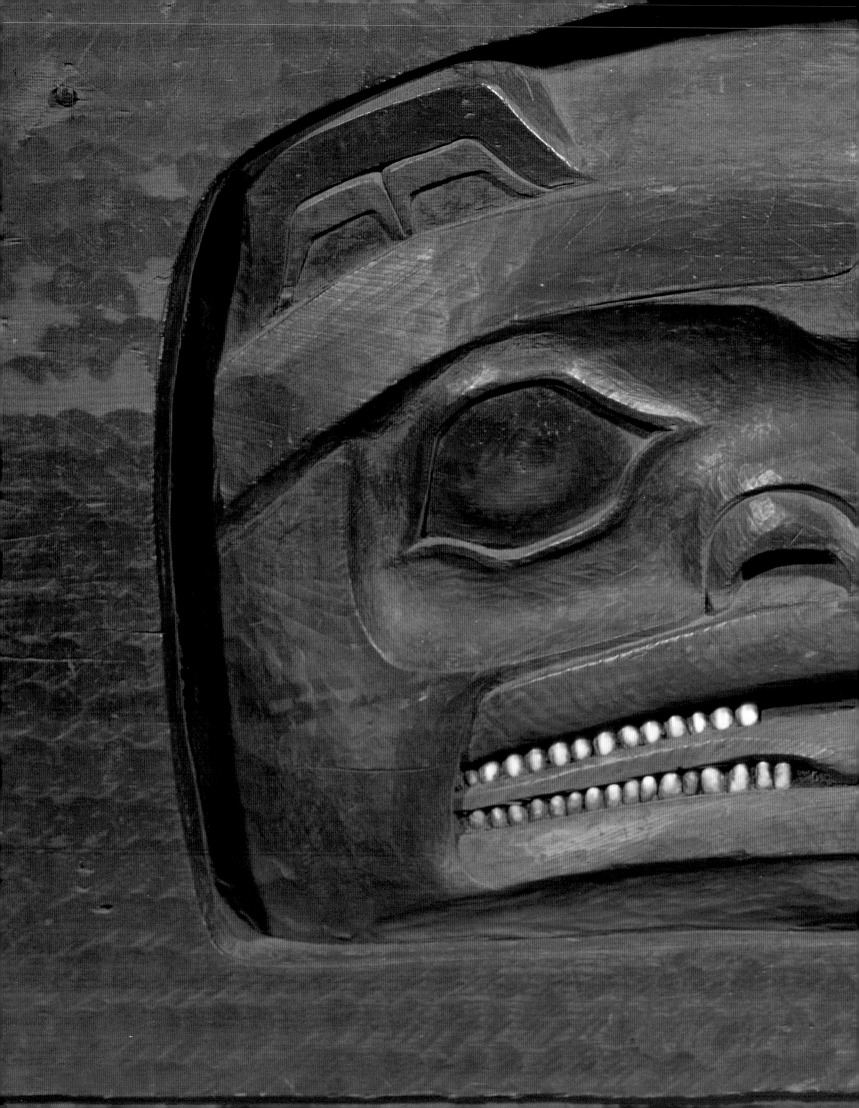

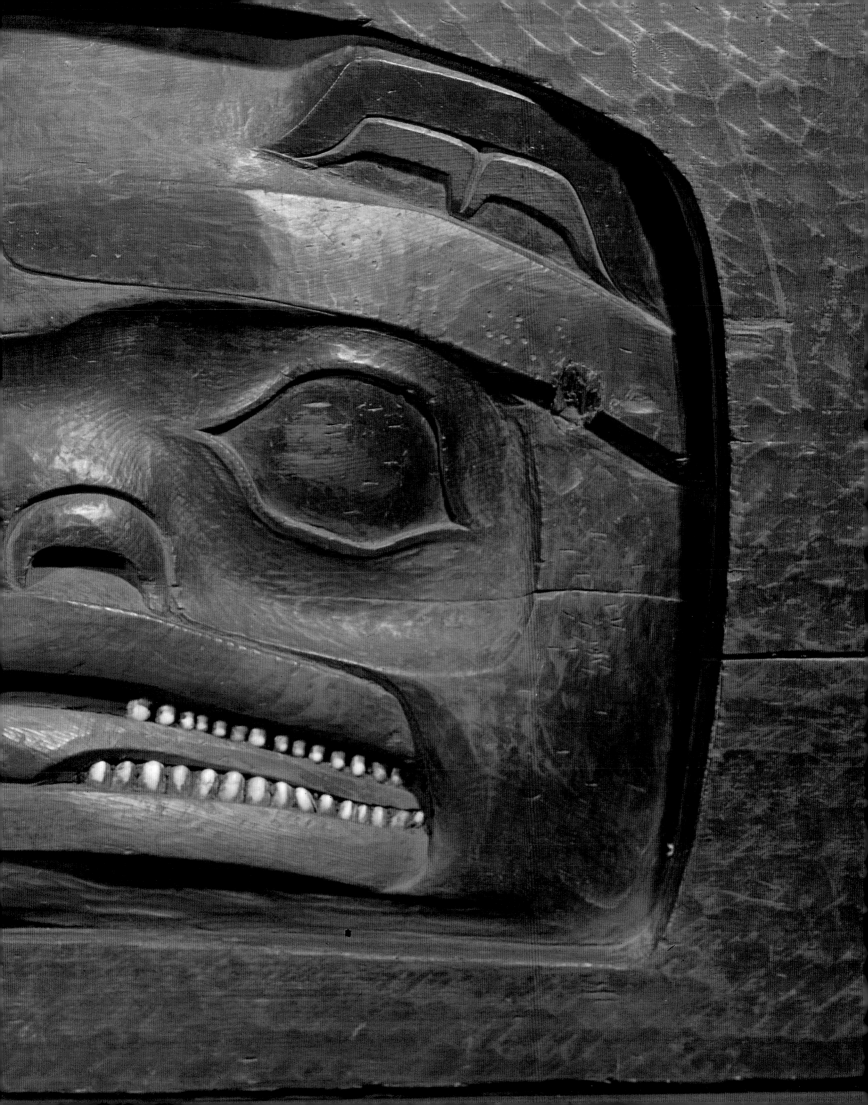

BEAR

A Celebration of Power and Beauty

Photographs by Daniel J. Cox
Essay by Rebecca L. Grambo

A Sierra Club Book

San Francisco

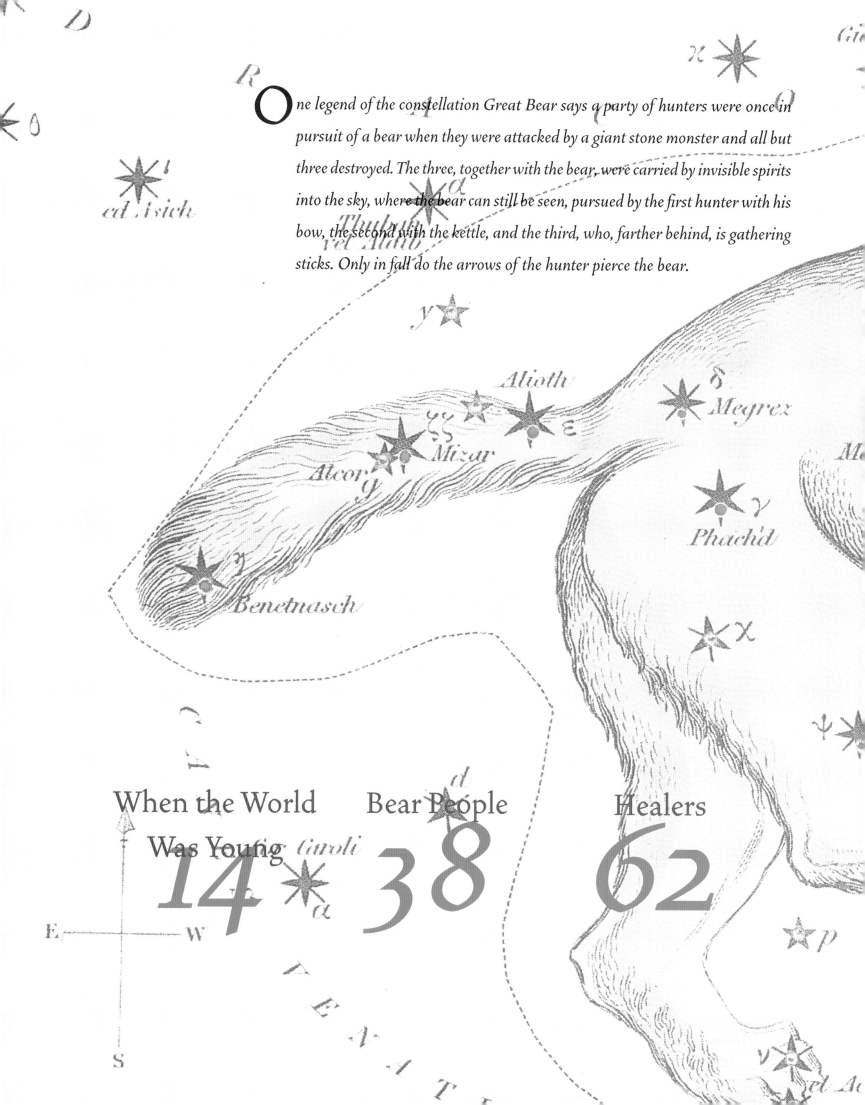

One legend of the constellation Great Bear says a party of hunters were once in pursuit of a bear when they were attacked by a giant stone monster and all but three destroyed. The three, together with the bear, were carried by invisible spirits into the sky, where the bear can still be seen, pursued by the first hunter with his bow, the second with the kettle, and the third, who, farther behind, is gathering sticks. Only in fall do the arrows of the hunter pierce the bear.

When the World
Was Young
14

Bear People
38

Healers
62

CONTENTS

INTRODUCTION

Dedicated to my good friend, Rick Meyer

—RLG

Dedicated to Michio Hoshino
At one with the Bear

—DJC

For much of my life, I knew bears only in the abstract. When I first heard of them, a very nice bear family was having problems with a peroxide-blonde break-and-enter artist named Goldilocks. My sympathies were entirely with the bears, and I could never understand why they didn't just have the little delinquent tossed in jail.

As time passed I was exposed to more bears in books, magazines, movies, and zoos, but I never got any feeling for the real animals until I began seeing them in the wild. I watched how they moved, what they ate, and how they took care of their young. I also experienced the primitive surge of adrenaline you get when you realize that two cubs have climbed the tree you are leaning against, their mother is just on the other side of some brush, and none of them know you are there.

I consider myself very fortunate in my opportunities to interact with bears because the vast majority of us are completely isolated from the reality of bears and their relationship with our world. We must glean our knowledge about them from televised nature programs and encounters at the zoo. As a result, our view of these animals contains a wealth of factual detail but is necessarily two-dimensional, lacking the depth given by personal contact and shared history. While we cannot all journey to the wilderness to live with and learn about bears, we do have other options.

Not only can we look at scientific information about bears in today's world, but we can draw upon the rich store of legend and artifacts left to us by those who knew bears as we do not: the early peoples whose entire existence was spent in intimate contact with the natural world, and whose survival depended on their powers of observation. Many of these people closely associated the bear with the most important things in their lives. They believed the bear held the power to heal and to hurt, to feed them and to withhold food. They directly linked the bear with celestial and seasonal cycles, and even with their own creation. In this book, we will explore the ancient connections between humans and bears with the help of Daniel J. Cox's remarkable photographs, which breathe life into legends.

The peoples of the Northern Hemisphere appear to have had more rites and rituals connected with the bear than with any other animal. We will look at the three bear species that were the focus for their beliefs: the American black bear (*Ursus americanus*); the brown bear (*Ursus arctos*); and the polar bear (*Ursus maritimus*).

Mixing material from many different sources requires the adoption of some naming conventions. For example, grizzly bears are actually brown bears. Usually "grizzly" denotes those living in the North American interior while "brown bear" refers to those living in Eurasia

and the coastal regions of North America. I have tried to follow this convention where possible but, for the purposes of this book, the two names may be considered interchangeable. Another possible source of confusion arises with the names of native peoples recorded in the literature. Many of those names were imposed by outsiders and have since changed to reflect the wishes of the people themselves. Adding to the confusion are the facts that some names were applied to more than one people, some people were given more than one name, and the names of many groups were spelled more than one way. I have done my best to attribute stories and artifacts to the right people, and, to make it easier for anyone wishing to follow up in the literature, I have used the group name given in the original source. Where applicable I have indicated the most current and correct group name I could find at the first use of an historic name.

Bringing together elements from different times and cultures does carry risks: one may oversimplify, misinterpret, or unconsciously filter information based on one's own moral and cultural background. Without question, the legends, myths, and objects we will see meant something different to those who created them than they will to us. However, I believe the stories and objects I have selected from the many available verbal and visual bear treasures tell an amazing tale in any context. I present them as a sumptuous banquet of ideas, rather than as an exhaustive encyclopedia of bear lore and natural history. Daniel J. Cox's magnificent images, together with these artifacts, represent the rich tapestry of the human/bear relationship with past and present interwoven—as, in fact, they are.

—*Rebecca L. Grambo*

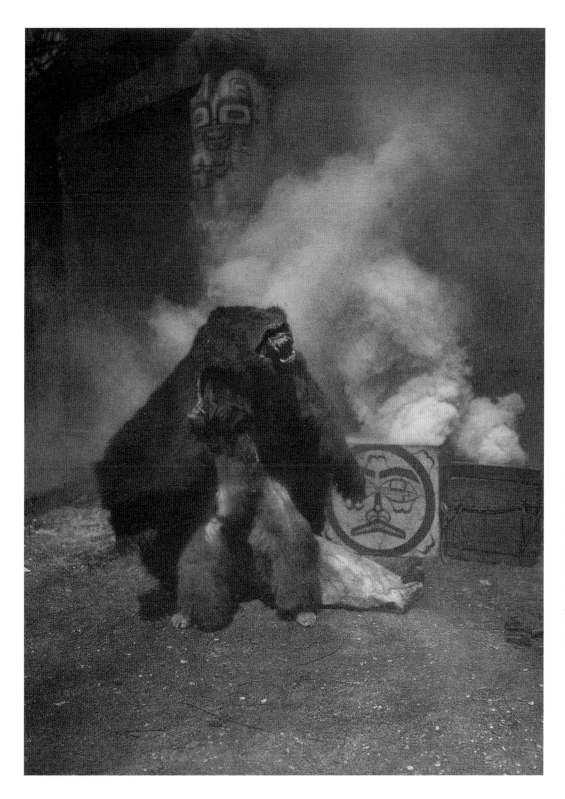

Grizzly Bear Dancer – Qágyuhĺ

In this 1914 photograph by Edward S. Curtis, a dancer in the Kwakiutl (Kwakwaka 'wakw) winter ceremony called tsétsehka impersonates a grizzly. Various performers representing different animals and supernatural beings participate in the four-month-long ceremony, during which feasts, potlatches, and other festivities take place.

WHEN THE WORLD
WAS YOUNG

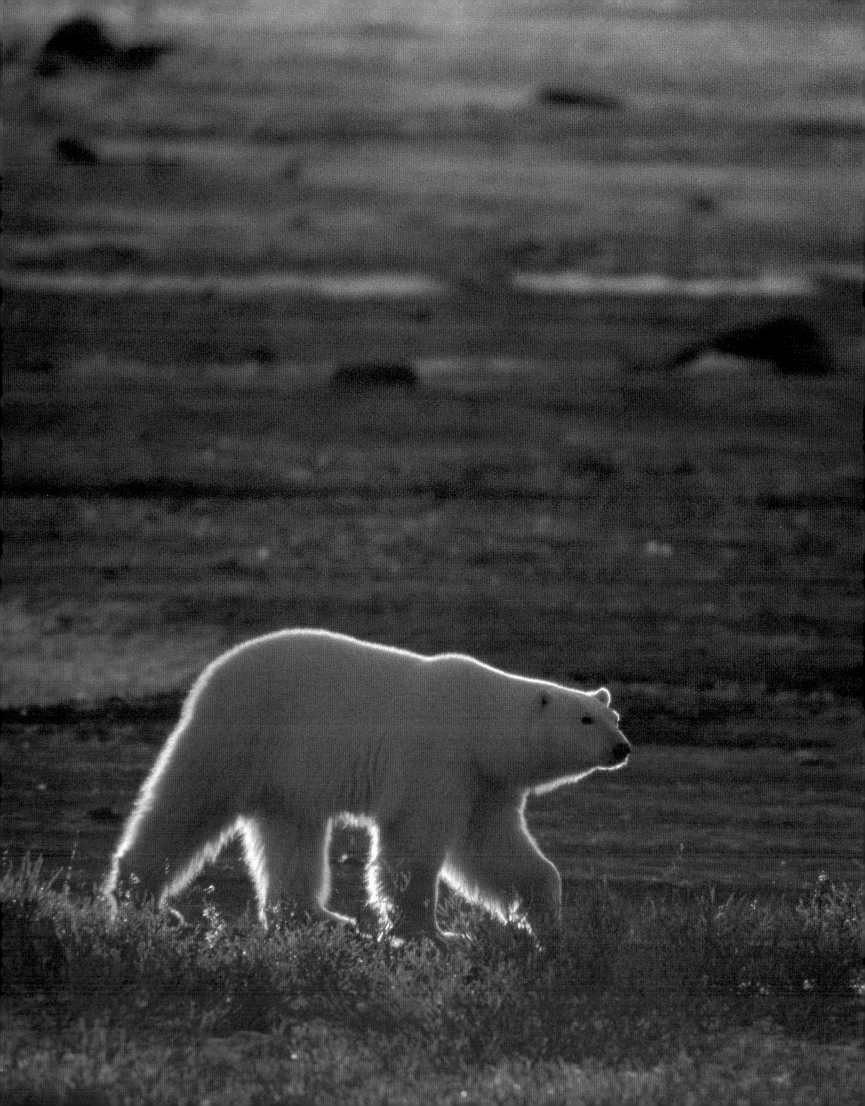

The Wind God of the Iroquois kept four animals near the mouth of the cave where he lived—a panther, a moose, a fawn, and a bear. In the sound of the west wind, the Iroquois heard the panther whining. The east wind was the breath of the moose spreading across the land. A warm south wind told them the fawn was returning to its mother. And when a chill north wind swept down upon them, the Iroquois said "The bear is prowling the sky."

Bears are recent entries in the chronicle of life on earth. Polar bears, which evolved from brown bears, are the youngest bear species: the oldest bones found so far that can definitely be called "polar bear" are about 100,000 years old, while DNA studies indicate that modern polar bears may have appeared only about 20,000 years ago. Paleontologists confidently trace bear history in the fossil record, although they may not agree about the exact timing of events. A simplified version of their discoveries takes us right back to the roots of the bear family tree.

Along with many other carnivores such as cats and dogs, bears trace their beginnings to a group of rather weasel-like creatures called miacids. About forty million years ago the miacids diversified, splitting off into various lineages including one that would lead to bears. The first true bear, *Ursavus elemensis*, appeared about twenty million years ago. These fox terrier-sized animals roamed through the subtropical wilderness of what is now Europe. Six million years ago, many bears, including some giant predators, inhabited the Old World. For the evolutionary path we are tracing, the most important fossil from that time comes from Spain: *Protursus*, a small bear that was the next step toward today's bears. The little bear *Ursus minimus* appeared soon after and from it evolved *Ursus etruscus*, the Etruscan bear which arrived on the scene about 2.5 million years ago. The Etruscan bear, which lived throughout Europe and Asia, is our link to the present, because among its descendants were black bears, brown bears, and the now-vanished cave bears.

Modern black bears appeared about 1.5 million years ago in Europe and arrived in America about 500,000 years ago. Modern brown bears appeared in China about 500,000 years ago but probably reached North American less than 40,000 years ago. With this arrival, the stage was set for black bears, brown bears, and, eventually, polar bears to play major roles in many cultures. Before exploring this cultural heritage, however, brief consideration must be given to the often misrepresented relationship between early humans and the other Etruscan bear descendant I mentioned: the cave bear.

Widespread across Europe about 300,000 years ago, *Ursus spelaeus*, the European cave bear, must have been an imposing animal—especially to hunters armed only with the most

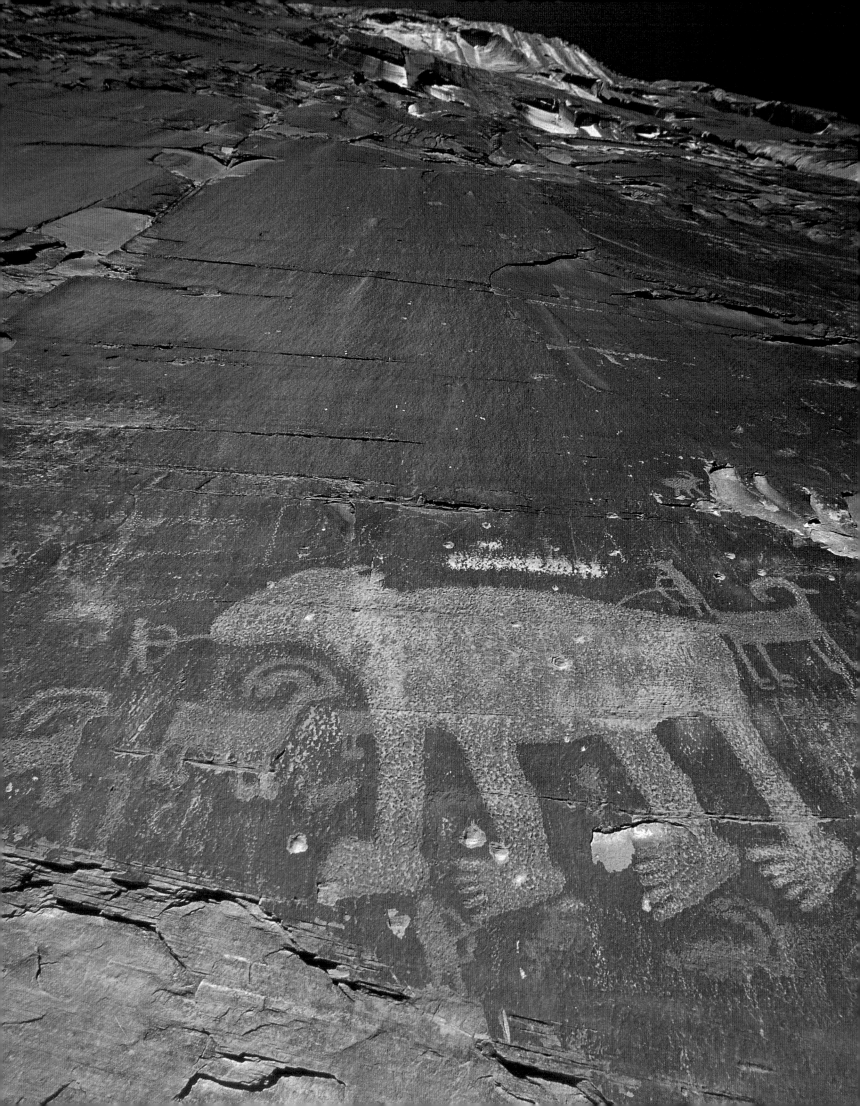

primitive weapons. Estimated to weigh about 400 kilograms (880 pounds), it was a heavily built, large-headed creature that was more herbivore than hunter. It used caves for protection from the elements, for rearing its young, and for hibernating. To early humans, the cave bear was sometimes a source of food and perhaps a competitor for shelter. But was it something more?

Many books, including numerous books on bears, contain authoritative statements regarding an ancient bear cult dating back to the Neanderthals. The authors describe cave bear skulls and bones that appear to have been purposefully arranged on altars, in stone bins, and in wall niches at cave sites including Drachenloch, Switzerland and Petershöhle, Germany. Current scientific opinion, however, is that "bear cult" sites can be explained by natural processes, such as running water depositing bear bones in caves, or bones accumulating from cave bears that died during hibernation. What were interpreted as cave bear altars were simply chance arrangements of rocks and bones colored by wishful thinking. So, despite the romantic attraction the idea once held, the overwhelming majority of authorities in the field today[1] do not believe, and have not believed for some time, that there was any such thing as a Neanderthal "clan of the cave bear." All is not lost, however, for those who crave a bear/human link from the ancient past. There is a younger site that does have a legitimate "ritual" bear.

Less than 20,000 years ago in a cave near Montespan, France, modern humans created a large, headless bear made of clay. When archaeologists discovered it, the torso was pitted with holes and a bear skull lay on the ground in front of it. The scientists hypothesized that during rites or ceremonies the clay form was draped in a real bear skin with the head still attached. The many holes may have been created by spear thrusts.

What was the actual purpose of the Montespan bear? We can never know for certain. Interpretation of artifacts is often a precarious process, particularly when dealing with abstract concepts such as magic or religion. We do not need to know everything to learn from ancient stories and artifacts. While we cannot pinpoint when humans began their mystical relationship with bears, knowing that the link has persisted for a very long time, we can theorize about its importance. We cannot know the reasons the relationship began but we can look at stories and artifacts to see some of its aspects at various times and places.

Humans have a long history of wanting to explain mysteries and to gain power. We can start to grasp the source of human fascination with bears by understanding that, in the eyes of early people, bears were the key to accomplishing both of these goals.

THE FIRST BEARS

We turn to paleontology and geology to tell us about the early history of the natural world. Ancient people had their own explanations for the age and origins of the things around them, including bears.

> Far back in the earliest days of the world, earth held no life. The Great Spirit, gazing down from his home among the stars, decided to come down to have a look around. He made a

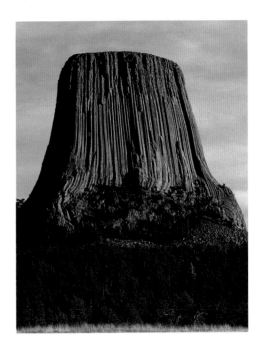

Bear Pictograph

Bear pictograph from the Colorado River gorge, Utah.

large hole in the blue sky, and pushed snow and ice through it, making a great mountain to step down upon. This was Mount Shasta.

Upon seeing the lifeless earth, the Great Spirit was moved by the desolation. He decided to make the earth beautiful, green, and alive. As he walked down from the snowy mountain, he placed his fingers on the ground. Trees, grass, and flowers sprang up and quickly spread out and across the surrounding lands. At his request, the sun grew warmer, melting some of the snow to create rivers and streams to provide water for the new growth. He used his walking stick to mark the course of the waterways.

Then the Great Spirit broke off a small piece from the thin end of his walking stick. Crushing it in his hand, he flung the pieces into the new waters where they became fish. Holding some leaves from the trees in his hand, he breathed upon them, blowing them into the air where

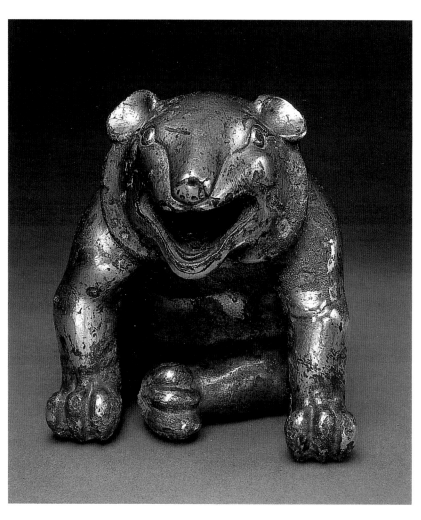

Shasta-Modoc legends say that far back in the mists of time, after the Great Spirit had created all of the other animals, he made a mighty ruler for them: the grizzly bear.

Han Dynasty Bear

Approximately 2000 years old, this exquisite ornament of gilded bronze was used by the Chinese as a weight to steady freestanding screens.

they became birds. Happy at what he had done, the Great Spirit began breaking off more bits from his walking stick, creating many kinds of animals. He made them different sizes and gave them different abilities so that all would have a chance to survive.

Soon all that remained of his walking stick was the large, heavy end that rested in his right hand. The Great Spirit gazed at it thoughtfully for some time, wondering what this special piece should become. Finally, he made an animal mightier than any of the others, intending it should rule over them—the grizzly bear. But when this animal took shape, it was so ferocious and strong that it chased the Great Spirit back up onto the mountain top, where he finally found a safe haven to rest after his great works.

— A retelling of the creation story of the Shasta and Modoc peoples of California and Oregon

Many tales of the bear's creation set it apart from other animals, either in how it was created or in its place of origin. The Ob-Ugrian peoples of northwest Siberia say that the first bear was the offspring of the heavenly father, *Numi-torum*. The female bear-child was raised on a cloud near the Great Bear constellation and treated as befits a goddess. She came to earth and, before returning to her home in the sky, taught humans the ceremony that would send home the spirits of earthly bears they killed.

HEAVENLY BEARS

Not only were bears sometimes said to have come from above but many of the tales early people told about the sun, moon, and stars included a bear.

According to an Iroquois legend, the question of whether there should be sunlight at all caused a heated argument between Chipmunk and Bear. Bear liked to roam about at night

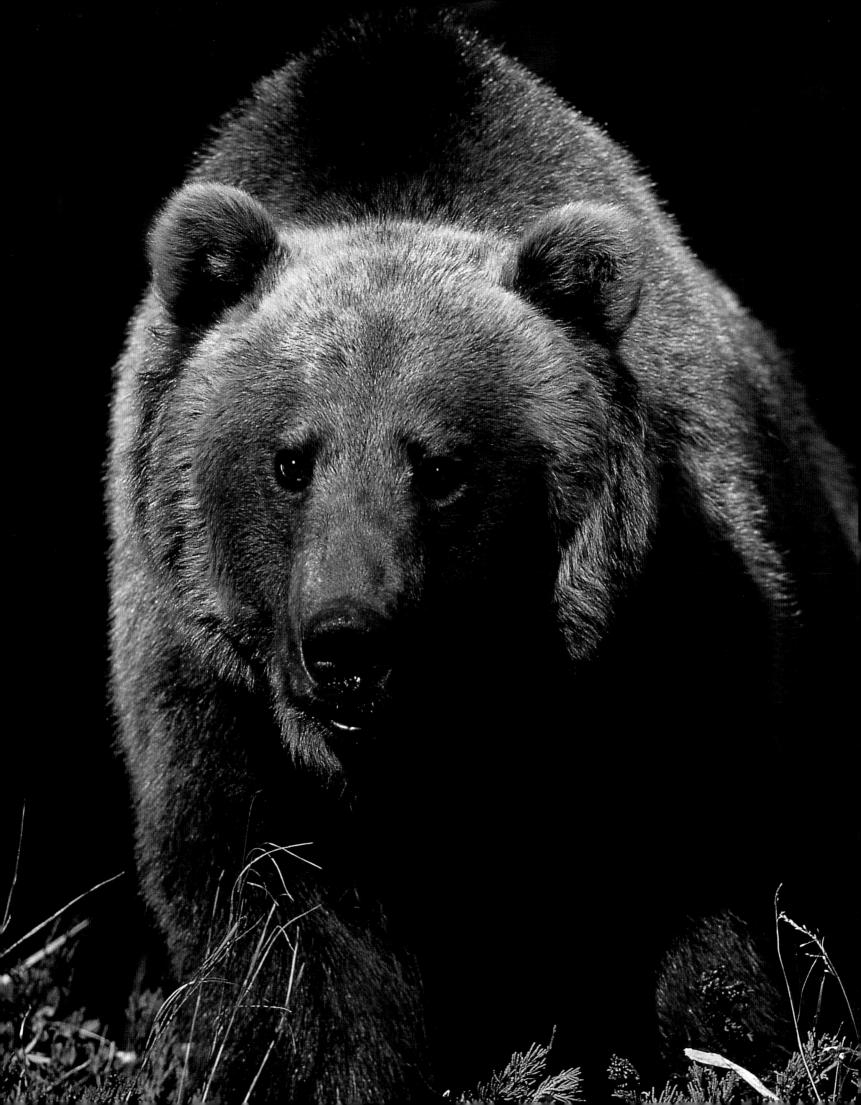

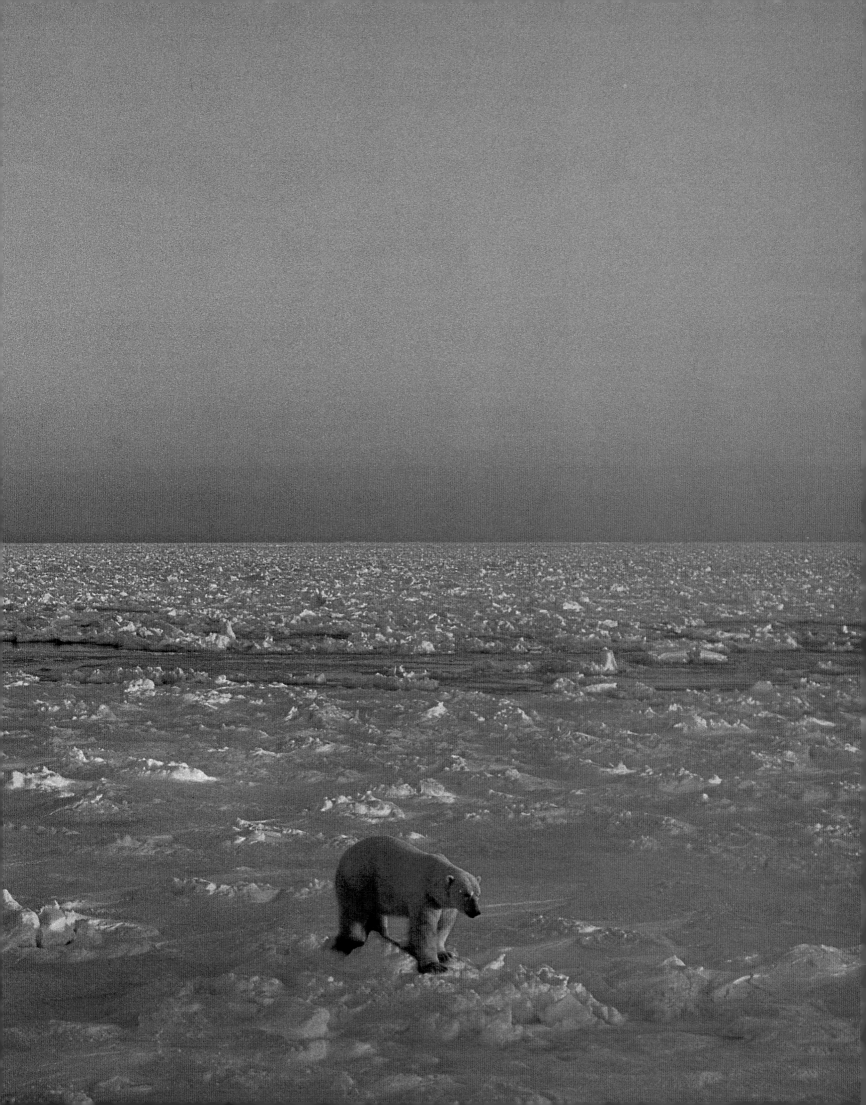

and wanted continuous darkness. He sang, "Night is best. Give us darkness!" Chipmunk wanted night and day to alternate. He liked the light and so sang, "We need the light. Bring us light!" Bear watched angrily as it began to grow lighter: day was breaking because of Chipmunk's song. He reached out to swat Chipmunk but the little animal zipped away up a tree. Only the tips of Bear's claws caught him, leaving the stripes which are there to this day. And, thanks to Chipmunk's song, day and night will follow one another forever.

The Chipewyan people of northern Canada said that, long ago, a huge angry White Bear tore the sun from the sky and kept it hidden inside his cave. The animals, suffering because they could not find food in the darkness, sent Crow to get the sun. Crow tricked White Bear into giving him the sun and flung it back into the sky, bringing light to earth once more.

The Dogrib (Thlingchadinne) and Slavey (Etchareottine) people of the Canadian subarctic told a similar tale. In their story it was Black Bear, who did not live on earth then but in the Sky World, who had bags in her lodge filled with the winds, the rain, the cold, the fog, and the sun. Tired of enduring the cold darkness of a seemingly endless snowstorm, the animals on earth went in search of sunshine. They climbed a ladder up through a trapdoor into the Sky World, and there stumbled upon Black Bear's lodge. By questioning her cubs, they figured out that Black Bear had the sun and they came up with a very clever plan to get it.

Caribou swam out into the lake, luring Black Bear to follow in her canoe, but Mouse had gnawed through the handle of Black Bear's paddle. The paddle broke, the canoe capsized mid-lake, and Black Bear disappeared beneath the water. All the animals ran to the lodge and pulled down the bag they needed. Inside were the sun, moon, and stars, which the animals flung down through the trapdoor. Through the door they could see the snow begin to melt under the sun's warmth.

In their hurry to get back down to earth, some of the animals had accidents. Beaver split his tail and ever since it has been flat. Beaver's blood spilled onto Lynx, making all lynxes spotted. Buffalo hurt his back and Moose bumped his nose. Now all buffaloes have bumps on their backs and moose have flattened noses.

One can find other ancient tales linking bears and the heavens in general, but perhaps the most interesting connection of all is written in the stars.

THE GREAT BEAR

Today most of us view time as linear, moving from past to future. Many early people, however, saw time as following circular paths in an overlapping, unending series of cycles: the change of seasons, the movement of the stars, even the cycle of life itself. The bear often became an earthly and heavenly metaphor for all of these. Nowhere is this more evident than in stories about the constellation you may know as "The Plough," "The Wagon," or "The Big Dipper." Its official name is *Ursa Major*—the Great Bear.

Called *Grande Ourse* by the French, *Grosse Bär* by the Germans, and *Orsa Maggiore* by the Italians, the Great Bear appears in every detailed description of the heavens—on parchment, clay and stone tablets, and in myths—reaching far back into the past. The Great Bear

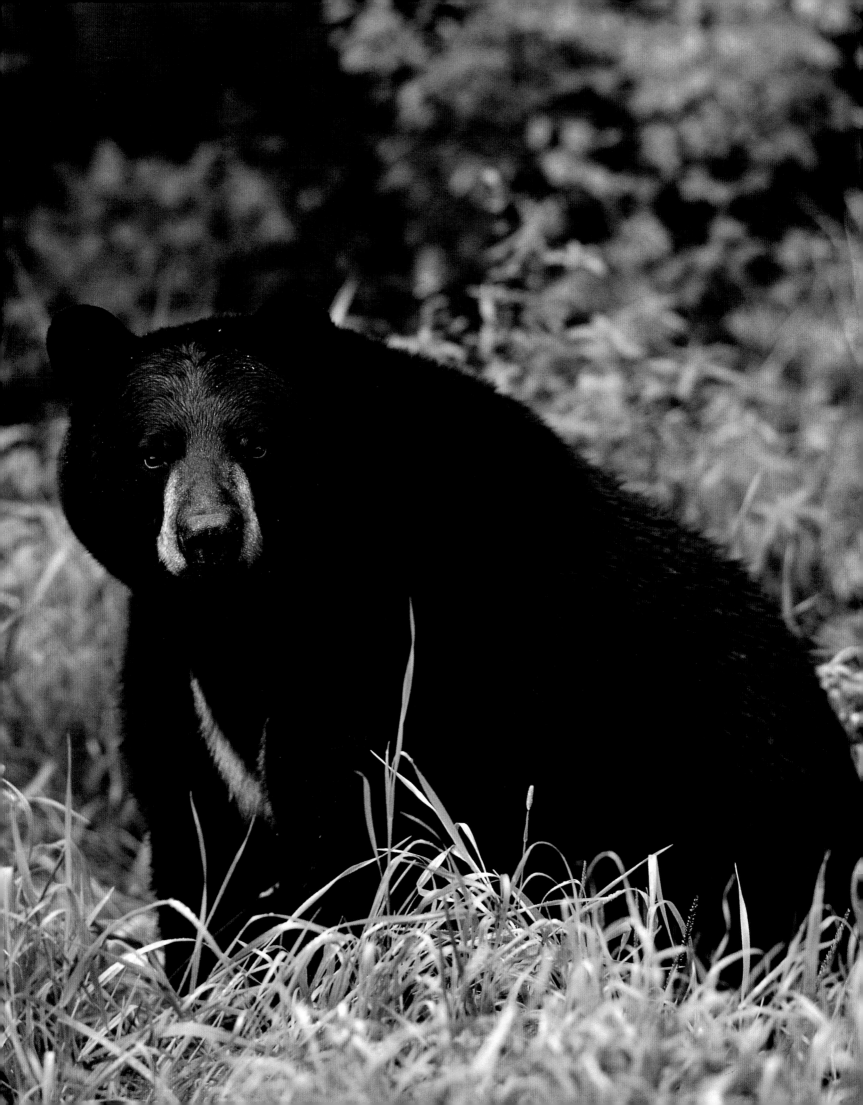

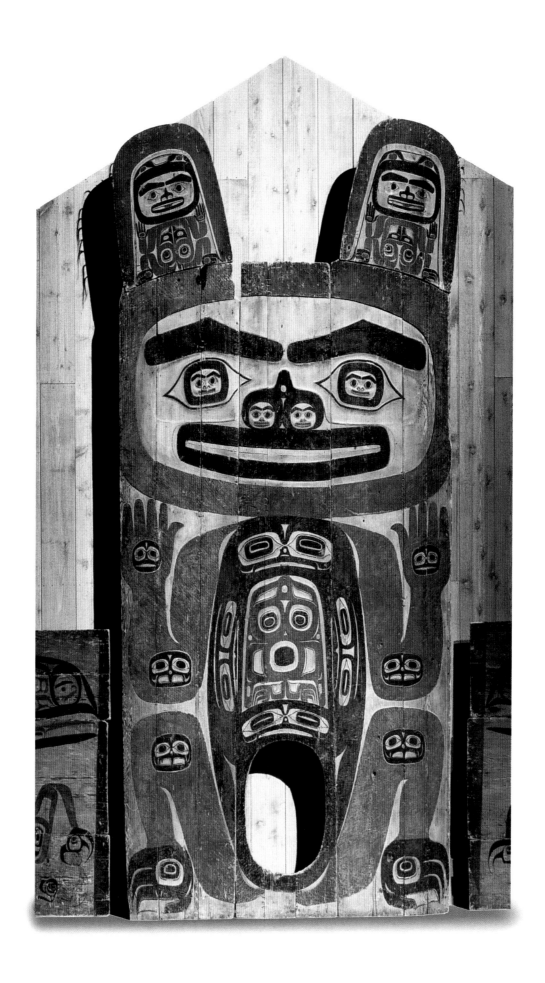

and *Ursa Minor*, the Lesser or Little Bear, are the first two constellations listed in all early star catalogues. And, although it is known by other names, many references to this group of stars make it ursine.

The ancient Greeks explained the origin of both starry bears with the story of Callisto. Callisto was a forest nymph and a devoted follower of Artemis, goddess of the hunt. After being either seduced or raped by Zeus, Callisto was banished by Artemis for her impurity. Eventually, she bore Zeus a son called Arcas. Callisto was then changed into a bear, either by Zeus wishing to spare her from the wrath of Hera, his justifiably jealous wife, or by Hera herself as punishment. Arcas grew up to be a hunter while, as a bear, Callisto roamed the forest. One day, catching sight of her son, Callisto rushed forth to greet him. Arcas, not recognizing his mother, would have killed her but Zeus, seeing what was about to happen, changed Arcas into a bear, too. Then Zeus flung the pair into the heavens where they were transformed into stars. Callisto became the Great Bear and Arcas, the Little Bear. The Greeks envisioned long-tailed bears, explaining that Zeus had grabbed the two by their stumpy tails and stretched them.

The Romans later adopted this story, using their own names for the gods. The poet Ovid, in *Metamorphoses* [2], described the last-minute rescue when Jove (Zeus)

> … snatched them through the air
> In whirlwinds up to heaven and fix'd them there;
> Where the new constellations nightly rise,
> And add a lustre to the northern skies;

Juno (Hera) was not at all pleased to see her husband's lover and bastard offspring so honored, complaining that they

> … proudly roll
> In their new orbs and brighten all the pole.

She begged Oceanus and Tethys, two "elders of the sea to whom the gods gave reverence and awe," to

> … forbid these bearlike
> Creatures in the stars to wade your waters;
> Shut out the creatures who at cost of sin
> Shine down from heaven, nor allow that whore
> To taint the waters of your sacred streams.

According to the story, this is why the Bears, as seen by the Greeks, Romans, and anyone else living at a high enough latitude, never dip below the horizon into the sea. Luiz de Camões, a sixteenth-century Portuguese poet, wrote about observing the stars from a lower latitude during a voyage southward:

> I saw both Beares, (the *little* and the *Great*)
> Despight of Juno in the *Ocean* set.

Tlingit House Partition

This stunning Tlingit house partition was originally part of the Grizzly Bear House at Wrangell Village, Alaska.

Model of Grizzly Bear's Mouth House

Grizzly Bear's Mouth House, which belonged to Chief Giatlin, stood in Skidegate on Haida Gwaii (Queen Charlotte Islands) off the coast of British Columbia. Its striking house front was sculpted as well as painted.

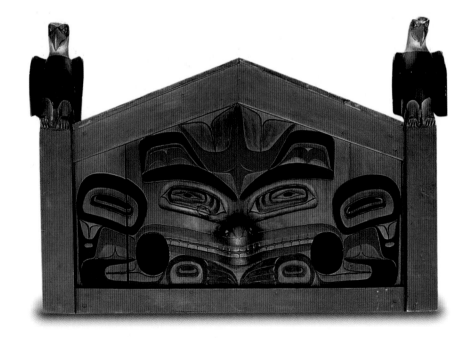

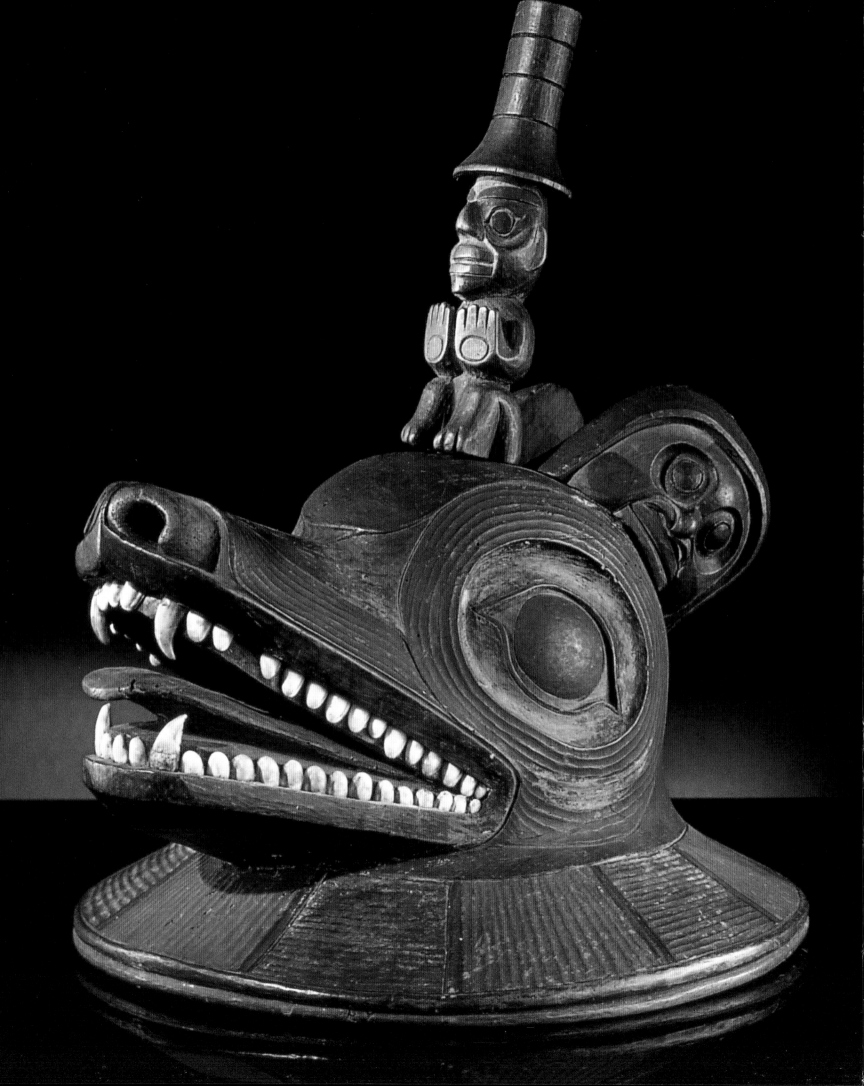

References to the Callisto legend and the celestial bears continued to appear in Old World prose and poetry through the centuries. Even William Shakespeare referred to them, writing in *Othello*:

The wind-shak'd surge, with high and monstrous mane
Seems to cast water on the burning Bear,
And quench the guards of th' ever fixed pole.

But did the idea that these stars should be called a bear first arrive in the New World with the Europeans? When folklore scholar Stansbury Hagar examined this question in 1900, he noted that early missionaries and explorers everywhere found native star names and legends well-known and said to be of ancient origin. LeClercq in 1691, Cotton Mather in 1722, La Fitau in 1724, and others recorded native peoples' original names for and legends about *Ursa Major*—and many included a bear.

One of the most beautiful and complete stories was recorded from the Micmac (Mi'kmaq) people of Nova Scotia and the Iroquois from near the St. Lawrence River, although it appeared with slight variations among several other groups. These peoples saw the bear as the four stars that form the "dipper" while the stars of the "handle" represented hunters.

The hunt begins in the spring, when the heavenly bear emerges from his den in the stars of the Corona Borealis. He is pursued through the summer skies by seven hunters: Robin, Chickadee, Moose Bird (Gray Jay), Pigeon, Blue Jay, Owl, and Saw-Whet. Chickadee carries with him a tiny cooking pot. As autumn nears, the four hunters farthest from the bear lose the trail, the stars setting one after the other. Robin, Chickadee, and Moose Bird continue their chase until, in autumn, Robin fatally wounds the bear with an arrow. The Iroquois say that it is the blood of the bear that colors the fall leaves red. The Micmac say that the bear's blood sprays onto Robin, who shakes himself and colors the leaves. One drop remains, giving Robin his red breast. When the hunt is over and the bear's flesh has been cooked and eaten by the hunters, only the bear's skeleton remains, lying on its back in the sky. It stays there through the winter with its back toward the horizon, until a new bear leaves the den in the spring and the cycle begins again.

The Iroquois and Micmac explained what they were seeing in the skies with a story that was quite logical considering how well the daily and yearly movements of the Great Bear lend themselves to comparison with the bears they saw around them—a similarity that is probably the main reason why so many early people envisioned a heavenly bear. During its daily journey around the pole star, the Great Bear seems to shift from a four-footed stance to a two-footed one and back again, as earthly bears often do. Each season, the constellation's position in the midnight sky echoes the behavior of bears below: In early spring, it seems to be emerging from its den head up; in midsummer, it appears upright as a feeding bear would; at autumn's end, its head is down as if to enter its den; through the winter, it lies on its back, dormant in hibernation. The leaves turning red each fall, as though tinted by the celestial bear's blood, dovetailed nicely into the Micmac and Iroquois explanations. Some of the neighboring Wabanaki peoples added yet another detail to the story by saying the white blanket of the first snows was a coating of the bear's grease falling from the kettle when the star-hunters cooked the fat.

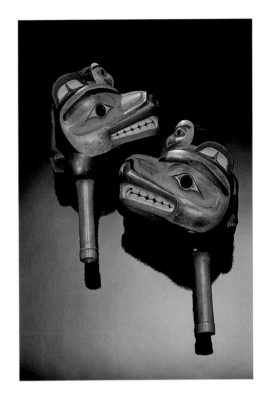

Tsimshian Bear Rattles

Onward the kindred Bears, with footsteps rude,
Dance round the pole, pursuing and pursued.

—Erasmus Darwin, eighteenth-century English
naturalist and poet, quoted in Allen (1963).

Tsimshian Bear Headdress

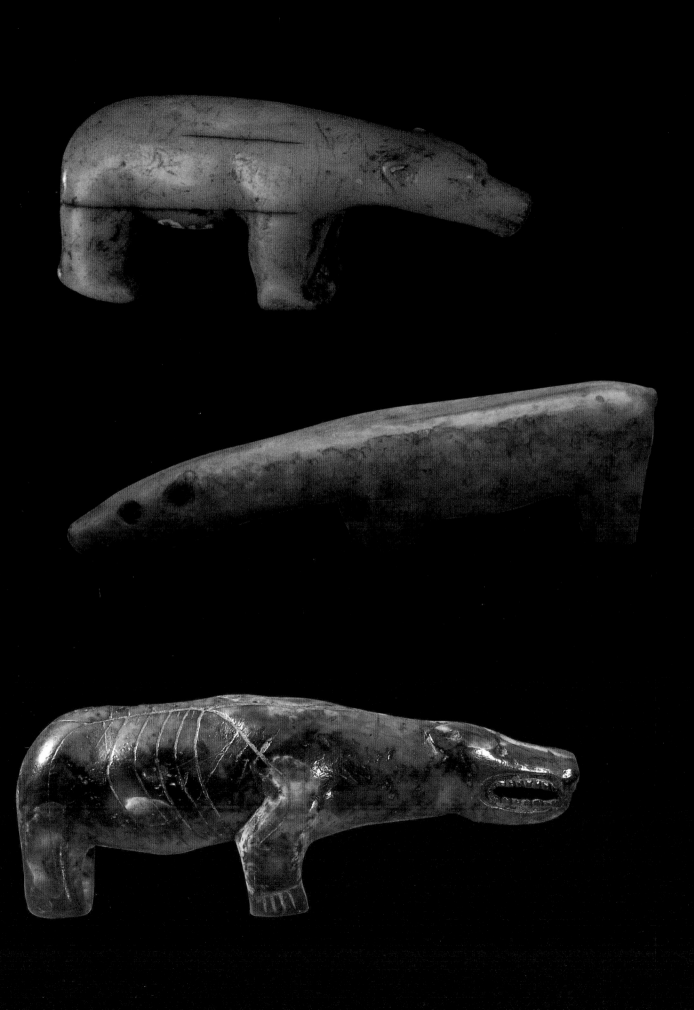

Other people saw different bears in the same stars. The Modoc saw the two stars that form the side of the "dipper" opposite the handle as two grizzly bears. The rest of the stars were wolves hunting the bears. To the Kootenay (Kutenai) people from the Pacific Northwest, the stars were a young woman who had been changed into a female grizzly and placed in the heavens. The Oklahoma Delaware (Munsee), originally from the northeastern United States, saw Ursa Major as a bear's body and the stars of the Corona Borealis as the bear's head. The bear is forever trying to get its head back and if it ever succeeds, the legend says, the world will end.

Of all the Great Bear origin stories I read, one of my favorites is attributed only to "American Indians" by author Julius Staal, making it impossible to give proper credit to the story's creators. Here is my version of the tale:

> Long ago, there was a forest of great oak trees. These trees were unusual because they could move about when they wished as long as it was after the sun had set and before it had risen again. Each night, soon after midnight, branches and leaves would begin to rustle loudly as the trees went to visit one another. One day a bear who had never traveled in those parts before ambled into the forest and somehow lost his way. That night, as the bear tried to find his way out of the forest, the trees began their nocturnal perambulations. Now, where the bear came from, trees grew in one place and stayed there. Unused to these unexpectedly moving obstacles, he eventually bumped into one of the trees and, not knowing any better, failed to apologize.

> This did not sit well with the dignified oak, who began to chase the confused and terrified bear. Through the dark night pursuer and pursued ran in a bizarre race, the tree never quite catching the bear. Suddenly the tree realized that dawn was near, the time when it must be back in its own place in the forest before the sun noticed it was missing. With one last desperate effort, the tree stretched out its longest branches. It grabbed the bear's tail and hurled the bear far into the sky where it can be seen today as the Great Bear.

You can best appreciate the power of many of these stories in surroundings where "today" fades away. Stand outside on a cold, clear winter night, away from the noise and lights of people, and watch the stars overhead. The Great Bear looks near enough to touch, and, as an icy breeze stirs the nearby trees, you can easily imagine them to be paying their nightly calls on one another.

OTHER FABULOUS BEARS

According to the oldest legends of the Menominee people who lived near the Great Lakes, the earth divided the universe into two parts. Good gods lived on four planes above the earth, evil gods in four tiers underneath. The powers of both increased with their distance from the earth. A white bear with a shining copper tail lived at the lowest level and was supreme ruler of the underground gods. His servant was a naked bear. Deemed the most important evil power, the white bear was also regarded as the traditional ancestor of the Menominee and the guardian of earthly bears. Some said the white bear's spirit guarded the valuable deposits of native copper found along Lake Superior.

Ancient Bear Carvings

These three small figures transcend time and space to connect us with the artists who carved them so long ago. All are from the North American arctic and may have been used by shamans to call upon the bear's power.

Fantastic bears also roamed the earth in early legends. Inuit tales told of evil creatures that were half polar bear and half whale or half polar bear and half seal. Far out on the icepack, they said, lived Kokogiak, a giant ten-legged bear. To the Inuit, seeing Kokogiak foretold death. Lenape parents frightened recalcitrant children with warnings that "a great naked bear" would eat them if their behavior didn't improve. According to Siberian natives, a giant polar bear dwelt on the ocean floor and created whirlpools when it inhaled water. The Ainu of Japan described two very distinct types of unusual bears: dangerous, wild bears living at the base of the mountains, whose clothing bore blood-red stripes and who sometimes killed people; and gentle, divine bears worthy of worship who lived in the heart of the mountains and wore clothing striped with gold, silver, and bronze.

BEARS AND HUMAN BEGINNINGS

When we began our journey to the distant past, we looked at archaeological indications of a very old connection between bears and the earliest humans. What do ancient legends and stories say about the subject?

Two stories from the American Southwest put bears squarely on the scene in the early days of human presence. According to a creation story from the Pueblo people of Hano, it was Bear Old Man who led the first people up from the lake of the Emergence. A legend of the nearby Hopi people says that a bear carcass was responsible for the names of seven clans:

> When the people left the place of first emergence, one group of people separated and went on ahead of the others. These people traveled many places but finally arrived at the Little Colorado River. Nearby they found a dead bear and from it took their clan name—Bear. Another group of people came upon the same carcass and named themselves Piqösha, after the carrying straps (piqösha) they cut from the hide. Another group arrived and were called Mú-yi for the small mice (mú-yi) that had nibbled the hair from the hide.
>
> Some time passed, and then another party happened by. They saw many bluebirds feeding on the bear's carcass and so became the Bluebird clan. More people came along and saw that spiders had spun many webs in and around the bear. So these people were called the Spider clan. Time passed and the bear carcass was reduced to bleached bones. A sixth group of people came to the spot and took the bear's skull, tied yucca leaves to it, and carried it along as a drinking vessel. They became the Jug (Wíkurzh) clan. Nothing remained of the bear when the last group arrived but ants swarmed over the ground where it had been. This group became the Ant clan. Because these clans all took their name from the same origin, they were considered to be related to one another.[3]

Ivory Bear Carving

Many other people from lands beneath the ever-circling Great Bear also believed in an ursine presence at the beginning of human history. They, however, saw bears playing a much more straightforward and intimate role: ancestors.

Long ago, before Bear had learned to sleep through the season of snows, it was early winter and growing steadily colder. Ice covered the ponds. As he walked through the woods, Bear was in a grumpy mood. Near the edge of a pond he saw Turtle's head sticking out of the ice.

"What are you looking at Slow One?" shouted Bear rudely. "I don't know why you call me slow," Turtle replied. "Hah!" yelled Bear. "I would leave you far behind in any race." "Hmm," said Turtle whose legs were slow but whose wits were not, "I think we should have a race to prove who is the swiftest."

"Any time, any place," snapped Bear. "All right," said Turtle. "Tomorrow morning we will race here at this pond. You can run along the bank and I will swim under water." "That won't work," said Bear. "The pond is covered in ice." "I will make holes in the ice," replied Turtle, "and stick my head out as I come to each hole during the race." "All right," agreed Bear, "just be ready to lose, Slow One."

The next morning many animals gathered to watch the big race. When everything was ready, Turtle's head popped out of the hole at the starting line and Bear rushed over to his place. At the agreed upon signal the race began. Turtle's head disappeared beneath the ice and Bear took off in a flurry of flying snow.

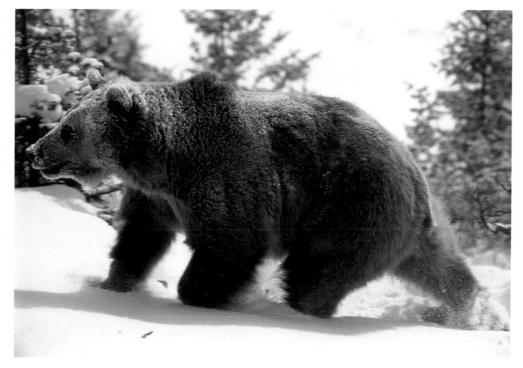

Suddenly, Turtle's head appeared in the next hole, far ahead of Bear. "Bear, you must hurry to catch me," Turtle cried and then disappeared. Bear couldn't believe his eyes and began to run even faster. It didn't seem to do any good because, before he reached the next hole, up popped Turtle's head.

"My friend, can't you catch me?" taunted Turtle. Again he disappeared beneath the ice. Bear was running faster than he ever thought he could. His sides heaved and his breath came in great clouds. But Turtle's green head appeared at each hole long before Bear could reach it.

Bear could hardly move by the time he finally reached the finish line. Turtle was there celebrating his victory and being congratulated by all the other animals. Bear was so ashamed of losing that he went home, crawled into bed, and slept until spring.

Turtle stayed at the pond until after Bear and all the other animals left. Then he stretched out a clawed foot and tapped on the ice. At the sound, a dozen green heads popped up out of the holes in the ice—the heads of Turtle's brothers and cousins who looked exactly like him. Turtle thanked them for their help.

"Today Bear learned that it is not a good idea to call other people names," Turtle said. "And I think we showed all the animals that turtles are not the slowest animals of all." Then Turtle's green face broke into a wide grin and, from the holes in the pond, a dozen green faces just like his smiled back.

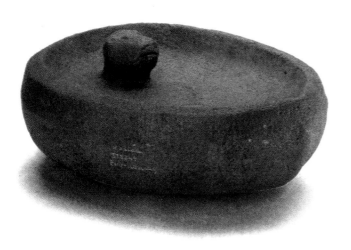

Ornamented Stone Lamp

*When this stone lamp was in use, the carved polar
bear would seem to be raising its head above the
pool of sea-mammal oil used for fuel just as a
real bear lifts its head out of the water.
The lamp comes from Kodiak Island, Alaska
and is at least 1500 years old.*

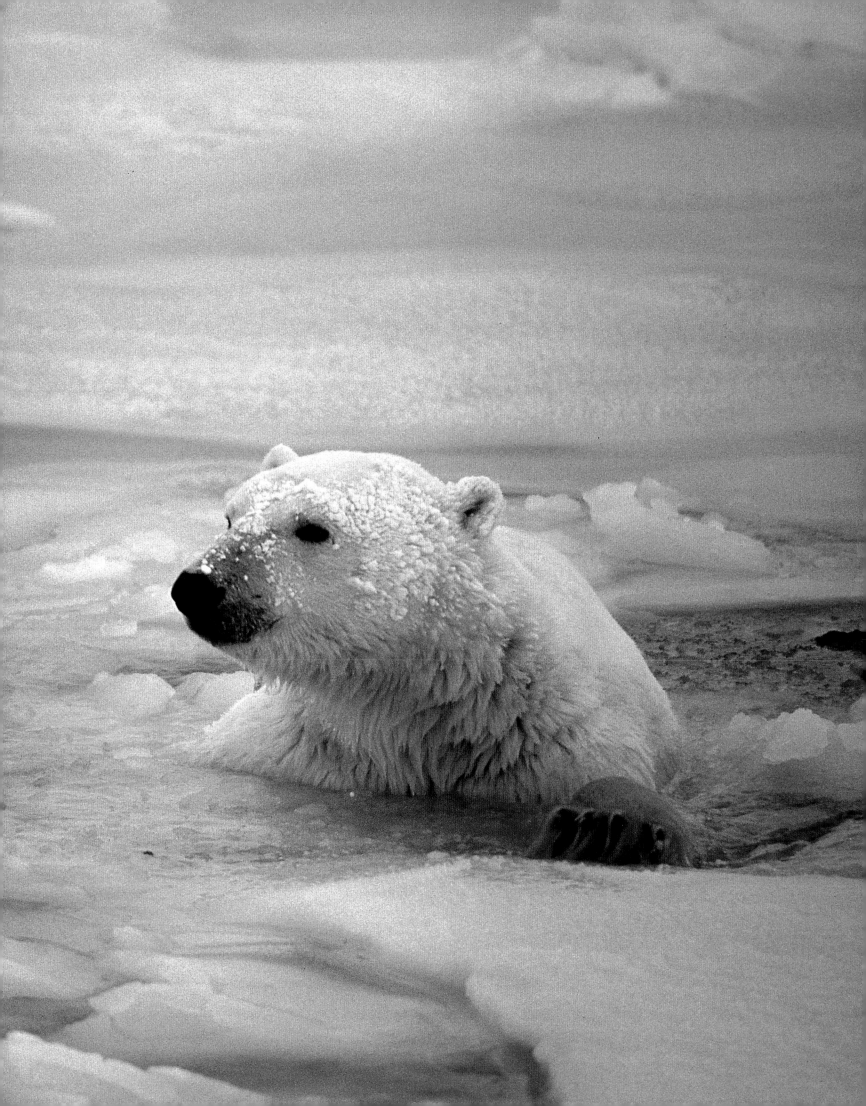

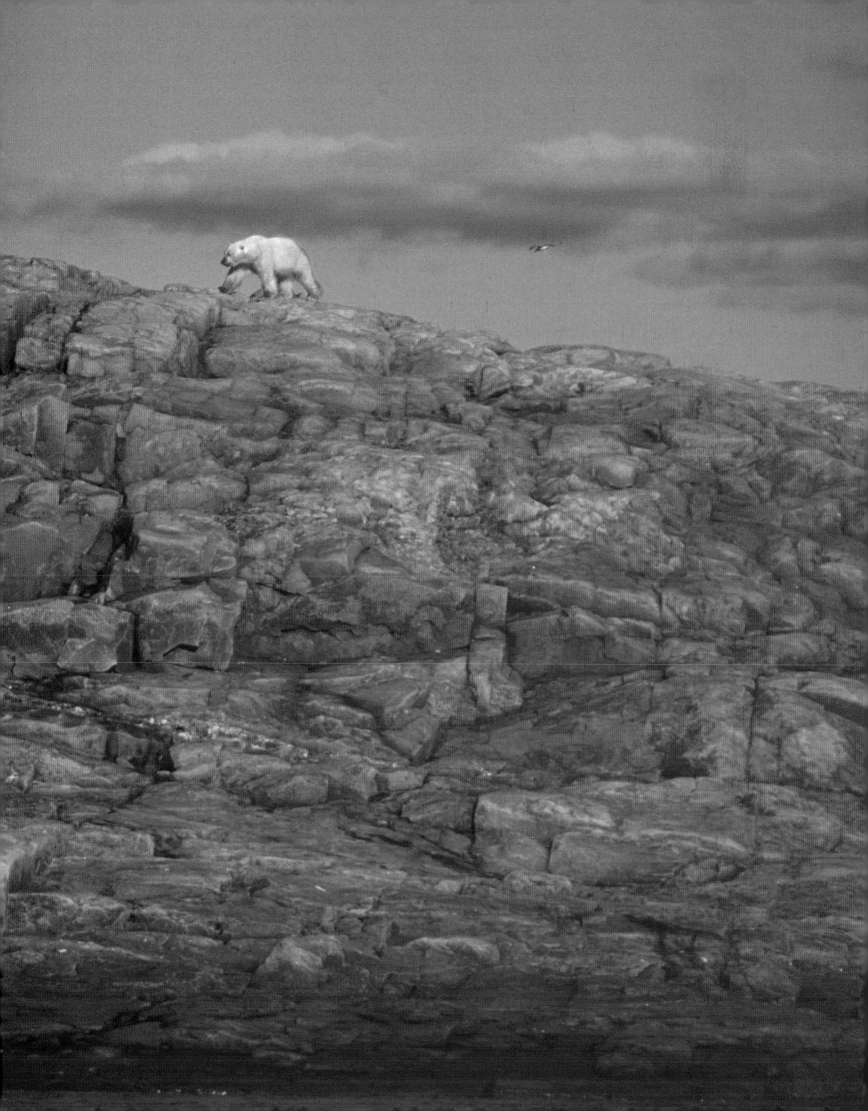

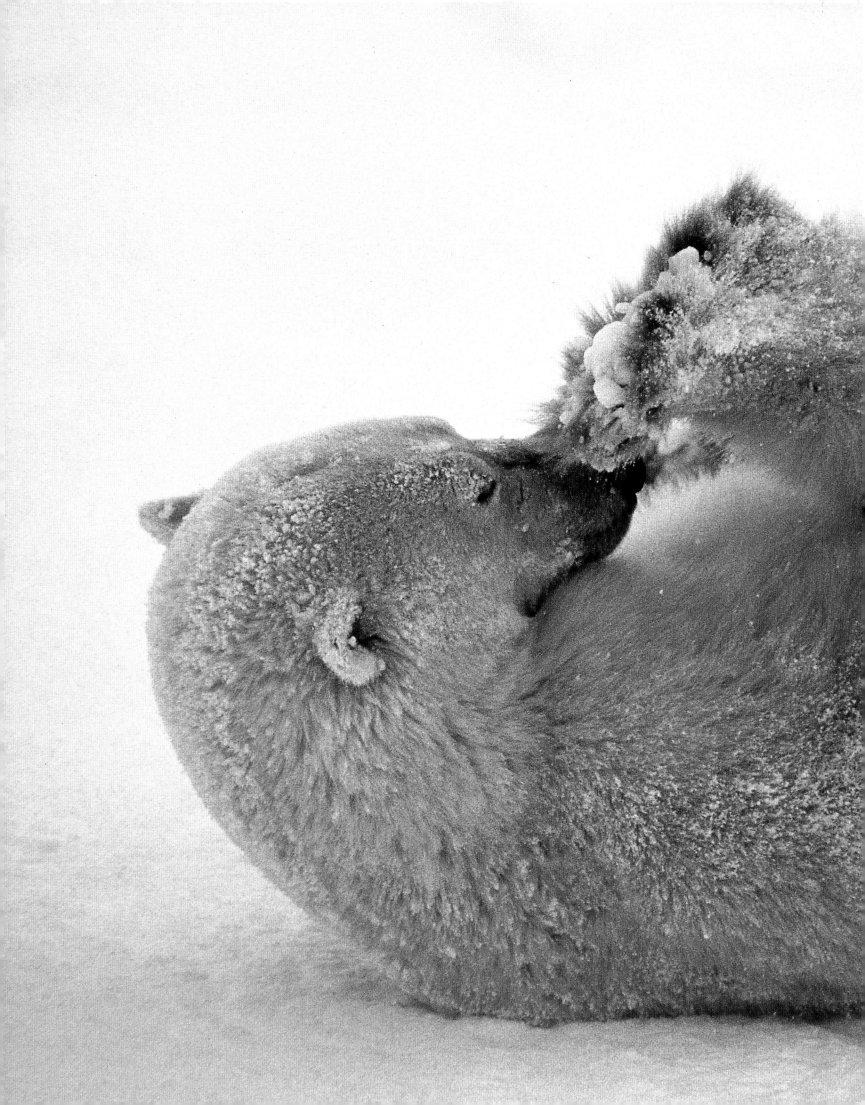

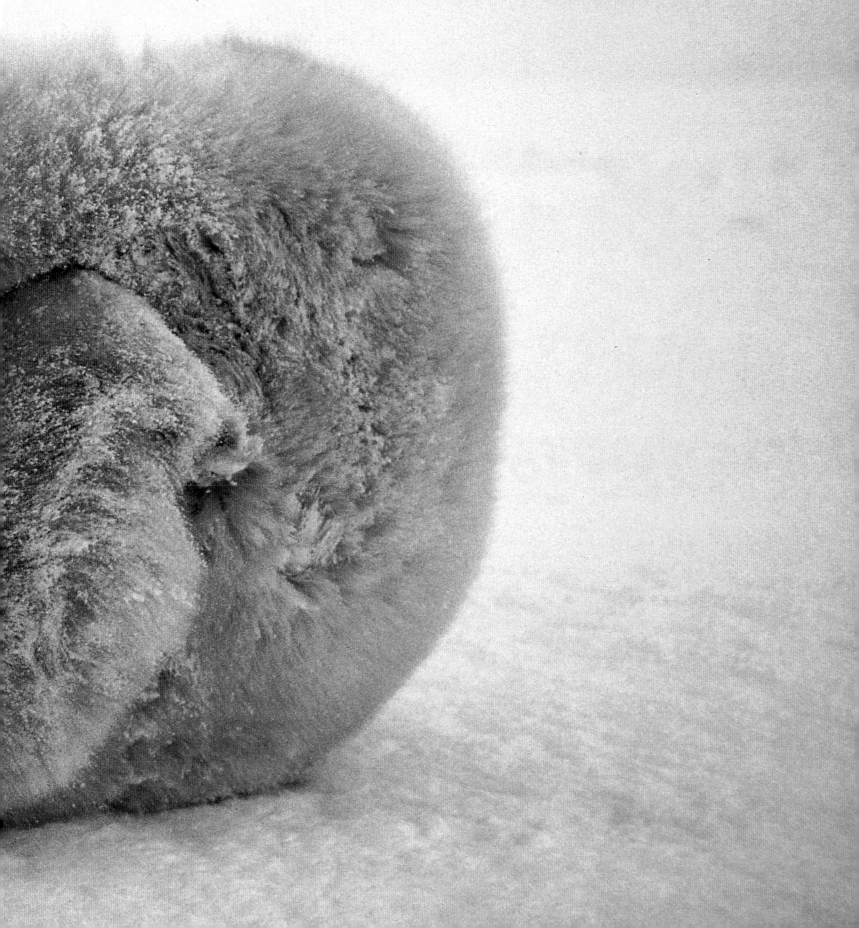

BEAR PEOPLE

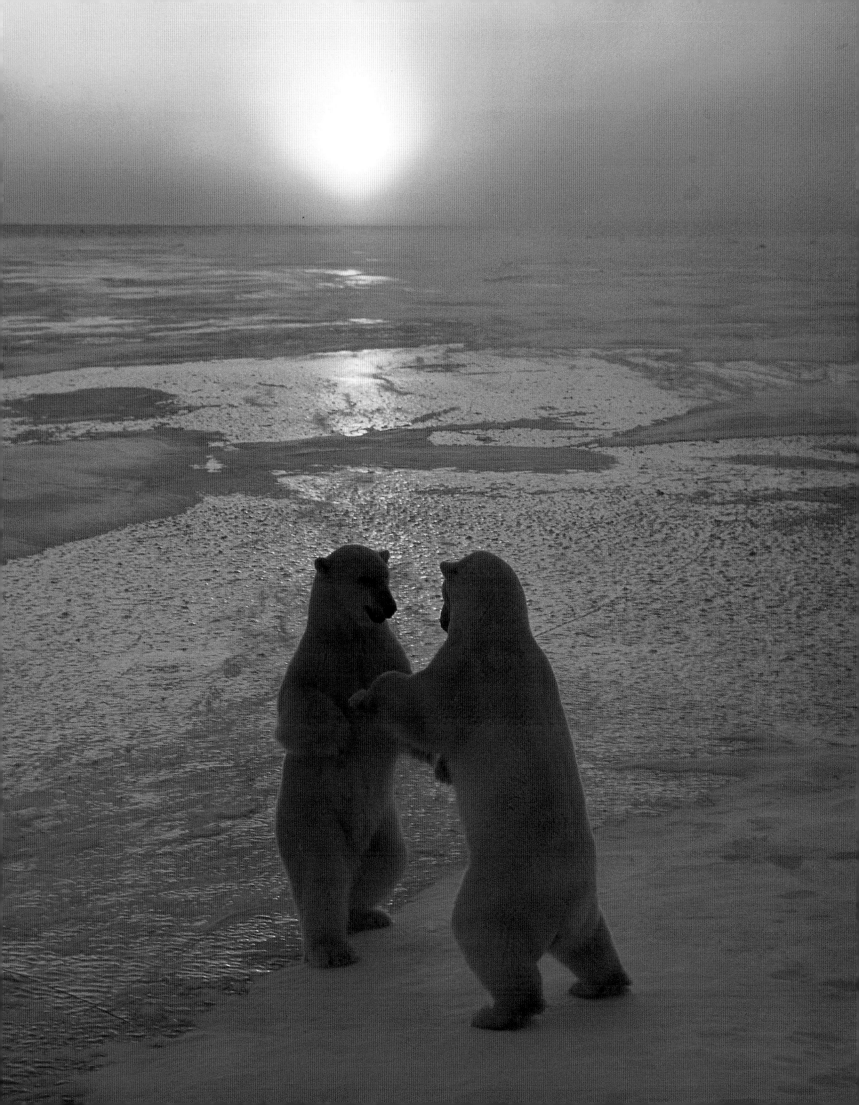

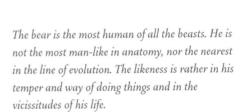

The bear was once a man, and man also lives in the bear.
—From the Selkup people of the Ob River Basin, *Siberia*

Among the native peoples of Siberia it is a common belief that humans are descended from bears. The Nanai tell how, long ago, a bear visited a woman in her *yurta*. Their children became the Nanai clan. When the children were grown, the woman turned into a bear and lived in the woods. She was finally killed by a hunter who disobeyed the bear-mother's request to her children not to kill any bears they met in the forest. Two tribes closely related to the Nanai, the Udegeis and the Orochi, share this origin story. Two other Siberian peoples, the Voguls (Mansi) and the Ostyaks (Khanty), each have a clan that calls itself "the clan of the bear." The clans claim the bear as direct ancestor and women of the clans regard the bear as their brother. Some of the Sakhalin and Okhotsk Evenks believed they were descended from a girl who had both a man and a bear as husbands. She lived long ago "when there was no bow and arrow, and when people hunted wild animals with a pointed stone held in the hand."[1] The Sym and Baykit Evenk people traced not only their origin but that of one of their most important resources to a bear:

> A girl named Kheladan met a bear who told her to kill him and cut him up. "Put my heart next to you, place my kidneys behind the hearth and my head near them, put my lower intestine across from you, lay my fur in a dry ditch, and hang my small intestine over a dry, gnarled tree." Kheladan did as the bear ordered and went to sleep. When she awoke in the morning she saw that the kidneys had become two children, near them lay a sleeping old man, and across from her lay an old man and woman. Looking outside she saw that the bear's fur had turned into reindeer, filling the little valley where she lived. When she ran out for a closer look, she saw halters for the reindeer hanging on the tree where she had placed the bear's small intestine.[2]

In North America, too, the bear was part of human beginnings. In the Pacific Northwest, the Shasta and Modoc told the following story:

> After the Great Spirit had turned the earth into a green and lively place, he decided to live here for a while. He turned Mount Shasta into a tipi and, after building a fire inside to keep it warm, brought his family down from the heavens to live with him. At night the sparks from his fire showed red against the sky while smoke floated lazily upwards during the day.
>
> One night during a terrible storm, the Great Spirit asked his youngest daughter, a beautiful red-haired girl, to climb to the tipi's top and ask the storm to be more gentle. She did as she

The bear is the most human of all the beasts. He is not the most man-like in anatomy, nor the nearest in the line of evolution. The likeness is rather in his temper and way of doing things and in the vicissitudes of his life.

—David Starr Jordon
in *True Bear Stories* by Joaquin Miller

was told but, desiring to see the ocean which she had never seen, climbed too far out of the tipi. The wind caught her long red hair and tumbled her far down the mountain side into the forest below.

At that time, the grizzly bears owned the forest and the lands down to the sea. They were different from the grizzly bears we see today—not really animals but covered with hair and possessing sharp claws. They lived in caves, walked upright on two feet, used clubs to hunt and fight, and had the power of speech.

One family of grizzlies lived close to the tree line. The old mother had just given birth to a cub and the father was out seeking food for his family. As he returned home he came upon the red-haired child shivering beneath a fir tree. He didn't know what to do with her so he took her home to his wife, who was considered to be very wise in all things. The old mother bear told him to leave the child with her and she would nurse it along with her own, but he must never tell anyone about it.

The red-haired child grew up among the bears until one day the old mother said, "It is time for our son to have a wife. And who shall he have but the small red one you found years ago." The father grizzly went out and returned with meat for the marriage feast. The marriage was a happy one and the couple had many children. The children, however, being part Great Spirit and part grizzly bear, looked and acted unlike either parent but a bit like both. They had bare, reddish skin like their mother but their heads were covered with long, black hair like that of their father. Like their father, they were courageous and strong, and they had inherited the wisdom of their grandfather, the Great Spirit. These children were the first of our people. The grizzlies from all around were very proud of the couple and their children and built them a great lodge.

Eventually it was time for the old mother grizzly to die, for she was very old. She knew that she would not be able to rest unless she told the Great Spirit what had become of his long lost daughter. She gathered all the grizzlies together and sent her eldest grandson to the top of Mount Shasta to speak with the Great Spirit.

The Great Spirit was overjoyed at the news and ran down the mountain to see his daughter. Thousands of grizzlies stood with their clubs on their shoulders, forming two great lines for him to pass through. But when the Great Spirit saw the children playing near his daughter, he was very angry that the grizzlies had created a new race. He drove the children out into the world, shutting forever the door of the lodge where they had lived. Then he frowned so horribly at the old mother bear that she died immediately. The grizzlies all began to howl but the Great Spirit took his daughter and prepared to leave. He told the grizzlies to be quiet, drop their clubs, get down on their hands and knees, and stay that way until he returned to set them free. They did as they were told as the Great Spirit took his daughter and went back up the mountain. He never returned and so the grizzlies have had to stay the way he left them.

Náne – Qágyuhl

"When the great Grizzly-bear cries
u! hu! nan! hiⁿ!
The people will fall in fright
As if thrown from a tilted plane."

Edward S. Curtis photographed this initiate into a Kwakiutl grizzly bear society in 1914. The man is emerging from the woods, in fierce emulation of a grizzly.

The people who lived near Mount Shasta long ago would never harm a grizzly, for it was because of these bears that the people came to be.[3]

The Ute people of the Great Basin region said their earliest ancestors were bears. From the bears came a race of people who were transformed into bears when they died. This second group of bears wandered through the forests until they, too, died and went to live in the future land. There they were given human wisdom, although they kept the shape of bears, and were allowed to be immortal alongside people. Bears today no longer go through this transformation but, as descendants of those ancient bears, are considered to be related to the Utes.

The Menominee called the bear "elder brother" while the Abnaki (Abenaki) called him "cousin." Groups throughout America, including the Tsimshian and Tahltan peoples of North America's northern Pacific Coast and the Ojibwa people of the Great Lakes region, referred to bears as "Grandfather," "Great-Grandfather," and "Grandmother." Many Siberian peoples did the same, including the Even people, who considered themselves to be descended from the bear's sister. During a bear hunt, when they were gathered at the den, the Even called out "Father Bear! Our grandmother who is your sister … has told you not to frighten us but to die."

OTHER RELATIONSHIPS

Ancient stories about bear and human relationships are not limited to describing bears as human ancestors. Many tales tell of strange transformations, kidnapping, sex, and marriage between the two groups.

A story from Iceland recorded by Arctic explorer Vilhjalmur Stefansson (1906) described how polar bear cubs were born as human children but changed into bear cubs when the mother bear touched them with her paw. One day a hunter captured a cub before the mother had a chance to effect this transformation. The child grew into a beautiful woman who loved to spend time on the seashore. One day an old polar bear approached the young woman. Showing no fear, she allowed the bear to come close enough to touch her. Immediately the young woman turned into a bear and followed the old bear, who must have been her mother, out onto the ice floes, never to be seen again.

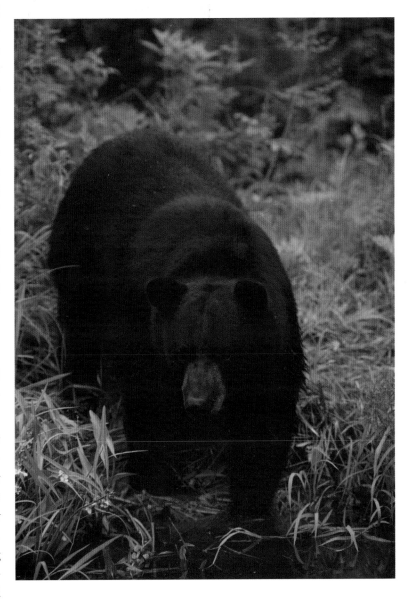

Along with stories of shape-shifting shamans and bear doctors, which you will read about later, tales of humans who could change into bears and vice versa were told by many groups, including the Tewa Pueblos and the people of Cochiti pueblo in the American Southwest, the Coos people of the Pacific Northwest, and the Ainu of Japan. The transformation was often temporary but could have long lasting effects, as the following story from the Tsimshian people illustrates.

[Man's and bears'] history together has been rich and primal. The bear has represented fearful evil and, at other times, regenerative power. The bear is not only complex, but ambiguous and contradictory.

—Paul Shepard and Barry Sanders
The Sacred Paw

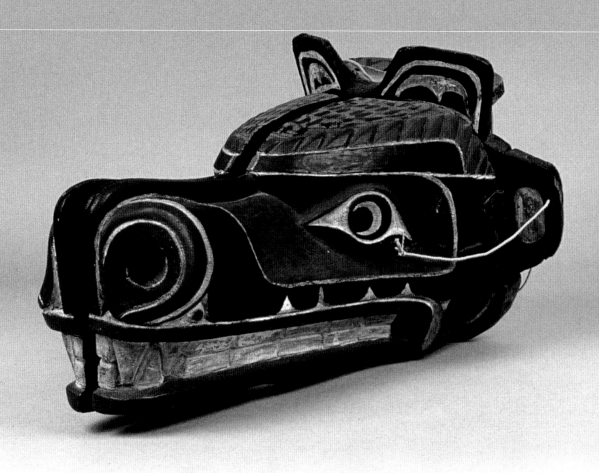

One day while out hunting, a man came upon a black bear. The bear took the man back to his den and taught him the bear's way of catching salmon and building canoes. The man stayed with the bear for two years and by the time he went back to his people, he looked and acted like a bear. The people were afraid of him and ran away, but one old man caught the bear-man and took him home. The bear-man could no longer speak and refused to eat cooked meat but the old man did not give up. He rubbed the bear-man all over with medicine until, slowly, he regained his human form and abilities. For the rest of his life, whenever he had trouble, the bear-man went to the bear for help. During times of hunger, when no one could catch salmon, the bear would catch one for this man. In gratitude, this man built a house and painted upon it a great picture of the bear. His sister had a picture representing the bear on her dancing apron, and all of her descendents used the bear as their crest. [4]

Legends from people including the Patwin of California and the Dakota of the Great Plains tell of girls who have bears as their clandestine lovers. In yet another bear-related explanation of how the Great Bear constellation came to be, the Blackfoot people from the western Great Plains told this story:

Long ago there was a beautiful young woman who had seven brothers as well as a little sister. Her father was quite unhappy because, although she had several offers to marry, she refused them all. What no one knew was that the young woman had met a bear and he had become her secret paramour. Eventually, someone saw the two together and told the woman's father.

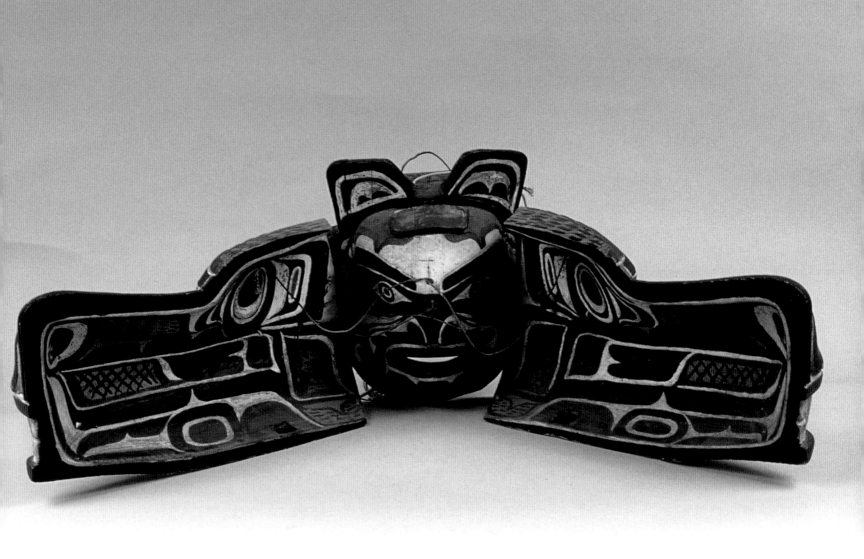

Not long after her lover was killed, the young woman was imitating a bear as she played with her little sister. She told the little girl to be very careful not to touch her over the kidneys, but in the excitement of the game, the girl forgot and touched her older sister's back in the wrong spot. Instantly, the older girl became a bear and charged into the camp. After killing many people, she reverted back to her human form. Her brothers and sister were afraid of the woman after that and quite rightly, as she soon turned on them in anger, too. Once again she turned into a bear and chased her siblings up a tree. The bear flung a stick into the tree, knocking four of the brothers down and killing them. On the advice of a little bird, one of the remaining brothers shot an arrow into the bear's head killing it.

The two boys and the little girl climbed down from the tree. The youngest boy shot an arrow into the sky and when it fell to earth, one of his dead brothers returned to life. He repeated this until all the boys were alive again. After a discussion, the children decided that they would rather live in the sky than remain here on earth where, thanks to their elder sister's depredations, they no longer had any living relatives. Closing their eyes, the children rose into the sky where they live to this day. The little brother shines as the North Star while his brothers and sisters form the Big Dipper. The little sister is nearest the North Star because she often carried her small brother on her back. [5]

Grizzly Transformation Mask

The dancer wearing this Kwakiutl transformation mask would perform for a while as a grizzly bear. Suddenly, by opening the mask, he would be dramatically changed to the bearlike human within.

Stories of intercourse and marriages between bears and humans are found among many groups. When questioned early in the twentieth century, an Athapaskan man said that humans learned about animal behavior during past marriages to them. In quite a few cases, a bear and human marriage had unhappy consequences for one or both of the parties involved, as this story from the Sahaptin people of the plateau region between the Rocky Mountains and Cascade Range illustrates:

> Many, many years ago there were five grizzly bear girls who dwelt by themselves, and close by there lived a black bear with his son and daughter. Near the bears lived five men. The oldest man had married the young black bear girl, and this made the grizzly bears angry because they wanted the men for themselves. They were so angry that they vowed to kill the men in the spring.
>
> When spring came, the oldest man was out hunting one day when he saw a woman digging roots. She was very pretty and dressed in lovely clothes. As he got nearer he wondered who she was. She called out to him and he walked over to her. Suddenly she turned into a wild bear—she was actually the eldest grizzly bear girl in disguise. She grabbed the man and snapped his neck, then took his head and carried it back to her den. The grizzly bear girls killed three more of the men in the same way.
>
> The black bear's son figured out what had happened. He told the remaining man not to go look for his friends but to let the young black bear investigate. The young bear traveled to where the men's bodies had been found. There he saw a woman digging roots, who was, of course, really a grizzly bear. As he approached, she invited him to come closer. As soon as she began to speak, the young bear shot her with an arrow. She tried to attack him but he killed her with a second arrow.
>
> The next morning the young black bear went to the same spot and found another grizzly bear woman digging roots. He killed her, too, and returned again and again until he had killed all five grizzly bear sisters. The young black bear collected the heads of the four men from the grizzly bear girls' den and took them back to his father. The old black bear placed the heads back on their bodies and then he stepped over them, restoring the men to life.[6]

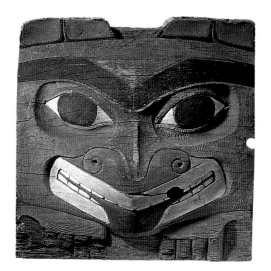

Haida Carving of Bear Face

Bear husbands and bear wives prowled through stories from the Coos, Bella Coola, Tlingit, and Tahltan peoples of North America's northern Pacific coast as well as many others. The Koyukon people of the Alaskan boreal forest said that if a woman met an angry bear in the forest, she should expose her genitals and call out, "My husband, it's me." The bear, ashamed by the encounter, would quietly leave.

Often, ursine spouses were killed by their human in-laws. There could also be consequences for humans who didn't hold up their end of the relationship, as in this Pueblo tale retold from Benedict:

> Long ago, a man from Cochiti fathered bear children. He promised that he would plant corn for the children and their mothers. But when the bears eventually came to eat the corn, he called upon the people of the pueblo to kill them. The bears escaped but the children's bear grandfather tracked down the unfaithful man. He ripped the man's heart from his chest, and took it back to the bears' cave so the bear children would have their father with them as they grew up.

The fact that kinship tales about bears and humans are found in so many cultures makes one curious about their origin. Is there a reason that ancient people made such a personal connection between themselves and the bear?

Bears Are Like People

Bears are like people, except that they cannot make fire.

— *Belief of the Yavapai people of Arizona*

The idea of a direct, physical relationship between humans and bears, or any animal, may seem strange to us but it becomes more understandable when you know that most early people considered humans and animals to be very much the same. Many groups did not even have a separate word that meant "animal." The jump from considering bears and humans to be similar parts of a larger group to linking them in a variety of intimate relationships almost certainly resulted from observations of the many ways in which bears appear to resemble humans.

If you watch a bear for a while, you begin to notice a familiarity about its movements: it uses its paws to pick up and examine objects; it wrinkles up its nose and rubs its eyes with its paws; it stands on its hind legs, letting its front legs hang arm-like by its sides. The last behavior is particularly striking, and even seasoned observers may be startled with just how much a standing bear resembles a human. This similarity is strongly reinforced by the fact that a skinned bear carcass looks eerily like that of a human. I strongly suspect these two resemblances are the source of stories about bears who become humans when they take off their fur coats and become bears again by putting them back on.

There are other similarities, too. Bears, like humans, are omnivores: exactly what they eat varies depending on their species, the season, and local availability. Bears walk on the soles of their feet, like us, rather than on their toes like many other animals, including your pet dog. This plantigrade motion leaves footprints that show heel, arch, and toes, as ours do. Like us, the bear can rotate its forearm because the bones inside are separate rather than fused. Bears may use their somewhat clumsy-looking paws with dexterity to carry food to their mouths or even, as black bears in Yosemite National Park have learned to do, open containers with screw-on lids.

Bears are playful. Young bears chase and wrestle each other. As they grow older, they still play, usually selecting a partner of approximately their size, but the frequency of bear play generally decreases with age. Several researchers and photographers have observed that perhaps the most exciting bear play to

*For many people,
the most endearing and
human-like characteristic
of the bear is the maternal
devotion shown by bear moth-
ers. This polar bear mother is
coaxed into a rollicking game
of pounce-and-roll by her cub.*

*Should danger threaten,
however, her playful manner
will vanish and she will defend
her offspring ferociously.*

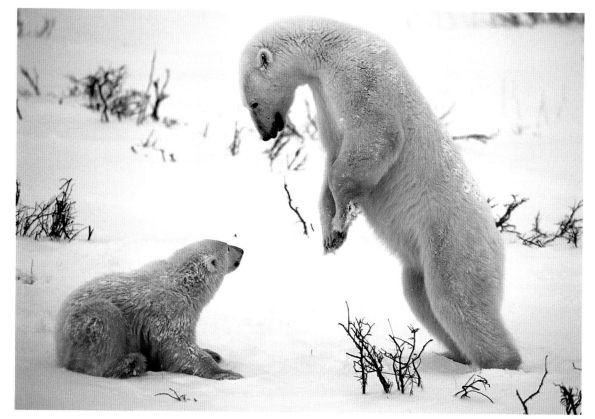

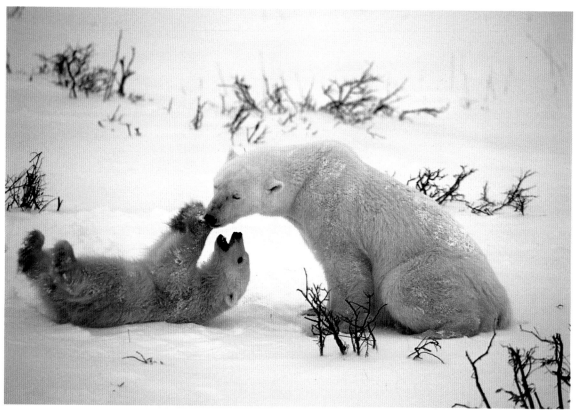

watch is that between two adult polar bears. Standing about 2.5 meters (8 feet) tall on their hind legs, they may push and shove each other, then fall to tumble end over end in the snow.

Bears are very curious, and experiments with black bears, although limited, indicate they are more likely than other animals to investigate unusual objects. This quality may be part of the reason those jar-opening black bears in Yosemite National Park have also learned to break into vehicles for food, raiding more than 1,100 cars in 1998 alone. (Statistics indicate the bears prefer Toyota and Honda sedans, possibly because their lightweight construction allows easier entry.)[7]

As you might guess from all of this, bears are intelligent and appear to be capable of remembering things over long periods of time. For example, they may find a food source that exists or is important only under certain circumstances, such as drought. They are then capable of relocating that food source when the same conditions arise again, even years later. Bears may also take action based on more rapidly changing circumstances. A researcher in Minnesota observed a female black bear's behavior when spring meltwater drained into her den. She came out and gathered extra bedding materials which she took back into the den to raise herself and her new cubs above the water.[8] Wild bears may live for twenty-five years or more; much of a bear's chance of living that long is based upon what it knows about where to find food and how to avoid trouble—and much of that it learns from its mother.

For many people, the most endearing and human-like characteristic of the bear is the maternal devotion shown by bear mothers. Bear cubs are born tiny, blind, and almost hairless during the depths of winter. Newborn brown bears and polar bears weigh only about 600 to 700 grams (21 to 25 ounces)—smaller than a pet guinea pig. Newborn black bears are even tinier, weighing only about 340 grams (12 ounces). For the first two to three months of their lives these frail creatures know nothing but their mother's scent and warmth. Contentedly nursing on her rich milk, which contains five to ten times as much fat as that of humans, they grow into roly-poly balls of fur ready for spring's adventures. Once a mother bear and her cubs leave the den, she begins to teach them the lessons they will need to survive, and she does her best to protect them from harm.

The ferocity of a mother bear defending her cubs is legendary, but refers most particularly to grizzly bears and polar bears. They evolved in more open environments where there aren't many places to which threatened cubs can escape. Therefore, a more aggressively defensive mother gave cubs a better chance to survive. To paraphrase Thomas McNamee (1984), grizzly cubs can play without care, safe in the knowledge that they are protected by the baddest mother in the woods. Polar bear mothers physically defend their cubs from attacks by other polar bears, particularly males. Black bear cubs, on the other hand, often protect themselves

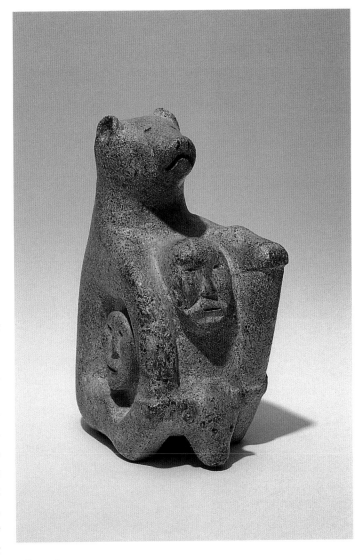

Stone Bear Statue

The inseparable intertwining of bear and human spirits is expressed in this stone carving from Kangirsuk in northern Quebec.

49

by disappearing into thick cover or up trees when danger threatens. Black bear mothers will actively protect their cubs if the circumstances warrant it, either by attacking the threat or by adopting other measures. Noted bear researcher Stephen Herrero (1985) once observed a black bear family being tormented by some teenagers throwing rocks at the cubs. The mother sent her cubs up a tree and followed them up. She then used her body to shield the nearest cub from the rocks. (At this point, Herrero reported that he stopped being a researcher observing bear behavior and chased off the teenagers.)

Herrero's experience and other descriptions of mother bears caring for and protecting their cubs strike a chord that resonates with most of us because it relates to a very basic and admired human trait. Ancient peoples heard this emotional echo, too, and from it and their observations came still another type of story about bear people.

BEAR MOTHERS — BEAR CHILDREN

Two related stories, known as the Bear Mother story and the Bear Son story, can be found in some guise in many cultures, especially those of the circumpolar regions. Some speculate that the Bear Mother tale probably originated with the Tsimshian peoples and spread outward to other groups in North America and Eurasia. Although details may vary slightly from place to place, the most common form of the Bear Mother story, retold from several sources, is as follows:

A young woman named Peesunt and two other girls were gathering berries. Peesunt spent the whole time chattering away, laughing about this and that, instead of singing to tell the grizzly bears of her presence or being respectfully quiet. She was so noisy that the bears heard her and came to watch the girls. When they were through for the day, the girls gathered their things and started back toward their village. Peesunt was so busy talking that it took her longer to pick up her pack and she was left a little distance behind the other two. As she hurried to catch them, her foot slipped on some bear dung and she fell. Her pack strap broke as she hit the ground and berries spilled everywhere. The other two girls thought nothing of Peesunt lagging behind as she often did and continued on to the village.

Peesunt looked around at the spilled berries and made several coarse comments about bears, which did not please those who were watching her. It was growing dark as she began to gather her berries and she was startled when two young men wearing bearskins appeared and offered to help her. When they had picked up all the berries, the two men took Peesunt to their home in the mountains.

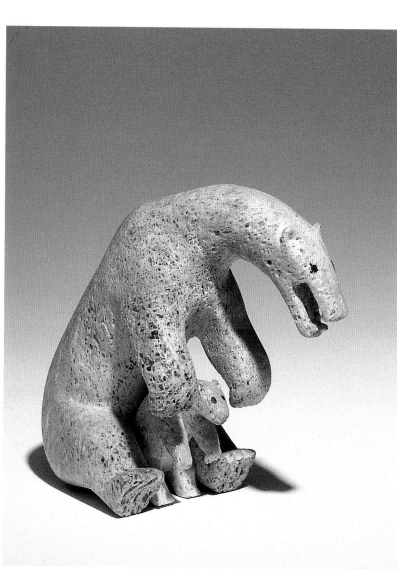

Bear Protecting Her Cub

Elisapee Ahlooloo's sculpture illustrates the protective nature of the female bear.

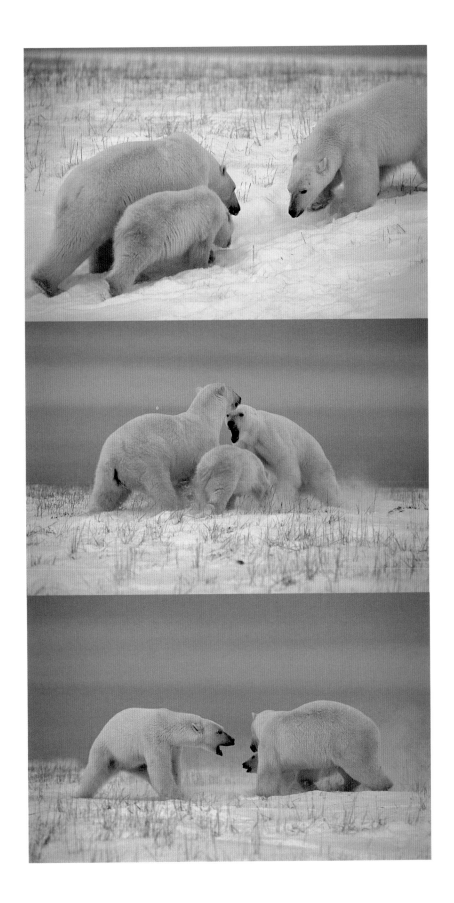

When a female polar bear and her cub cross paths with another bear, things can get rough.

In this case, in spite of fierce posturing on the lone bear's part, the mother stood her ground, shielding and protecting her cub. Eventually, the other bear backed off and decided to depart.

There the two men removed their fur robes and revealed themselves to be grizzly bears. Offered the option of either marrying one of them or dying, Peesunt married the bear who was a chief's son. The following spring she gave birth to twins who were half human, half bear.

Peesunt's family had been searching for her all this time. Her husband gave Peesunt permission to betray him, and with her help, her two brothers finally found her. They killed her bear husband but spared her twin children. Before he died, Peesunt's husband taught her brothers the songs they must sing over bears they killed to ensure continuing good luck.

Bear Mother legends are a good example of how much information about cultural beliefs may be contained in a single tale. These stories reinforce the belief that bears are kinsmen but, although they indicate that both bears and humans carry within them part of the other, the tales make it clear that bears and humans are separate and distinct entities. Bear Mother stories contain the bear to human transformations that we have seen in other tales as well as the creation of chimeric offspring. And finally, we are presented with the bear as a willing sacrifice and given an explanation for the origin of rituals performed over slain bears.

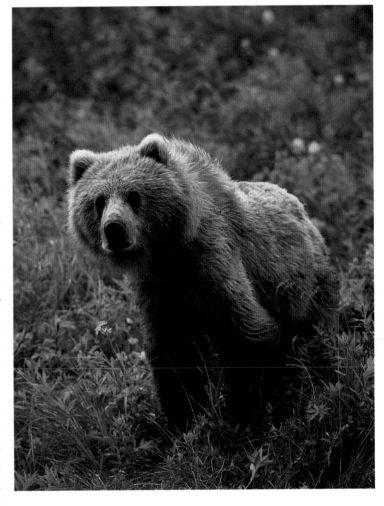

Bear Son stories continue from the point at which the Bear Mother story ends, telling of the heroic adventures of the offspring of a human mother and bear father. Sometimes, the bear/human twins of the Bear Mother story return home with Peesunt and her family, remove their robes and live as humans until their mother dies. They return to the Bear People and have a series of adventures, miraculously reappearing when all believe they are lost. In another form of the tale, Bear Son's father is a bear god, and Bear Son must fight off a variety of hideous monsters while trying to come to terms with his mixed parentage. Eventually he returns home to marry a princess he had rescued earlier in his epic journey.

The Tlingit people inverted the Bear Mother story with their tale of *Kats*, which is also found among the nearby Tsimshian and Haida. *Kats* was a young man who belonged to the *Tékwedi* clan. He took a grizzly bear as a wife and the two had children. But he also had a human wife, and when he wished to return to her, his bear wife told him that he must provide food only for his bear children or there would be great trouble. *Kats* eventually failed to follow this rule and was killed by bears. From that time on his clan, the *Tékwedi*, claimed the bear as their crest.[9]

Another kind of "bear mother" is found in stories from the Onondaga people of New York State and the Kutenai people of the plateau region between the Rocky Mountains and coast ranges. The Kutenai told of a female bear who found a boy lost in the woods:

She took him home with her and raised him along with her own cubs. He learned to eat bear food and to hibernate through the winter. One cold winter night, the mother bear woke her

children and beckoned them to follow her. The snow crunched beneath their feet as they passed through the woods toward a distant flickering light—the people of a nearby village were performing a Bear Ceremony. After the humans prayed for plentiful food and good health, they smoked their pipes and the mother bear gathered up the pipe stems. She carried them back to her den where, under the watchful eyes of the boy and her cubs, she sorted them into two piles. Those belonging to people who were sincere and respectful to bears went in one pile, those insincere in the other. Then the family snuggled together and returned to their winter sleep.

A year later, the mother bear again heard the singing and dancing in the night, and woke her children. This time she gave the boy the ability to hear his people as she did. Together the mother bear and the boy took the pipe stems from last year's ceremony back to the village, the bear showing the boy how to tell the genuine from the false. The two went back to the den and to their sleep but in the spring, when the boy returned to live with his people, he told them it was important during the Grizzly Bear ceremony to be earnest in their prayers because the bears knew when they were not.

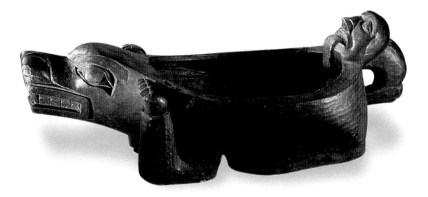

Kwakiutl Bear Dish

The reverse of the Kutenai story, a human "bear mother," has been reported in real life. Samuel Hearne traveled across northwestern America from Hudson's Bay to the Arctic Ocean between 1769 and 1772. In a footnote to his description of the journey he wrote: "It is common for the Southern Indians to tame and domesticate the young [bear] cubs; and they are frequently taken so young that they cannot eat. On those occasions the Indians oblige their wives who have milk in their breast to suckle them." Harold McCracken, who quoted this passage in his book *The Beast That Walks Like A Man* (1955), speculates that there must have been a very important reason, much more than simple amusement, for keeping a game animal alive and asking a woman to suckle it. In Japan, where the Ainu raised captive bears for periodic ritual sacrifice, Ainu women were also said to have nursed young bear cubs when necessary, although John Batchelor, a missionary who lived with them in the late 1800s, said that he never observed this phenomenon.

Haida Bear Dish

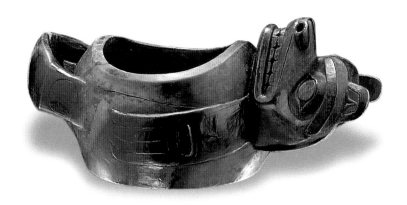

The Ket people from the Yenisey River region of Siberia often took bear cubs home as pets after killing the mother. Usually cared for by childless families, the cubs were treated like children: they lived in the family's tent, had their own beds, and ate when the family ate. The cubs were adorned with copper earrings and with copper collars that were exchanged for larger ones as the cubs grew. When the bears were three years old, they were set free still wearing their adornments. Neighbors were told when the bears were released so that they would not chase or harm them. According to anthropologist E. A. Alekseenko, who described these customs, the Ket never killed a bear they had raised.

From North America come two similar tales. Kutenai informants told anthropologist Claude E. Schaeffer (1966) that bear cubs were sometimes kept as temporary pets and spoke of a woman who suckled a very young cub. The bears were released before they reached full size and a piece of red flannel was tied around each bear's neck to end the relationship between the bear and its owner. Part of an Oklahoma Delaware legend related by Speck (1937) speaks of raising bear cubs until full grown and then releasing them with wampum tied around their necks.

While pet bear cubs might be referred to as "bear children," the term had another meaning for the Thompson (Ntlakyapamuk) people who lived in the northern part of the plateau between the Rocky Mountains and the coastal ranges. On rare occasions when twins were born, they were called "grizzly bear children" and given special treatment. The Thompson believed that a mother could tell before the birth that she was going to have twins because she would repeatedly see a grizzly bear in her dreams. Grizzly bear children were believed to be under the protection of the grizzly and to have his special qualities, such as great healing powers, bravery, and control of the weather. To honor this connection, grizzly bear twins were raised in a house apart from the rest of the village, not allowed to associate with other children, and constantly watched and waited upon. When anyone passed by the house, they were to whistle loudly so that the grizzly bear children could be hidden from view.[10]

The stories of bear mothers and bear children show many facets of the same two relationships: the unique bond between parent and child and the intimate association of two species. They tell of not only physical traits being passed from bears to humans but supernatural powers as well. It is to one special aspect of those bear powers that we turn next.

Tsimshian Food Dish

The carving on this Tsimshian food dish represents Grizzly Bear of the Sea and a human soul.

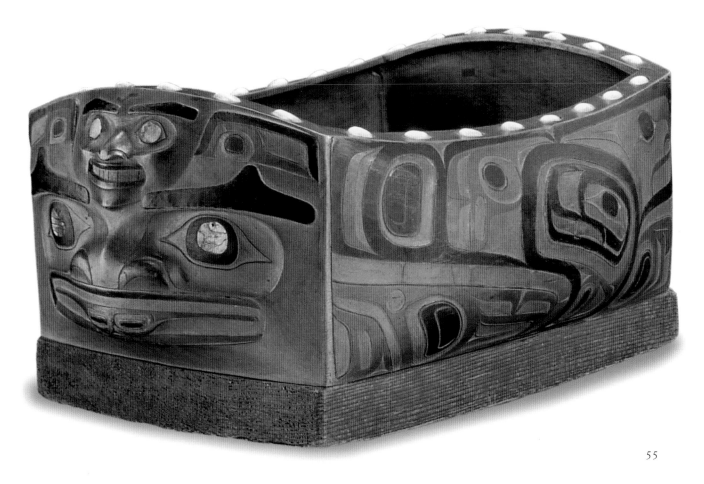

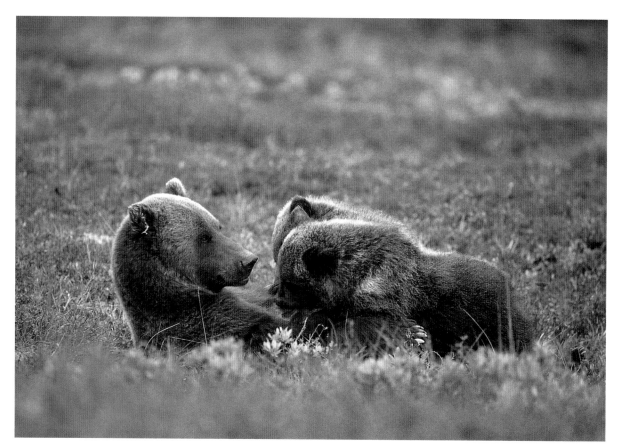

To a bear cub, Mother means safety, sustenance, comfort, and warmth.

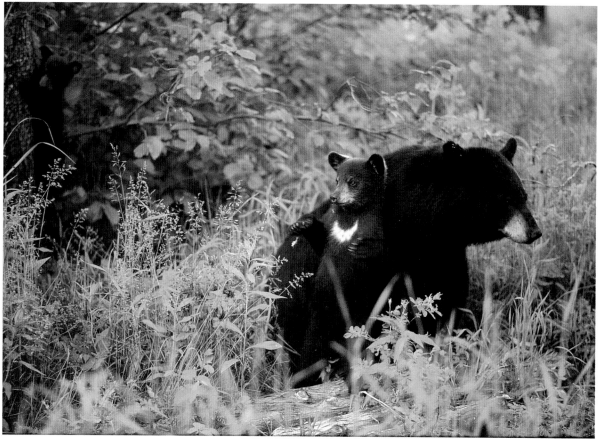

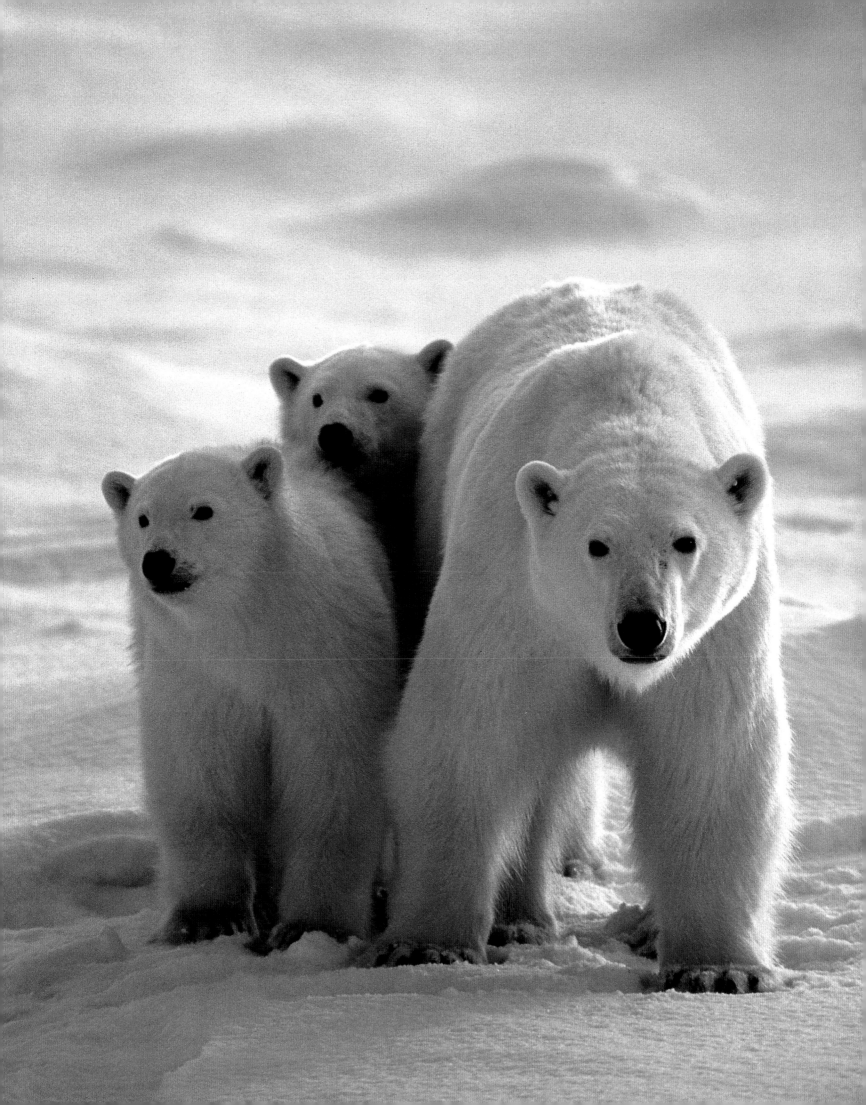

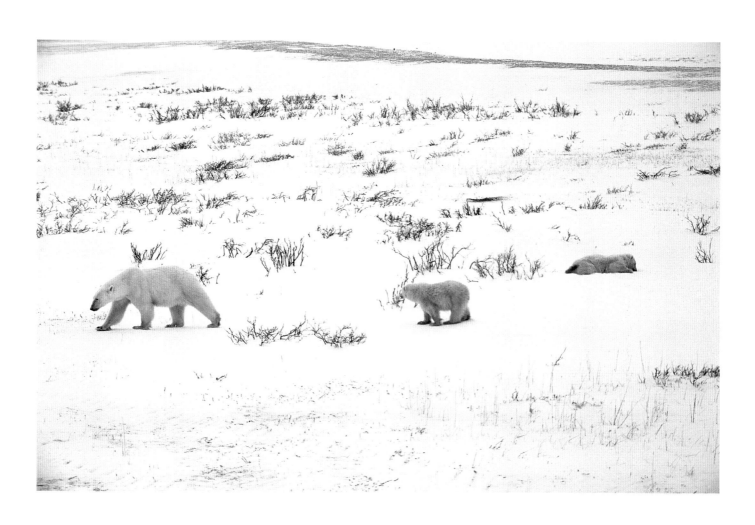

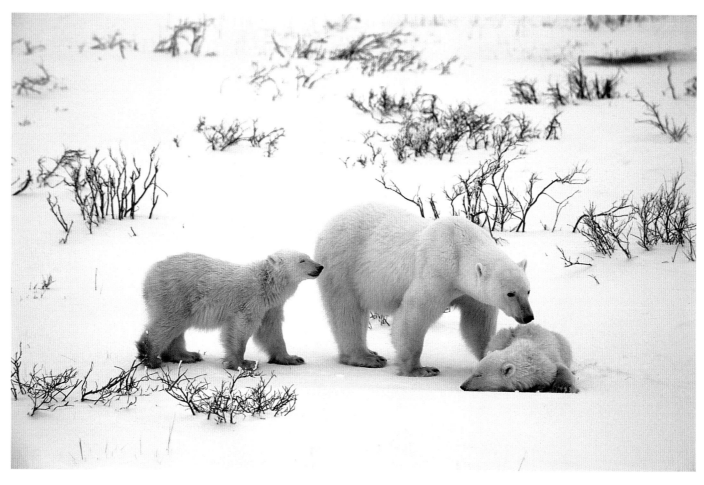

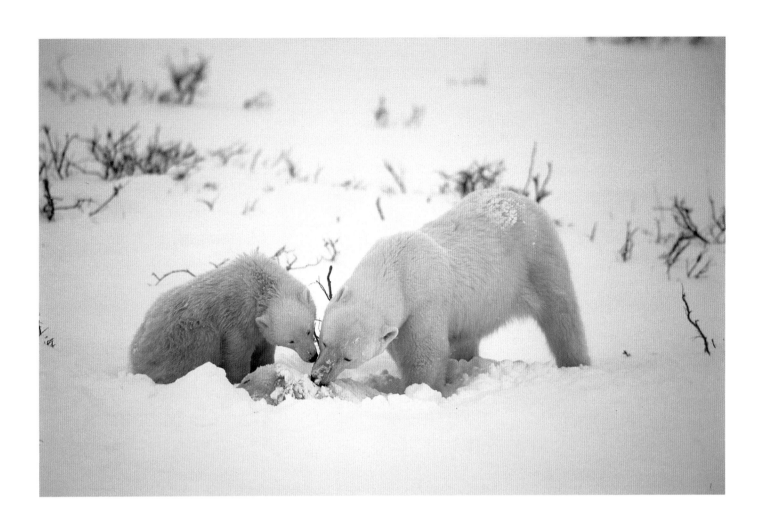

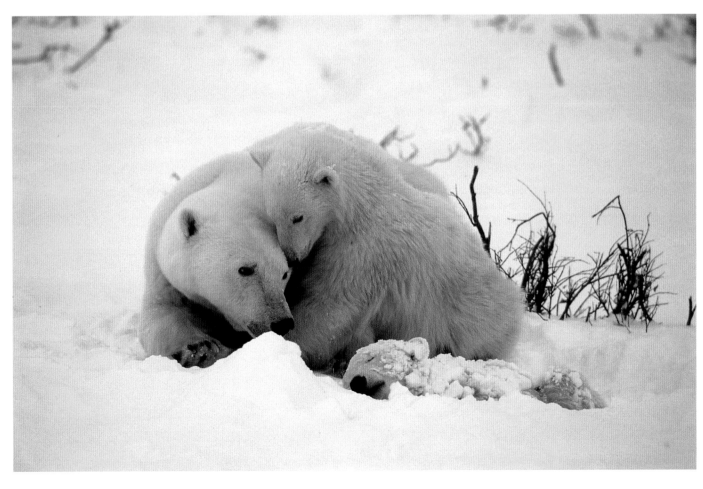

I was photographing at Cape Churchill in Manitoba, Canada, a popular gathering place for polar bears. They wait there until Hudson Bay freezes, so they can go out on the ice to hunt seals. I had been watching a female bear with two cubs for several days when I noticed that one of the little bears was in trouble. Much as it tried to follow in the footsteps of its mother and sibling, it couldn't keep pace. The next day, I noticed blood on the cub's fur, as well as on the snow. The cub was obviously very sick, and although its mother and sibling took care to walk more slowly, it kept lagging behind. On the third day, I found the bears huddled on a snowbank, where the mother tried many times to coax the sick cub to its feet. At one point she even pulled it out from beneath the snow by grasping its head in her mouth. But the cub was too weak to move on its own, so the female and her other cub snuggled near it and waited. On the fourth day, the cub was almost entirely covered by snow. It was dead. Still the mother tried lifting it; still she waited. But when I returned the next day, the female and her healthy cub were gone. In their place was a male bear feeding on the corpse. It wasn't easy to watch the cub die, yet we have to remember that this is sometimes the way nature works.

—Daniel J. Cox

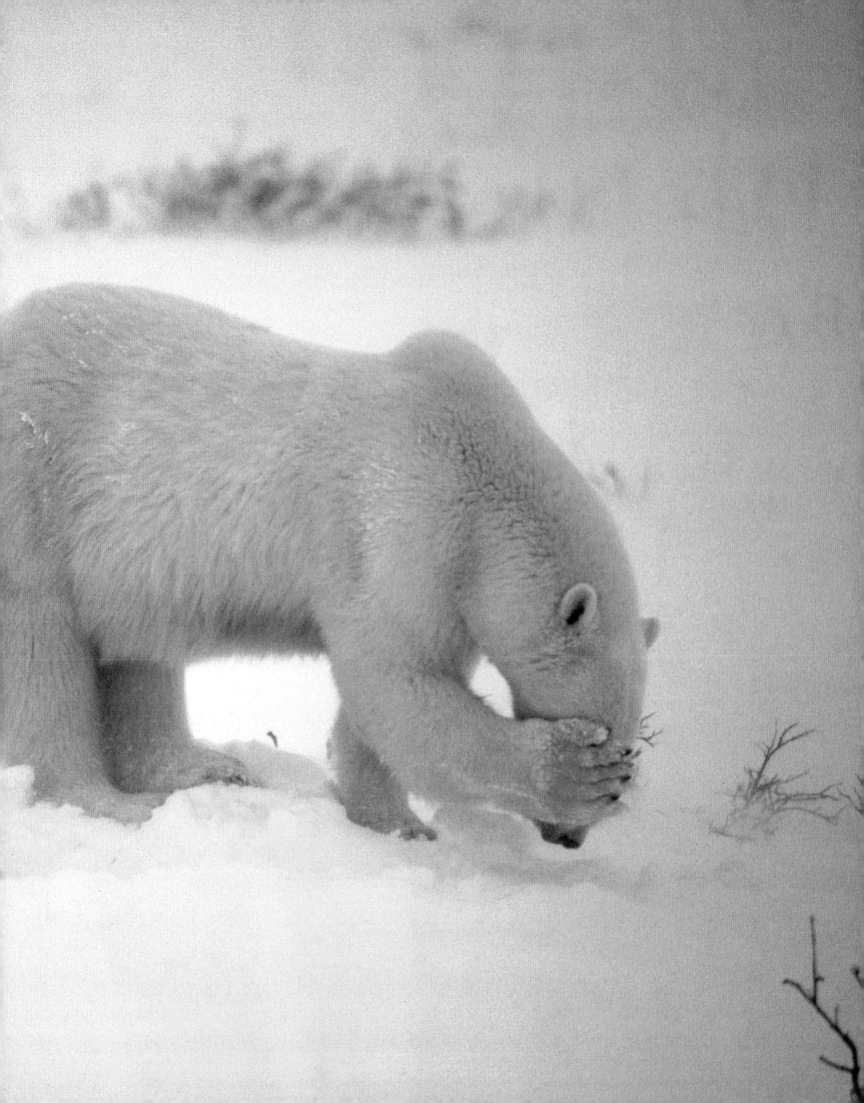

HEALERS

*M*y paw is sacred, the herbs are everywhere.
My paw is sacred, all things are sacred.

— *Lakota medicine-plant song*

Throughout time and across cultures, the bear has been considered a great healer, capable of sharing its knowledge and power with a select group of humans. Countless rituals and stories revolved around this belief which probably originated from observations of two particular bear behaviors. Ancient people watched black bears and brown bears find and eat many plants and plant parts, including some that could also be used by humans as food and medicine. And, each winter when the bears hibernated, the people saw them appear to die only to be miraculously reborn in the spring.

BEARS KNOW ABOUT PLANTS

In the early 1900s, S'iya'ka (Teal Duck), a Lakota from Standing Rock Reservation, which lies on the border between South Dakota and North Dakota, told ethnologist Frances Densmore:

> The bear is quick-tempered and is fierce in many ways, and yet he pays attention to herbs which no other animal notices at all. The bear digs these for his own use. The bear is the only animal which eats roots from the earth and is also especially fond of acorns, june berries, and cherries. These three are frequently compounded with other herbs in making medicine, and if a person is fond of cherries we say he is like a bear. We consider the bear as chief of all animals in regard to herb medicine, and therefore it is understood that if a man dreams of a bear he will be expert in the use of herbs for curing illness. The bear is regarded as an animal well acquainted with herbs because no other animal has such good claws for digging roots.

Despite the popular view of bears as killer carnivores, the fact is that plant material makes up 80 to 90 percent of most brown and black bears' diets. They choose their comestibles carefully, moving from place to place as supply and season dictate. In the spring, young plant shoots, willow and aspen catkins, bees and wasps, the cambium (sapwood) of trees, and carrion are important foods. Throughout the growing season, brown and black bears eat plants at the preflowering stage when nutrient content is at peak level. Grizzlies eat a great many starchy roots, tubers, bulbs, and corms, especially early in the year when other foods may be scarce or unavailable. During summer and fall, the bears' menu broadens and may include a variety of berries, insects, hard mast (acorns, beechnuts, etc.), and spawning fish

The berries of kinnikinnick or bearberry are eaten by bears, and were used along with the rest of the plant for food and medicine by many native peoples.

Berries are an important food for
black and brown bears during their
pre-hibernation quest for calories.
These bears are enjoying mountain ash
berries and chokecherries.

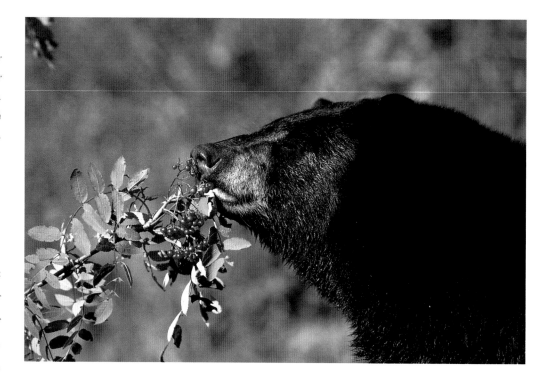

In "The Bear" Robert Frost wrote:
The bear puts both arms around the tree above her
And draws it down as if it were a lover
And its chokecherries lips to kiss good-by,
Then lets it snap back upright in the sky.

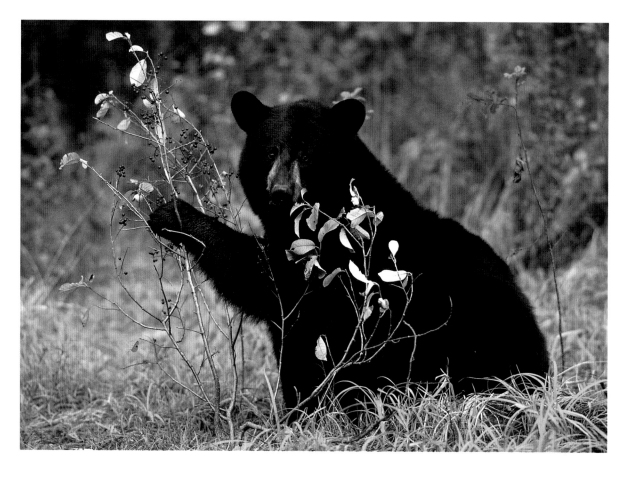

and their eggs, as well as green plants. (The meat-eating habits of brown bears, black bears, and highly carnivorous polar bears are discussed in more detail later.)

Ancient people who watched a bear carefully selecting berries and greenery to eat, or deliberately excavating and consuming roots, must have been impressed with the bear's botanical knowledge, especially when they found multiple uses for many of the same plants. For example, the overwintered berries of *Arctostaphylos uva-ursi*, known as kinnikinnick or bearberry, are a spring favorite with brown and black bears. These berries were also used as food by many peoples including the Bella Coola, Blackfoot, Carrier, Cherokee, Ojibwa, Coeur d'Alene (Schitsu'umsh), Woodlands Cree (Swampy Cree), Inupiat, Flathead (Confederated Salish and Kootenai Tribes), Koyukon, Coast Salish, Thompson, and Yurok. The plant was also widely used ceremonially and medicinally. The Blackfoot used the plant to make a salve for itching and peeling skin, in an infusion as a mouthwash for cankers and sore gums, and mixed with tobacco and the dried cambium of red osier dogwood as a component of all religious bundles. The Cheyenne of the Great Plains used an infusion of the stems, leaves, and berries as an analgesic particularly for back pain; the berries were used in cold remedies; and the leaves were burned "to drive away bad spirits for people going crazy." Among the Woodlands Cree from near Hudson Bay, Canada, the berries were used as a diarrhea medicine for children, while the stems were brewed along with blueberry stems to make a decoction used to help prevent miscarriage and to speed recovery after childbirth. The Thompson people used a decoction of bearberry stems and leaves as a diuretic, as a wash for sore eyes, as a tonic for the kidneys and bladder, and as an antihemorrhagic given to those who were spitting blood. They also placed bearberry leaves in the moccasins of a surviving husband or wife for protection after the death of their spouse. The Navajo (Diné) of the American Southwest mixed dried bearberry leaves with mountain tobacco and smoked it to bring good luck. Many groups smoked the leaves either alone or mixed with another plant, and some even sold it as a cash crop for this purpose.[1]

Other plants eaten by bears had similar uses: these powerful healing plants were often called "bear root" or "bear medicine." People told stories to explain how they had learned about these plants from bears. In California, anthropologist Pliny Goddard (1904) recorded and translated a Hupa formula for pregnant women's medicine known as "Bear's Medicine":

> While walking in the middle of the world Bear got this way. Young grew in her body. All day and all night she fed. After a while she got so big she could not walk. Then she began to consider why she was in that condition. "I wonder if they will be the way I am, in the Indian world?" She heard a voice behind her. It said, "Put me in your mouth. You are in this condition for the sake of Indians."

> When she looked around she saw a single plant of redwood sorrel standing there. She put it into her mouth. The next day she found she was able to walk. She thought, "It will be this way in the Indian world with this medicine. This will be my medicine ... I will leave it in the Indian world. They will talk to me with it."

The Kutenai people said that it was Grizzly Bear who had charge of all plants, roots and berries, and who had taught women how certain plants, such as camas roots, should be

Bear Basket

Baskets woven from peeled spruce roots were used by the Haida people for many purposes, including cooking, berry gathering, and food storage. This basket is decorated with a bear design.

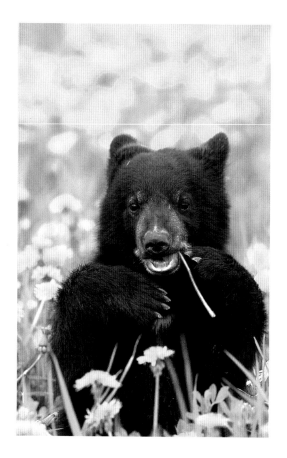

Learning which foods to eat, as well as where and when to find them, is an important part of a cub's education.

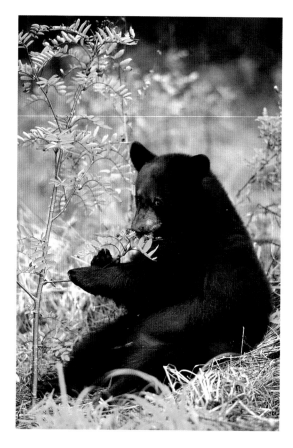

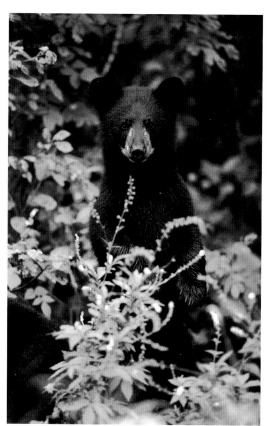

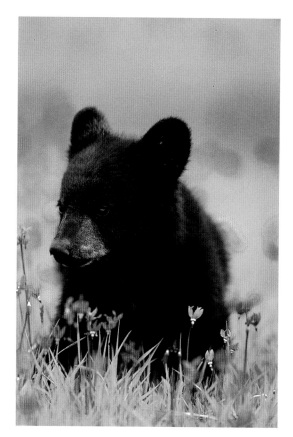

cooked. However, humans were forbidden by Grizzly Bear to eat some plants, as they belonged solely to the animals; Kutenai children were taught early in life which plants not to eat.[2]

Perhaps the bear acquired its knowledge of underground roots during its long winter sleep. Many beliefs and rituals involving bear healing power appear to have grown from this part of the bear's yearly cycle, and it is easy to understand why.

Imagine that you know nothing of how hibernation works. You, and perhaps generations before you, observe that bears disappear into the ground in early winter. You do not see them again throughout the long, cold winter. In the spring, the bears emerge alive, in some cases accompanied by young. Did the bears die in their dens, only to be reborn? If not, how did they survive without eating those many months? This time, instead of examining ancient stories, our focus shifts to the revelations of present-day research, because the facts about what happens inside a bear's den are more fascinating than any legendary explanation.

A LONG WINTER'S NAP

During a northern winter, food is scarce and the weather can be extremely harsh—many animals die each winter from some combination of starvation and exposure. Hibernation is a way of minimizing energy expenditure, and thus, energy demand, during this difficult period. Each year, black and brown bears spend an average of four to six months tucked snugly away in their dens. Polar bears, on the other hand, are equipped to spend the winter hunting seals on the ice. Usually only pregnant female polar bears den, seeking a warm, sheltered place in which to give birth and nurse their young.

Scientists have long debated whether what bears do in their dens should really be called hibernation. If you examine an animal considered to be a "true" hibernator during its winter torpor, the changes in bodily functions from a normal state are striking. A hibernating woodchuck appears dead and feels cool to the touch. Its body temperature, typically close to our own, hovers around 4.5 °C (40 °F). The animal's heart, which usually pulses a hundred times each minute, beats once every fifteen seconds, and the woodchuck breathes only once every six minutes. Other animals show even more dramatic changes: a hibernating ground squirrel's metabolism plummets to 1/25 of normal. Woodchucks, ground squirrels, and other true hibernators, however, cannot remain in this state all winter. For several reasons, including the need to eliminate body wastes and, in some cases, to eat, true hibernators must awaken periodically, accelerating their body processes back up to normal speed. In terms of energy expenditure, these brief speed-up periods are very costly: one awakening for a ground squirrel has been calculated to use the same energy as ten days of hibernation, and it must awaken every week or so. Simply put, true hibernators alternate periods of extremely low energy output with brief bursts of energy-expensive exertion. Bear bodies have evolved to do things differently.

Research, done mainly on black bears, tells us that bears stay warmer, their body temperature falling only by 3 to 7 °C (5 to 13 °F). Their metabolism drops only by half, and their heartbeat slows to eight to twelve times per minute rather than the usual forty to seventy. Do these numbers mean that a woodchuck and a ground squirrel are more efficient hibernators

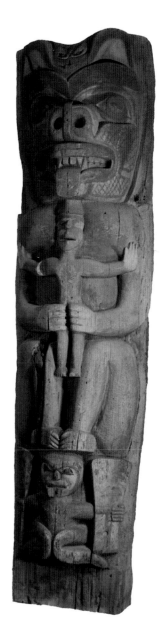

House Post

A Kwakiutl interior house post shows a bear holding a small human figure between its paws. It depicts the relationship between bears and humans frequently found in native origin mythology.

Found only in a small part of the heavily forested coastal area of southeastern Alaska and northwestern British Columbia, the glacier bear is a bluish-gray color phase of the black bear.

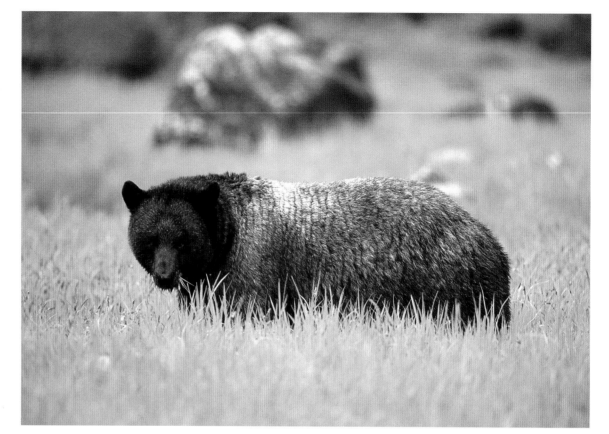

During summer and early autumn, a grizzly bear may spend up to twenty hours a day eating. In that time, an adult grizzly might pack away 36 kilograms (80 pounds) of food, which could translate into 40,000 calories. In case you're wondering, that's the equivalent of about 130 chocolate bars.

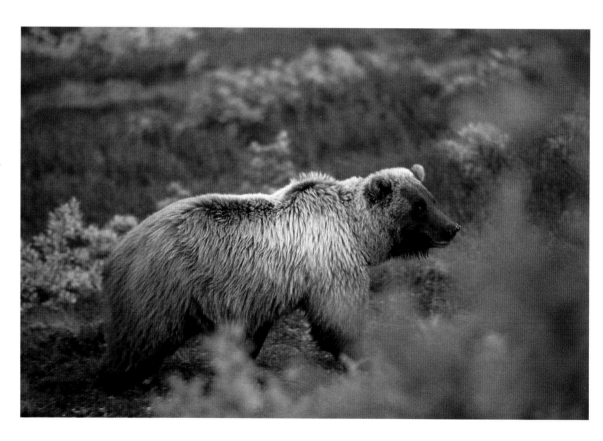

than a bear? They might, except for one thing: while true hibernators pay the high energy cost of repeatedly rousing themselves, the bear does not. Once a bear has slipped into hibernation, it remains there and does not eat, drink, defecate, or urinate for the entire time—four to six months or even longer. To get an idea of how remarkable this is, consider that when humans don't eat or drink and are unable to eliminate their body wastes, they usually die in less than ten days.

Hibernating bears live off their body fat, losing as much as a third of their body weight over the winter. Along with the fat, the bear's body breaks down small amounts of muscle protein into simpler compounds, forming urea and several other poisonous metabolic by-products. Rather than waking to get rid of these wastes, the bear's body has evolved to recycle them by building new proteins from their components. As Thomas McNamee writes, "There is a phoenix inside a midwinter's bear, creating new self from the ashes of the old." This process is so efficient that, after many months of hibernation, a bear has a lower urea level than it did in midsummer when it was actively eliminating its wastes.

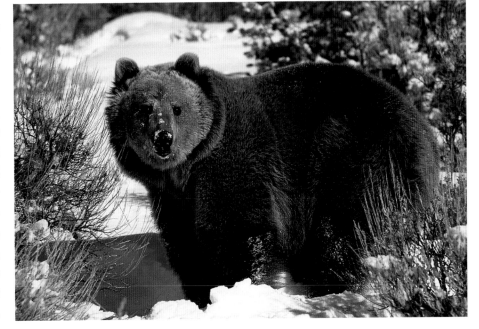

The bear loses water as vapor when it breathes, but its body produces water in excess of this amount as it metabolizes fat and reabsorbs wastes to build proteins. Therefore, the water content of tissues and cells throughout the bear's body stays balanced during hibernation without the bear taking a single drink.

Even though the bear hardly stirs for many months, it doesn't suffer from osteoporosis, which is bone loss because of calcium deficiency. A bear's body somehow replaces bone at the same rate that it is being destroyed without any intake of calcium. Bears' muscles also don't atrophy from the inactivity as ours would—according to researchers, bears don't even get cramps.

Despite having a cholesterol level twice that of most humans, the bear's arteries remain clear and no stones form in its gallbladder. There are no stones in the bear's kidneys either, even though they have been working overtime to filter wastes. And, most amazing of all, while all this is happening, some female bears give birth and produce enough milk to allow their tiny cubs to grow big and strong so they can follow along when it is time to leave the den.

Female bears are able to do this thanks to a process called delayed implantation. After the female mates, each fertilized egg begins to divide until eventually it forms a hollow ball of cells, known as a blastocyst. At this stage, in most mammals, the blastocyst implants in the uterine wall, and continues to develop while being nourished by its mother through the placenta. After the appropriate gestation period, the new baby is born.

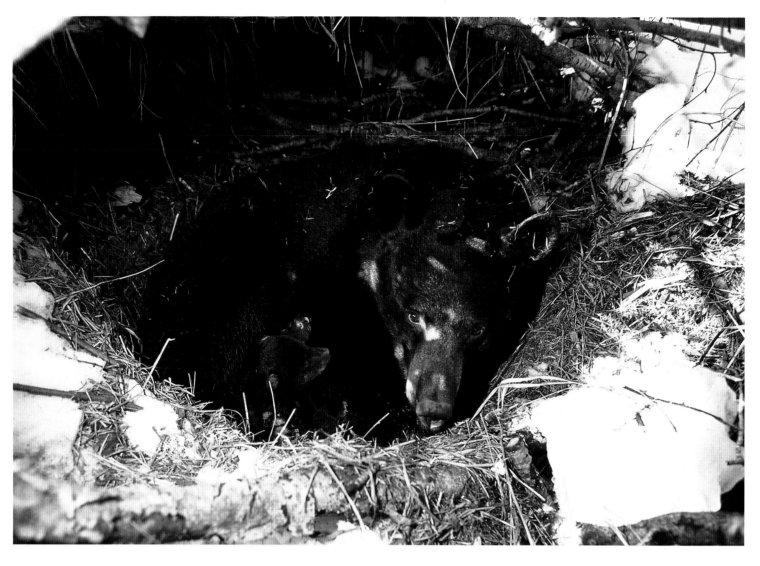

Bears' bodies perform seemingly miraculous feats during hibernation. Perhaps most amazing of all is the ability of females to give birth and nourish their cubs without taking in any food or water until they emerge from the den in spring.

In bears, however, development stops at the blastocyst stage and nothing else happens for the next five months or so. Then, in a process probably triggered by a decrease in day length, the female bear's brain releases chemicals that get things going again. The blastocyst implants and pregnancy progresses as usual. However, implantation occurs only if the female has accumulated enough fat to carry her through the demands of pregnancy. If her condition is less than ideal, implantation doesn't happen. Delayed implantation offers another advantage for bears; it allows them to mate in early summer rather than in fall, when breeding activities would disrupt the essential task of eating to store up enough fat for winter.

The restrictions imposed by their mother's hibernation cause bear cubs to be born at a stage we would regard as premature. Once the fetuses reach a certain size, she can no longer meet their food requirements from within her body, but after they are born, she can produce milk capable of sustaining them. That the female is able to provide this milk without drinking any liquid is another small miracle. By rousing just enough to consume her cubs' urine and feces, she reduces her total fluid loss and, as an added benefit, keeps the den clean. While the cubs spend their first winter awake, their mother, for the most part, slumbers on.

Medical researchers have taken note of all these phenomena, and the search is on for the keys to the bear's remarkable recycling system and for ways to apply what has already been learned. A synthetic version of a bear bile acid, ursodeoxycholic acid, has been used to treat gallstones in humans, and it is being tested for use in liver disorders. Doctors have also used information gleaned from studying hibernating bears to devise diets that help people with severe kidney disease go for longer periods before needing dialysis to cleanse their blood.

Ancient people were not privy to all of this information about bear diets and hibernation. However, their own observations were enough to make many of them consider bears to be an important source of healing powers.

BEARS AS HEALERS

According to some ancient stories, certain bears were invulnerable to injury and could bestow this valuable quality on deserving humans. A tale from the Pawnee, who lived in the Platte River Valley in Nebraska, told of a grizzly who did just that, and also shared with the same fortunate young man the powers to wipe away the wounds of others and to restore the dead to life (Murie, 1981). The recipient of healing powers did not necessarily have to meet the bear face to face. Respected Shoshoni medicine man Tudy Roberts, from the Great Basin area, gave anthropologist Ake Hultkrantz this account of how he acquired his invulnerability in a dream vision:

> I dreamt that I looked toward the east at sunup and saw three bears sitting under some pine trees. I shot at them. One of them approached me and said, "Look now, you see all these bullets twisting the fur here?" "Yeah, I see them," said I. "This is the way I am," said the bear. "The bullets can't kill me." They looked like mud twisted in the fur. The bear said, "I want you to cut off one of my ears and hang it in a thong at your side. This is the way you should be in the Sun Dance." The dream ended there. Later I found a dead bear, cut off the ear, and wear it now in the Sun Dance. No bullet can kill me. This is true. I never tell lies. That's the way I like to be.

Other bears were also believed to possess the ability to treat their own wounds, heal humans, and pass their curing power on to humans. In the origin myth of the Lakota, for example, it was Bear who took pity on the first people and gave them healing medicines.

The bear is very truthful. He has a soul like ours, and his soul talks to mine in my sleep and tells me what to do.

—Teton Sioux (Lakota) healer
Bear-With-White-Paw, in Densmore (1918).

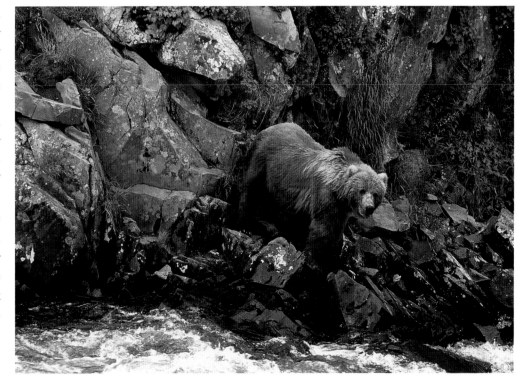

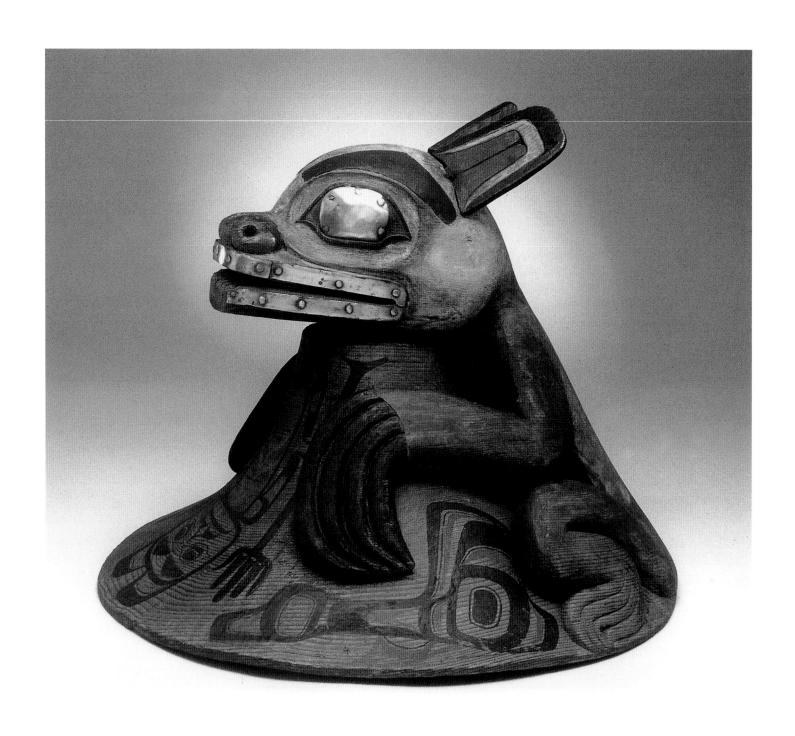

Haida Bear Hat

*Clan hats such as this one are extremely significant
ceremonial and religious objects. Many have been
removed from public display, so it is a privilege to be
allowed to view and publish them.*

Some tales described a bear pressing mud or the leaves of certain plants into its wounds, stressing the bear's association with herbal medicine. The Blackfoot legend of Mikápi describes how a courageous and honorable young warrior was badly wounded by enemy arrows, a fall over a cliff, and a journey down a rushing river. Finally, he crawled out of the water:

> Mikápi lay half-drowned and exhausted on the shore. Looking up into the morning sunshine he prayed, "Oh, great Medicine Person, help your wounded child!"
>
> Even before he had finished speaking, a huge grizzly walked out of some nearby brush and looked down at him. "My brother, how come you to be here? Why do you pray for help to survive?"
>
> Mikápi described the noble mission that had taken him on his troubled journey, and told of his travails. The grizzly listened gravely, then gently picked up the injured man and carried him to a place where there was a special kind of mud. Softly singing a medicine song, the grizzly patted the watery mud onto Mikápi's wounds and then carried him into the woods. As Mikápi lay resting, he could see the grizzly gathering certain berries. From these the grizzly made a medicine which he gave to Mikápi.
>
> After this, Mikápi recovered rapidly. When he was strong enough, the grizzly told him to climb on its back and in this manner carried him back to his people. Then the grizzly turned and disappeared into the woods.
>
> The young warrior never saw the grizzly again, but Mikápi became one of the greatest of all Blackfoot chiefs. Throughout his life he performed many daring feats, assisted by the powerful spirit that had saved his life—the grizzly bear.[3]

The Skidi Pawnee told a similar tale of a warrior who was healed by a bear related to the sun and, in the process, acquired miraculous powers which he later passed on to another.

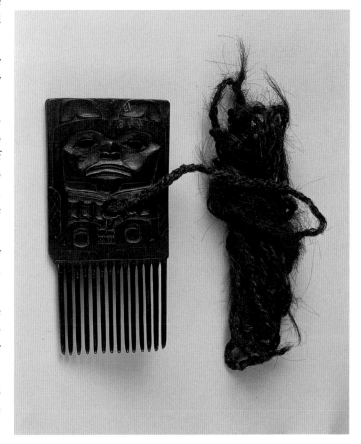

Shaman's Comb Depicting Bear

This artifact is described as a Northern Tlingit shaman's comb, although most sources say that a shaman's hair was believed to contain power and was never to be combed, cut, or touched.

BEARS AS SHAMAN HELPERS

Bears, great healers themselves, were widely believed to be the most powerful protective and helping spirit that a shaman could have. *Shaman*, as used in this book, is a person primarily involved in curing physical and spiritual illness. Some shamans were said to turn into bears or, like the legendary Pawnee medicine man Smoking-with-the Bear, to be able to magically produce a live bear during curing rituals. The process of obtaining the bear's valuable assistance was not without its dangers, however.

In 1883, anthropologist Franz Boas spoke with the Inuit living on Baffin Island. They told him that some spirits protect angakoqs (shamans or magicians), allowing them to deal with malevolent beings. These spirits were good to their angakoq but dangerous to ordinary people who happen to see them. The mightiest of these spirits belonged to the polar bear and was envisioned as a huge animal, hairless except for a bit of fur near its mouth, and on

Bear Tipi of Chief White Man

This bear tipi was handed down in the family of White Man, who became head chief of the Kiowa-Apache in 1875.

The tipi originated in a dream of Lone Chief's maternal grandfather. It passed to Lone Chief's son, who gave his father his best horse for it. When the son died in 1870, his sister (White Man's mother) then gained title to it.

This tipi was considered good and powerful medicine, but strict rules regulated its use. No one except a member of the hereditary family was permitted to sleep in it. If one who had the right vowed to renew the tipi and did so, a sick member of the family would surely recover. When the tipi was renewed, the bear was prayed to, for there was a widespread belief among the Plains Indians in the power of the bear to cure sickness. The old tipi cover was not destroyed by burning, but was carefully staked out on the plains and abandoned, with the head pointing toward the rising sun.

—John C. Ewers, from *Murals in the Round, Painted Tipis of the Kiowa and Apache Indians*

the tips of its ears and tail. An angakoq who wished to acquire the polar bear as his tornaq, or secret helping power, had to display his mastery over the bear and over his own fears. The angakoq traveled for many days, until at last he reached the edge of known land. Here he cried out to the bears and waited for them to come to him. Once a large group of bears gathered around him, the terrified angakoq collapsed. How he hit the ground determined his fate: If he landed on his back, he died instantly; if the angakoq fell on his face, a bear stepped forward from the crowd, offering his spirit as the angakoq's tornaq. From then on, the bear tornaq intervened whenever the angakoq needed assistance or rescue from danger.

It was not always by choice that a person became a shaman. The Iglulik Inuit told of a woman named Uvavnuk who was 'spiritually shanghaied.' Uvavnuk stepped outside her dwelling one winter night, only to be struck down by a ball of lightning. Before losing consciousness, she felt her body being filled by the light of a spirit that was both human and polar bear. When she recovered, Uvavnuk drew upon the energy of the spirit inside her and became a great shaman.

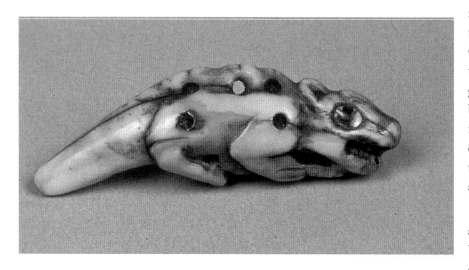

Amulet

Fashioned from a bear's canine tooth and enhanced with abalone shell, this Tlingit amulet is carved in the shape of a land otter. Tlingit people believed that people who drowned or became lost were transformed into land otters, which were the animals most strongly linked with Tlingit shamans' work.

As is the case with any powerful being, some people thought that bears could harm as well as heal. Stepping on a bear's track, stepping over bear feces, or even catching a glimpse of a bear at the wrong time might cause illness. The Navajo would neither gather piñon nuts from where a bear had fed upon them, nor make a cradle from a tree on which a bear had rubbed. Ancient people believed those drawing power from the bear shared its dichotomous disposition of gentleness and danger. Because of this, bear shamans were not necessarily popular, despite their beneficial activities.

The Assiniboin people lived on the northern Great Plains. Members of the Assiniboin Bear Cult, who obtained their supernatural abilities through dreams, held ceremonies to cure the sick and to fight enemies, but were feared by most Assiniboin people. Said to be easily angered, Bear Cult members were also believed to be unlucky.

The Assiniboin Bear Cult is particularly interesting because of the ways in which its members' ceremonial dress emphasized their resemblance and relationship to the bear. As anthropologist John C. Ewers described:

The cult member shaved the top of his head and rolled some of his hair at each side into a ball resembling a bear's ear. He painted his face red, then made scratches [representing a bear's claw marks] on each side of his face by scraping away some of the paint with his fingernails. He then painted a black circle around each eye and around his mouth. He wore a bear-claw necklace over a yellow-painted skin shirt. This shirt was perforated with many cut holes and was decorated with cut fringes along the bottom edge and the sleeve ends. A small, rectangular flap of skin, cut from the garment itself, hung down at the center of the wearer's chest.

Siberian peoples believed in the strength of the bear's spirit, too. Ethnologist G. N. Graceva (1996) wrote about the decorations on a Nganasan shaman's parka, including drawn bears which give the shaman extraordinary powers: "The bear on the dark half of the parka is red, the one on the red half is dark. Both bears are the shaman's helpers during the shamanizing act. Harnessing them to … sledges, one of whose runners symbolizes winter and the other represents summer, the shaman can get swiftly to the place he wants to go…. The bear is, besides, the principal protector against all kinds of lies and evils."

Many shamans worked alone as healers but in several tribes there were medicine societies made up of shamans who worked together. Given the bear's reputation as a healer, it is not surprising that some of these societies were said to derive their powers from the bear.

THE OJIBWA MIDEWIWIN

The renowned healing society of the Ojibwa people, the Midewiwin, contained male and female members who used herbal medicine to cure ailments with help from supernatural beings. According to Ruth Landes (1968), the Midewiwin origin tale, related by society officers during curing rituals, told how Bear brought the healing methods from the Great Spirit to the people in a long journey that began deep in the earth and ended near Lake Superior. Because of his gift to the people, Bear was the patron of the Midewiwin and many of the society's rituals involved him.

Midewiwin members moved upward through four levels or degrees of the society, as Bear climbed upward through the four layers of Earth, and were said to "follow the bear path." It could take a year or more to learn the herbal lore and society rituals needed to progress to the next level. For a novice just entering the Midewiwin, the climax of his initiation occurred when a society officer "shot" and "killed" him with a small shell discharged from a "magical fur." The novice fell to the ground as though dead, only to come back to life as a Midewiwin member after being revived by the other society members. The magical shells, known as "midis" and believed to hold a "charge of life," and the fur from which the midis were shot were a Midewiwin member's most powerful possessions. The fur belonging to a member who had reached the fourth and highest society level might be taken from a bear paw.

Bear paws were also made into bags used to hold one of the Midewiwin's strongest remedies, a root known as "bear medicine." *Smilax herbacea* (carrion flower), *Apocynum sp.* (dogbane), and other roots were cut in 5-centimeter (2-inch) pieces and threaded onto a cord for storage. The resulting string of roots looked a bit like a bear claw necklace.

Another major association of the bear with the Midewiwin was the sweat lodge sometimes used as part of a cure. A patient might be ordered to build a sweat lodge with a framework of eight arching sticks covered with hides or blankets to hold the steam made by pouring water on heated rocks within the lodge. A leading shaman explained to anthropologist Ruth

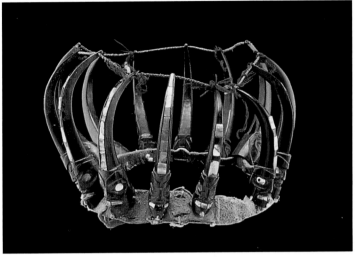

Coast Tsimshian
Imitation Grizzly Claw Headdress

Tsimshian healing shamans wore bearskin robes and headdresses, or "crowns," of grizzly claws. This particular Coast Tsimshian example was made with imitation claws but probably was treated just as it would have been if the claws were real.

Overleaf

Haida Shaman's Rattle

A shaman's curing rattle, such as this Haida example depicting a bear with a frog in its mouth, was used to summon power and assistance from the Spirit World.

Tsimshian Bear Rattle

In general rattles were used in dances to calm or appease the spirit represented.

Nisga'a Tsimshian Bear Mask

81

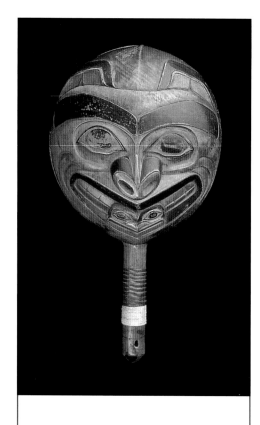

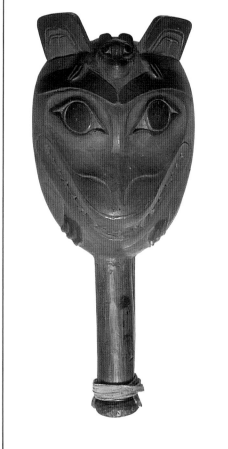

Landes that "our Grandfather [Bear] told the Indian to get in under him and then he dropped his hide over him" forming a cave-like lodge. The paraphernalia used in the sweat lodge ceremony all had names relating to bear. For example, the drumsticks which Bear's representative used to rap upon a pan of water or a stone while he sang were referred to as "forepaws of our Grandfather" and the forked stick used to carry the hot stones was called "Bear's shoulder strap."

Although the Midewiwin was a benevolent healing society, evil spirits were sometimes believed to be present during their ceremonies. Landes wrote, "Because of the evil and secrecy, a patient dreaded the rite as one does major surgery." Once the ritual was over, the healed patient was not out of danger until he had made offerings of tobacco for at least a year to objects given him as mementos of the ceremony.

PUEBLO BEAR HEALERS

Among the Pueblo peoples of the American Southwest, Bear was the "great doctor," valued both for his ability to unearth medicinal roots and his warlike nature, useful in fighting off disease caused by witches—a major cause of illness according to Pueblo beliefs. At Zuñi, it was said that a half-man, half-bear founded the medicine society and that bear shamans could transform themselves into bears. A Zuñi doctor often used bear leg skins and paws in healing rituals, for these brought him the power to cure. He usually wore a necklace of bear claws and carried a whistle made of bear bone for additional help in combating sorcery. According to anthropologist Ruth Bunzel, the bear medicine of the Zuñis was made from *Senecio spartiodes* var. *multicapitatus* (broom groundsel).

Among the Hopis, the herbal medicine known as "bear charm" was made from the root of a member of the Aster family, and was used in almost all of their medicinal infusions. The Keresan Pueblos' Bear Society was a group of medicine men, also called "bears," who derived their healing abilities from the bear and whose powers were strong enough to cure the ills caused by sorcery.

Noted anthropologist and sociologist Elsie Clews Parsons described a healing ceremony performed by the Shikani society at the Laguna pueblo. An altar was set up in the house of the patient and near it were placed, along with other things, a medicine bowl and a bear's paw. The doctor moved about, searching for the patient's heart, which was believed to have been stolen by a witch animal. Eventually the doctor rushed outside, bear paw on his left hand, flint knife in his right, and slashed the air with this knife against the presence of witches. At this point the doctor might rush to the riverbank, where stolen hearts were often found, or he might dig elsewhere with his bear paw. Once he unearthed the "heart," the doctor carried it back to the house in his bear paw, and finished the ceremony that would restore his patient to health.

Bear was impersonated in many Pueblo ceremonies. The portrayer could simply wear a pair of gloves made from bear leg skins, or he might go to the extreme of wearing a full bear skin and dancing in imitation of the bear's movements. In any case, the presence of the bear

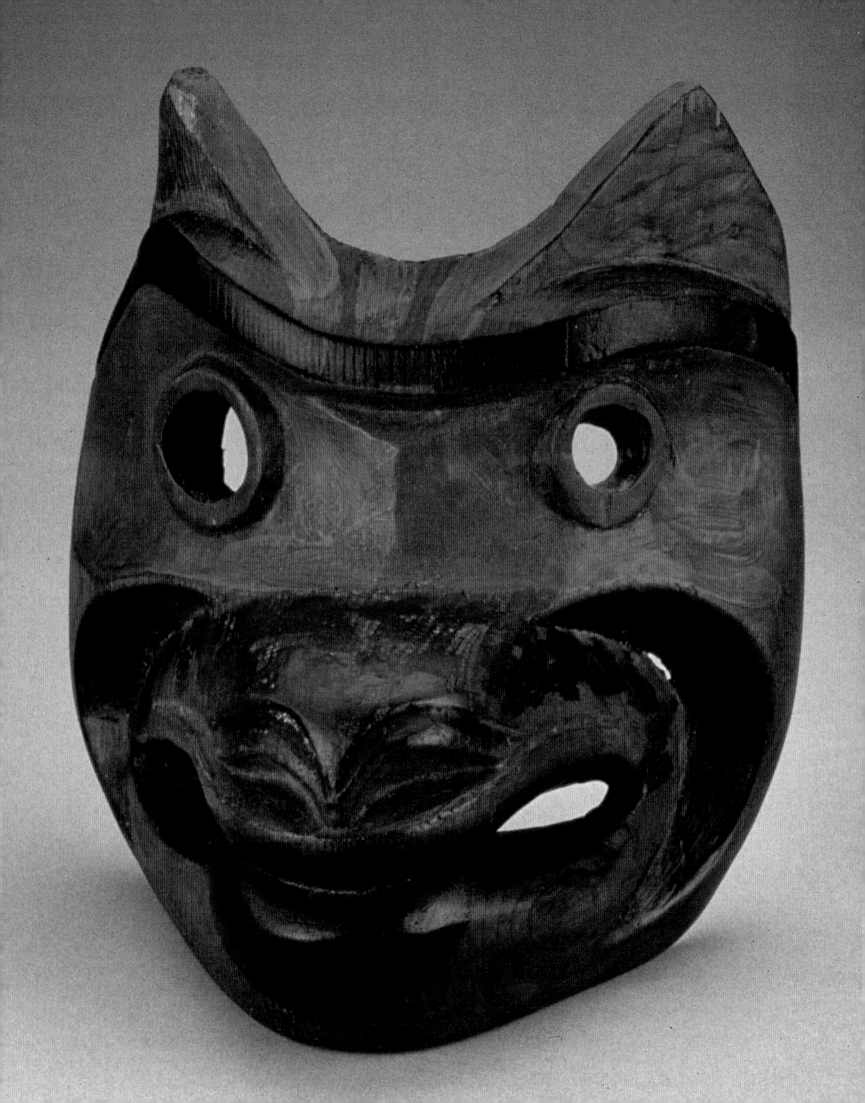

The Story of Bear Old Man

The people of Taos pueblo told of Bear Old Man, who would come down from where he lived to dig for medicine:

Bear Old Man sang as he walked along and, when he was halfway between his home and the village, Bear Old Man said, "People are seeing me. I must dance harder." Singing once again, he kept walking until he reached the place where he wished to dig. Bear Old Man spit with his medicine in the four directions, then dug with his cane, moving it in the direction that the sun moves.

All the while Bear Old Man sang his medicine song. When he got his medicine, he chewed it and dabbed the chewed mass on his body, legs and back. Satisfied, he began his homeward journey, stopping at the halfway point and repeating, "People are seeing me. I must dance harder." The people saw him and knew that Bear Old Man had been to dig his medicine again.

—Retold from Parsons (1940)

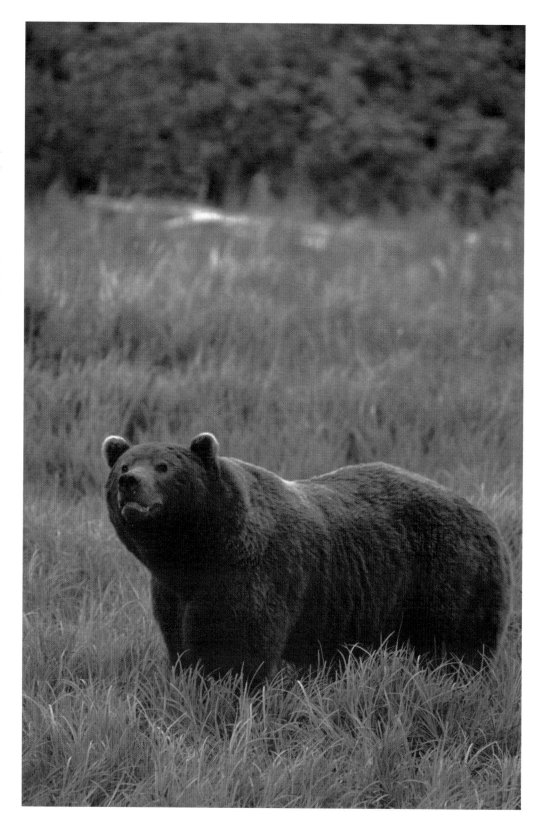

and the use of his healing and cleansing powers was an important part of most curing ceremonies and many other rituals, including the initiation ceremonies and renewal rites of various Pueblo societies.

The Bear as Pharmacopoeia

Besides the power provided by the spirit of the bear, the bear's body itself was considered to be a source of potent medicines. Some parts of the bear, such as its paws and claws, were used symbolically in various curing rituals. Among some of the Yokut people of California, if a woman's labor was prolonged, a shaman was called. To hasten the delivery, the shaman placed a bear's paw on the women's abdomen. Frightened by the presence of this ferocious creature, the child hurried to leave the womb.

A special kind of bear power came from bundles wrapped in bear hide containing various powerful medicine objects and herbal remedies. The Hidatsa of the Great Plains recognized two kinds of bear bundles as having great medicine powers. The first type of bear bundle was obtained through visions, which often resulted from being mauled by a bear. The rites associated with these bundles were simple, and feasts were rarely held for the bundle. Grizzly bear bundles, on the other hand, were hereditary and originated with the bear who was captured by Moon's son to serve his grandmother, Old-Woman-Who-Never-Dies:

Acoma Medicine Bear

This medicine bear, holding eagle feathers and a rattle, was painted on a chamber wall as part of the ceremony during which an Acoma Pueblo boy became a medicine man.

> Grizzly Bear, the helper of Old-Woman-Who-Never-Dies, adopted a boy called Brave-While-Young. The other gods teased Grizzly Bear because his adopted son failed to make offerings to grizzly bears, despite the fact that Brave-While-Young enjoyed great success in hunting and trapping.
>
> Eventually, while Brave-While-Young was away hunting, Grizzly Bear stole his wife and children, and brought them to his lodge deep in the forest. When the young man returned and cried for his wife, Grizzly Bear told him how to find his family but made him promise that next year he would perform the Bear ceremony. All the holy people would attend.
>
> Brave-While-Young worked hard for the next year to prepare for the ceremony. He needed twenty robes and twenty pairs of moccasins because the bear has ten fingers and ten toes. The guest list was impressive. Spring Boy and Lodge Boy would bring their holy bow and arrows as a gift for Brave-While-Young, and he would also receive a rattle covered with owl's skin and decorated with raven feathers. All the animals would be there, and some—buffalo, dog, bear, elk, deer—would play special parts in the ceremony. First Creator was going to give Brave-While-Young a magic snare with which to catch enemies.
>
> At the right time, the guests arrived and the ceremony was performed as Grizzly Bear had directed. The gods blessed Brave-While-Young. Now, buffalo would stay nearby. Brave-While-Young gained the power to heal with the bear's help and to use the sacred arrows to remove arrow points or other foreign objects from a person. All Grizzly Bear bundles had their beginning with this ceremony, although some have had their contents changed slightly because of the owner's subsequent visions.[4]

Grizzly bear bundles were a source of great healing power for a medicine man. When the person who owned a grizzly bear bundle died, he was wrapped in the bear hide that was the outer wrapping of his bundle, so that he and the bear could go away together. To purchase

such a bundle, the potential buyer had to kill a grizzly bear to provide a new hide for the bundle, and then go through a transfer ceremony. Before the advent of firearms, only very brave men owned grizzly bear bundles because killing a grizzly bear unassisted was an extremely hazardous undertaking.

Besides these ceremonial uses, bear body parts themselves were sometimes administered as medicine. Bear fat was prized by North America's native peoples as a liniment for sore muscles and joints. The fat rendered from one large black bear could amount to 40 to 60 liters (10.5 to 16 gallons) of oil. A Salinan tale from California tells of making medicine from a bear's entrails. The bear also has been an important supplier of material for the traditional Oriental medicine cabinet for more than a thousand years. The most valuable part of the bear in the Oriental pharmacopoeia is its gall bladder. Powdered bear gall bladder is traditionally used to treat headaches, heart disease, hemorrhoids, epilepsy, and a variety of other ailments. Another Oriental tradition, dining on bear flesh, is believed to increase strength and vitality.

Today, poaching of bears for their gall bladders is a severe problem being addressed by conservation authorities in several countries, including Canada and the United States. In China, bears may spend their lives in cages little bigger than themselves, being "milked" once a day for their bile through a rusting catheter surgically implanted in their gall bladder. While there may historically have been a reason for using bear gall bladders to treat some diseases, a synthetic version of the curative ingredient, ursodeoxycholic acid, has been available for more than fifty years. Herbal alternatives also exist that offer both easier and cheaper treatment for ailments now being treated with bear bile. The belief that bile from a bear is more powerful than any of the alternatives keeps people from switching. For those concerned about bear survival there is hope that, through education, practitioners of traditional medicine will change their ideas and prescriptions.

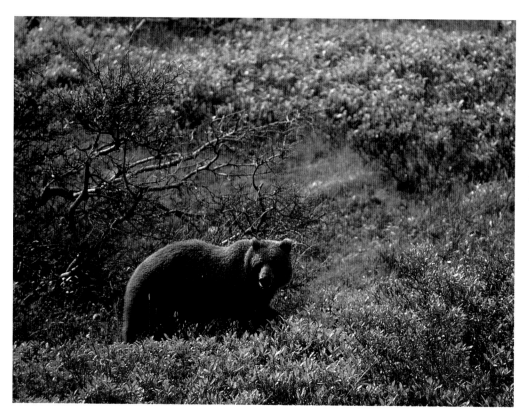

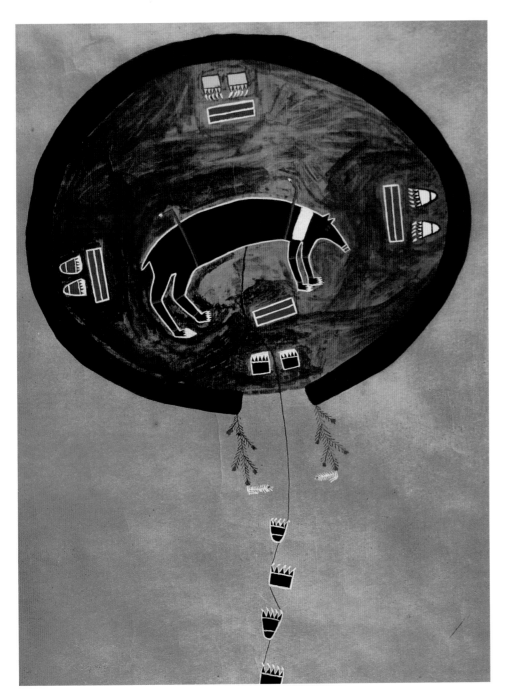

Pikehodiklad – Navaho

This Navaho sand painting, photographed in 1907 by Edward S. Curtis, is called "Frighten Him On It." It is used during the Night Chant and Mountain Chant to frighten the patient and scare away the evil within him. Curtis described the imagery's symbolism and the ritual this way:

The whole represents the den of a hibernating bear. Inside the ceremonial hogan is thrown up a bank of earth two or three feet high, with an opening toward the doorway. Colored earths picture bear-tracks leading in; bear-tracks and sunlight—sun dogs—are represented at the four quarters, and the bear himself, streaked with sunlight, in the center. The twigs at the entrance of the bear den represent trees, behind which bears are wont to dig their dens in the mountain side. Everything tends to make the patient think of bears. He enters midst deep silence and takes his seat upon the pictured animal. The play of his imagination has barely begun when a man, painted an garbed as a bear, rushes in, uttering hideous snarls and growls, in which all assembled join. Women patients seldom fail to faint.

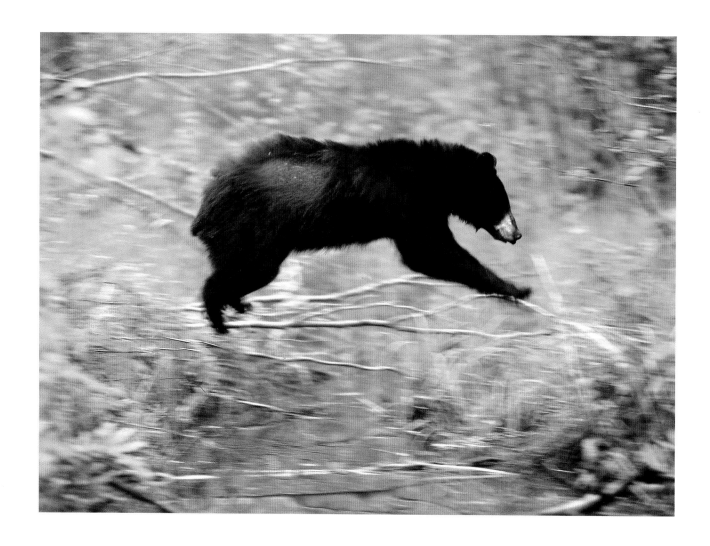

This is the way he is singing.

When earth and the heavens were new in the beginning,

He went around singing like this.

Dark Medicine sign was all over his body.

The Dark Medicine lightning was put on his body

Around over it.

The cloud Breath he put around on his body.

This is the way he used it

Around over there in the beginning,

Just singing like this.

—Northeast Yavapai song telling how healing powers came from the bear,

E.W. Gifford [1936] 1965.

Bear Dream Representation

After reading about this important and highly regarded object, with its medicine drawing of a bear as seen in a dream, I was pleased to find a photograph of it in the Smithsonian Institution National Anthropological Archives files. I had just sent this to be photocopied when two researchers working nearby asked if I was working on bears. When I replied that I was, they said they had come across something I might find interesting and handed me a letter which contained the following: "Yesterday I received what I consider one of the choicest 'medicine articles' I have ever obtained. It is the drawing of a bear referred to … [in] my paper on Chippewa Art. The cloth is yellow with age and streaked with the liquid medicine that has been put on it."

The letter was dated November 8, 1918 and written by Frances Densmore to Dr J. W. Fewkes, Chief of the Bureau of Ethnology at the Smithsonian Institution. As it turns out, the letter was referring to the same artifact I had just discovered.

—Rebecca L. Grambo

Ancient people drew upon the bear's strength and wisdom to help them cope with illness and trouble. Much of the respect they felt for the bear appears to have its origins in this relationship.

This beautiful Cherokee legend, retold from Joseph Bruchac's The Native Stories from Keepers of the Animals, *speaks of both the bear and a mystical healing place.*

The old people tell of a lake called Ataga'hi hidden deep within the Smoky Mountains. Animals journey to this lake to heal themselves when they are sick or injured. No one has ever seen this lake but some men say they have been near it. They tell of walking across flat, empty ground when through the mist they began to hear water falling and the sounds of water birds. Although they searched, they could not find the lake.

Those who live their lives as friends to the animals are sometimes given a vision of Ataga'hi when they have spent a night fasting and praying. They see springs in the high mountains falling down over rocks, the waters joining to form a stream running into the lake. For an instant, just as dawn is breaking, they see birds and animals bathing and healing themselves in purple waters that seem to stretch far into the distance. But the vision lasts only a moment, for the animals use their powers to keep the lake invisible so that hunters may not find it.

They say that the sands around the shores of Ataga'hi are covered with the tracks of the bear, who is a powerful healer. In the old days, a woman saw a bear with a horrible spear wound splash into Ataga'hi's waters and emerge on the other side of the lake, unmarked and full of life.

It has been a very long time since anyone has talked of seeing Ataga'hi—some worry that it no longer exists. But the Cherokee say that it is still as it ever was, protected by the animals and hidden among the mountains. They say that if you respect all animals, live well, and pray, someday you may be granted a vision of the purple, healing waters of Ataga'hi.

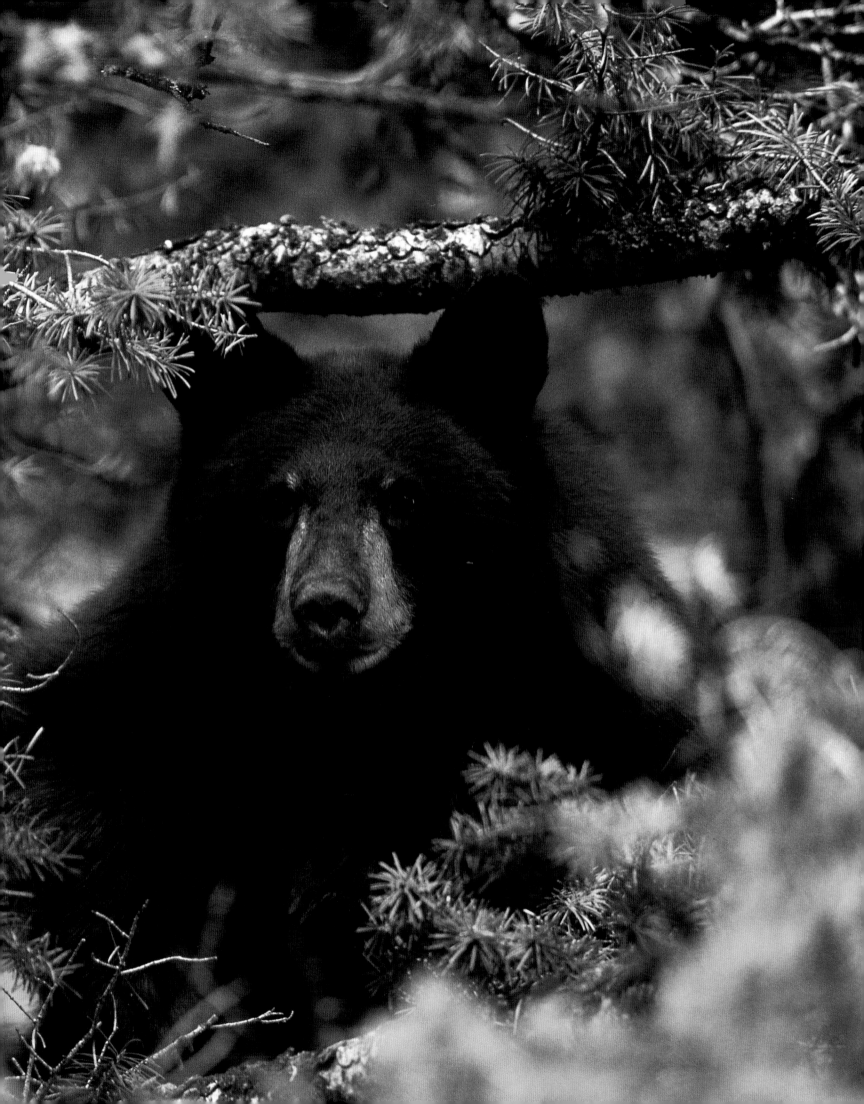

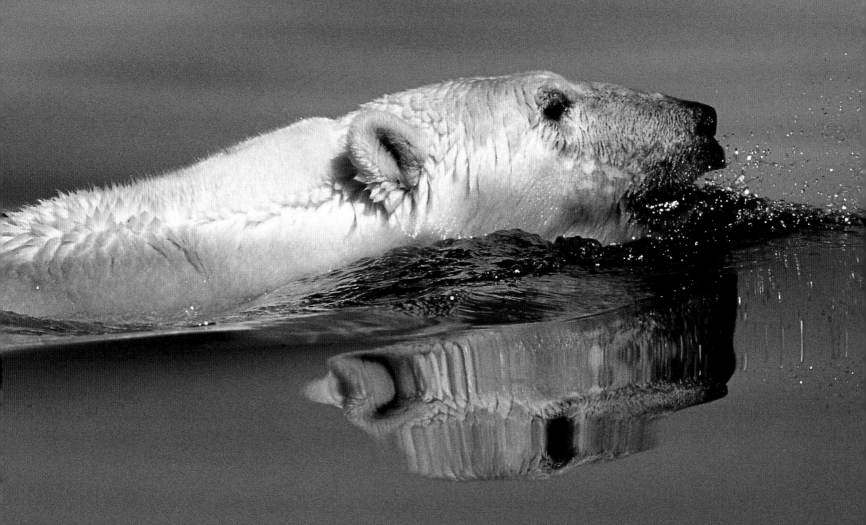

HUNTERS

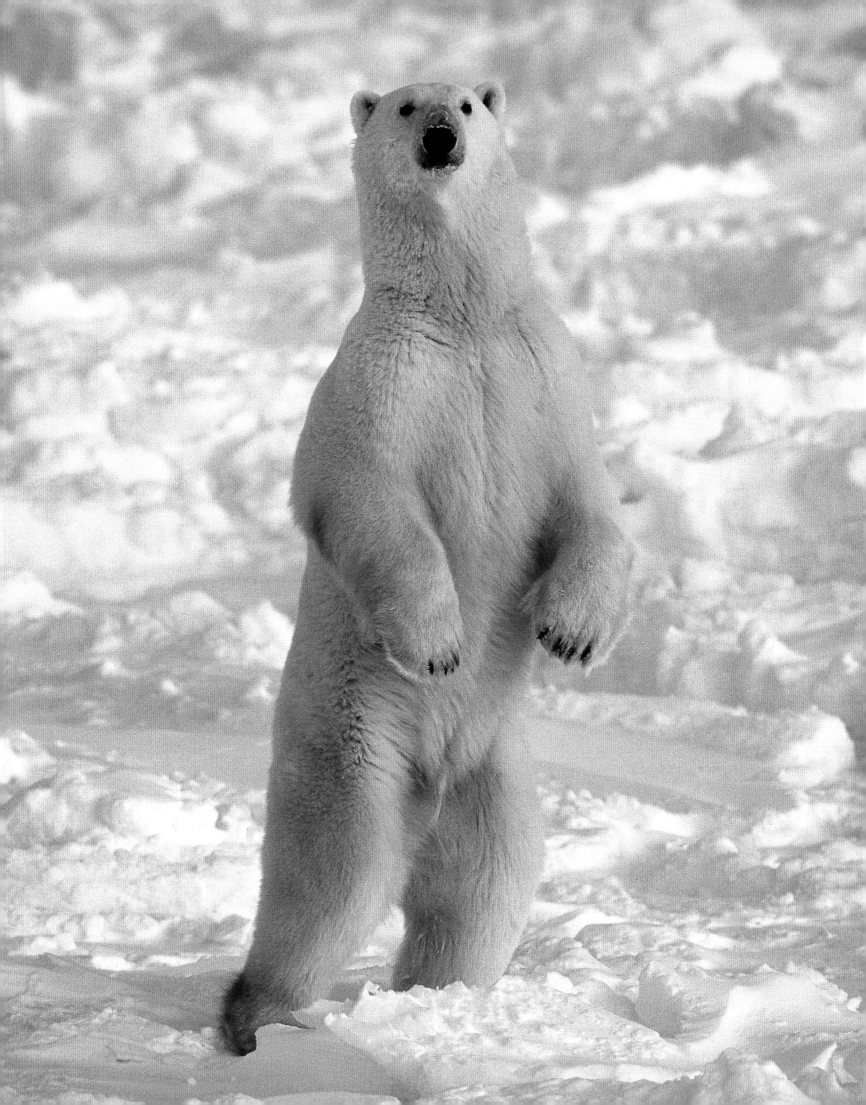

In the sky each night, the spirit moose Kheglen (Ursa Major) and her calf (Ursa Minor) graze among the stars. Mangi, the bear and chief ancestor spirit whose body is found in the stars of Arcturus and Boötes, comes out to pursue them. Mangi's ski tracks appear as the Milky Way. Each spring, Mangi succeeds in his hunt and from the parts of his kill the new life on the earth below arises. The snows cease to fall, the birds return, and young animals are born. In the autumn, the great hunt begins once again.

—*A retelling of a Siberian myth from* The Sacred Paw *by Paul Shepard and Barry Sanders*

Once again, a celestial bear is part of an annual hunt but this time as hunter rather than quarry. Mainly vegetarian, black bears and brown bears are not hunters everyday but, as we will see later, they do play this role on occasion. The polar bear, on the other hand, relies on its predatory expertise to survive in one of the world's most challenging environments. Early people who shared the white bear's domain often carved its image on their hunting equipment, hoping to share its skill at getting food. They respected the polar bear so profoundly because they watched how it hunted—and glimpsed a reflection of themselves.

HUNTERS IN AN ICY WORLD

Early northern hunters identified strongly with the polar bear: both sought the same prey in the same areas, using skill and intelligence to secure the food they needed to survive. Seals, whose caution required a hunter to be particularly patient and cunning, were a staple diet item for both bears and people. Many stories say that early hunters learned their seal-hunting techniques from the bears. If this is so, the people could not have asked for better teachers.

Polar bears locate seals with their almost unbelievably acute sense of smell and then employ one of two basic hunting strategies. The most common technique is still-hunting: the polar bear remains motionless beside a seal lair or breathing hole and waits. The less frequently used stalk involves a stealthy approach to a seal or a lair followed by a sudden leaping plunge to seize the prey. Bears most commonly use the stalk during the time when seals are giving birth and nursing their pups in snow lairs. If a bear's nose tells it a lair is occupied, the bear cautiously approaches then crashes through the lair roof to seize the seal within.

The polar bear's two basic strategies are quite effective. However, it is when we look at some of the variations that polar bears use in particular hunting scenarios that we truly begin to appreciate what efficient and intelligent predators they are. The different ways in which polar bears still-hunt seals in winter are a good example of this.

Ringed seals scratch through the ice with the short, sharp claws of their front flippers to create and maintain three or four breathing holes. If snow covers the hole, the seal scratches

In a cave near Ungava Bay in the Hudson Strait dwelt Torngarsoak, a giant white bear. As master of all whales and seals in the bay, Torngarsoak determined whether or not they would be sent to hunters.

— Belief of the Labrador Innu

95

out a small snow cave so that it can haul out on the ice without being seen. Polar bears wait, often for hours, lying on their stomachs near these breathing holes for the seal to appear. They position themselves downwind of the hole because seals are wary and immediately take a quick sniff when they emerge. The bear listens for the sound of the seal's breathing to signal its arrival. If the ice is thin the bear smashes through with its paws and with the same blow crushes the seal's skull. In thick ice, the bear may prepare ahead of time by digging around the hole to weaken the ice. Or it may dig a separate hole some distance away. In this case, the bear waits until it hears the seal then slips into the water and catches the seal from

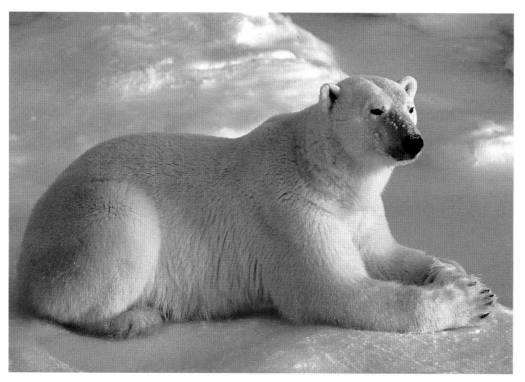

underneath. Open water requires a slightly different technique. The bear either digs a hole in the ice near the water's edge, as it would near a breathing hole in thick ice, or simply waits near the edge. In either case, once a seal appears, the bear slides stealthily into the water to catch it.

Seals sleeping in the water, noses pointed to the sky and bodies rocking gently with the waves, provide easier prey for the bear. It can often swim or stalk close enough to the unwary sleepers to kill them. The same is true when the seals sleep on small, flat bits of ice or the ice edge along the water, although the technique is a little different. The bear swims toward the seal but, while still some distance away, submerges. Swimming underwater, it surfaces next to the ice, leaps onto it and cuts off the seal's escape. Author and naturalist Richard K. Nelson points out that bearded seals must be especially vulnerable to this type of attack because they are such sound sleepers and often lie on very small pieces of ice, allowing the bear to swim very close before jumping out to surprise them.

These everyday polar bear techniques show a high degree of resourcefulness. On occasion, however, polar bears display a level of cunning that surprises even researchers who know them well. For example, seals resting on the ice next to their breathing holes sometimes get a nasty surprise: a polar bear suddenly pops up out of the hole, cutting off any chance for escape. Polar bears may also stalk seals by swimming under the ice, from breathing hole to breathing hole, taking a breath and checking their bearings at each hole before diving again. According to Ian Stirling, who has spent thousands of hours observing polar bears, the bears surface, breathe, lift their heads to look, and go under again without creating so much as a single ripple in the water.

Even more amazing is the story of a polar bear in Wager Bay, Canada who used its acting abilities to fool its flippered victim. When observers first caught sight of the bear and the seal, the two were in the water about 60 meters (200 feet) apart. The bear slowly paddled towards the seal whenever the seal was on the surface, but stopped immediately and remained motionless whenever it submerged. Each time this sequence was repeated, the bear drew a bit closer to the seal. Finally, the seal surfaced next to the bear, which immediately killed it. Those who had watched the entire performance speculated that the seal had believed the bear to be a harmless piece of floating ice.

Once it has killed a seal, a polar bear usually eats only the skin and blubber. This is where most of the seal's food value lies: the blubber alone from a yearling ringed seal may contain nearly 70 percent of the total calories in the carcass. As an added bonus, these calories are in a concentrated form, which allows the polar bear to eat less food and still gain weight. One researcher calculated that the average active adult polar bear would require either 2 kilograms (4.4 pounds) of seal blubber or 5 kilograms (11 pounds) of seal muscle to fill its daily caloric needs.

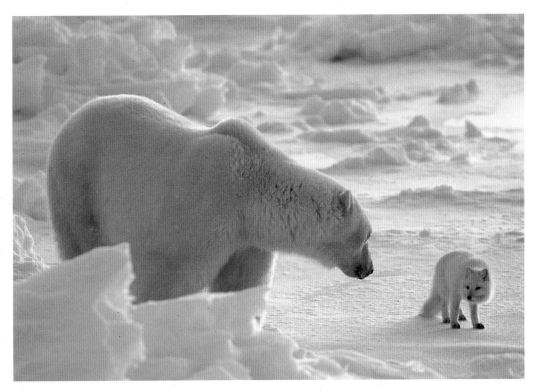

The polar bear may get an extra benefit from its blubber bias because the metabolic wastes produced during blubber digestion are water and carbon dioxide, which the bear's body can use or get rid of by exhaling. If the bear ingests food higher in protein, such as seal muscles and guts, its body produces mainly urea, which must be excreted in urine. The bear must replace the water lost in this process, possibly by eating snow. People who get lost or stranded in winter are advised to avoid eating snow because it takes so much body energy to melt the snow into water. It works the same way for bears. A polar bear who eats seal muscle not only gets less calories per bite, but, if it has to eat snow, uses energy in digestion and excretion that may reduce the meal's value even more.

Polar bears also eat other prey, including walrus, muskox, carrion, and, every once in a while, an arctic fox that has become too bold in snatching up scraps from the bear's meals. Polar bears will also kill beluga whales, particularly when the belugas become trapped in a small area of open water surrounded by ice. Off the western coast of Alaska, polar bears killed forty belugas under these conditions. No one witnessed the killings but observers later counted about thirty bears feeding on whale carcasses spread on the ice around the

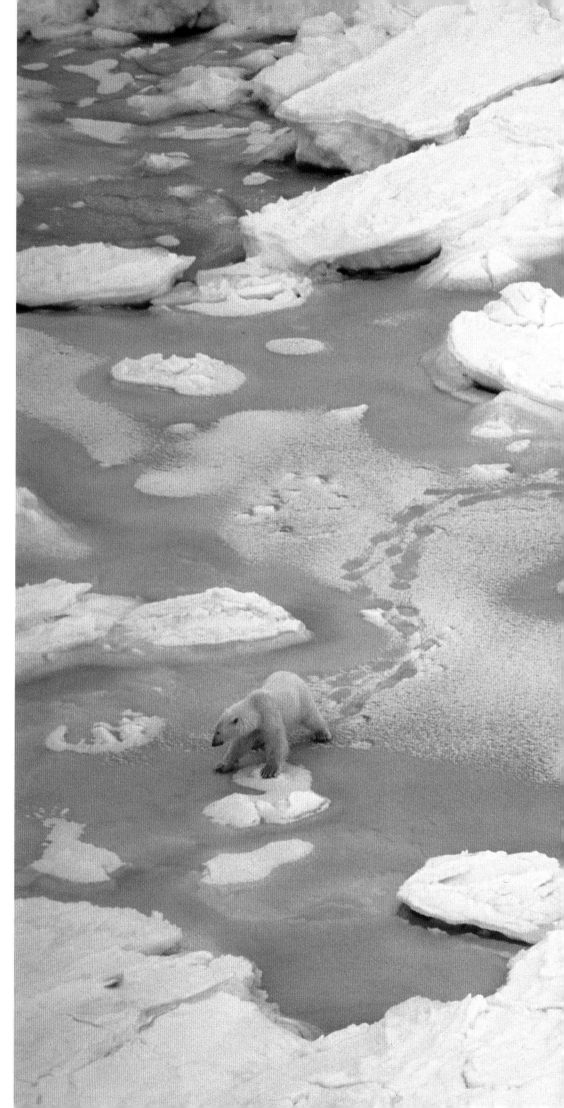

In such a bleak landscape, finding and capturing prey requires a hunter to be patient and resourceful. The polar bear investigates any seal breathing holes it encounters as it pads over the ice, in the hope of finding one showing signs of recent use. Should it find a promising hole, the bear may wait close by for hours to have a chance at catching an emerging seal.

Polar bear feet are ideally suited for travelling across the ice. Thickly furred against the cold, they also have an extremely effective nonskid surface on the pads.

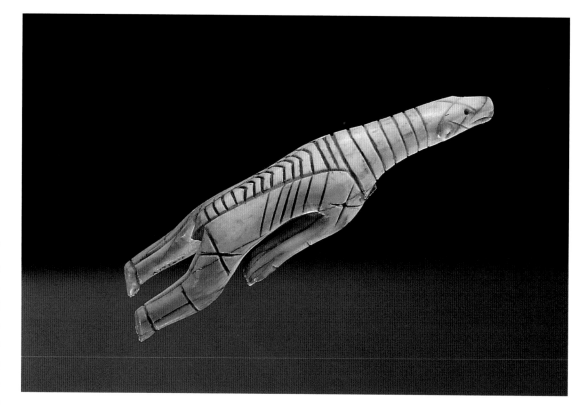

Ivory Carving of Bear

About 2,000 years ago in Canada's central Arctic, the respectful hands of a Dorset artist carved this ivory polar bear. Lines were incised to represent the bear's skeletal structure and a magic mark was placed on the skull. The figure may have been used to call upon the bear's hunting prowess or for other shamanic purposes. Carvings such as these are sometimes referred to as "flying" bears, but to capture the bear's shape, the artist may have drawn on his knowledge of swimming polar bears or playful ones, such as the mother we saw earlier.

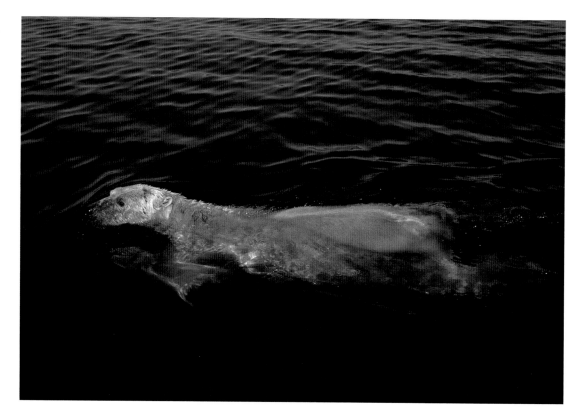

open water. Occasionally, a polar bear may do a little foraging on the tundra and eat berries, grasses, kelp, bird's eggs, as well as the odd lemming or vole.

The late Finnish paleontologist Bjorn Kurtén hypothesized that polar bears evolved from a population of brown bears that was isolated from other brown bears by a glacial ice sheet about 200,000 to 250,000 years ago, during the Ice Age. In an environment where seals were abundant and lacked a land predator, these brown bears adapted to fill the vacant niche. The species that evolved as a hunter in this wet and snowy environment had paddle-like front paws for swimming, thick, white fur for warm camouflage, and teeth designed mainly for tearing and cutting meat rather than for grinding plants. Part of Kurtén's speculation was given credence by biologist Dr. Mitchell Taylor's observation in May 1991. Five hundred kilometers (310 miles) north of where he would expect to see one, Taylor spotted a brown bear on the sea ice. After tranquilizing and weighing the bear, Taylor followed its tracks back to where it had been hunting ringed seals. After carefully scrutinizing the snow around the seal kills for polar bear tracks and finding none, Taylor concluded that the brown bear had made its own kills and not scavenged carcasses from a polar bear kill. Although brown bears had been seen along the coast near seals on the ice, this was the first proof that they actually ventured out onto the sea ice to hunt seals. A more common prey of coastal brown bears is salmon.

WORKING WITHOUT A NET

When salmon are spawning around the North Pacific rim, brown bears congregate on streams and rivers to feast on the dead and dying fish. At some locations, such as along the famous McNeil River in Alaska, mothers with cubs, big males and sub-adult bears can be observed crowding in, year after year, to share the feast. Normally solitary, the bears somewhat warily tolerate others nearby, although there is a pecking order in which dominant bears get the best fishing spots. Given a chance, any bear will steal fish from a less dominant one, so bears lower down in the hierarchy often carry their fish away from the water before eating.

People who have never watched brown bears fish for salmon often assume that the bears either catch them with their claws or swat the fish out of the water and onto the bank with their paws. In reality, neither of these are among the bears' fish-catching techniques, which range from the sublime to the ridiculous— as a look at the methods of McNeil River bears will show.

Fishing bears use different methods on different parts of the river according to Larry Aumiller, sanctuary manager of McNeil River State Sanctuary since 1976. In *River of Bears* by Tom Walker, Aumiller described several basic scenarios: at McNeil Falls, bears pounce on fish as they attempt to swim or leap the falls; farther down the creek, bears run back and forth in the shallows, chasing and catching fish; and many bears just

In warmer climes I've been in the water with sharks. I fear the white bear infinitely more. More than fear, I respect it. It is respect for our kinship. We, Nanook and I, are warm-blooded, sentient creatures. I appreciate the bear's mammalian intelligence, his superb adaptation to this environment, where I am the intruder. The bear is a terribly efficient predator …

—Charles T. Feazel, *White Bear*

Bear Diving After Walrus

This amazing sculpture, carved by Aibilli Koonoo around 1965, portrays a hunting polar bear in pursuit of a walrus.

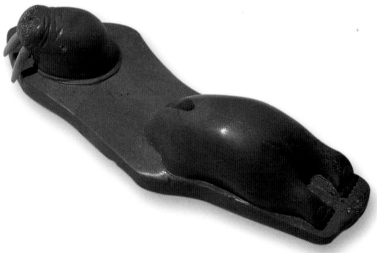

stand around in the shallows or on the rocks in the river, watching for fish in the foaming water. These are the most common techniques, but, of course, individual situations and bear personalities sometimes lead to more unusual fishing methods.

Aumiller recalled a time when unusually high water made it possible for fish to jump the falls "like little rockets. Two bears stood at the top of the falls, snapping at fish as they were flying by. Snap right, snap left. Dinner out of the air." He also described a bear who would take a flying leap to belly flop into a pool, hoping to catch a stunned or confused fish. An-

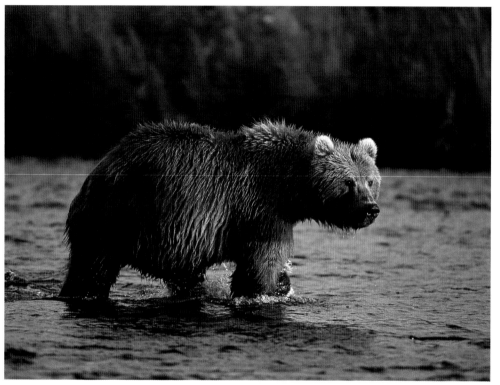

other bear dove to the bottom of a twelve-foot-deep pool, frog-kicking its way down to bring up fish remains. My personal favorite among Aumiller's anglers, a bear called Siedleman, would put just his head under water, lunge around apparently looking for fish, and manage to catch one salmon out of every six tries.

What kind of a catch do the brown bears bring in? At McNeil River, a bear commonly catches fifty salmon in one day. Once they have reduced their initial hunger, bears usually eat only the high-fat parts of their catch—the brain, eggs, and skin—as polar bears do with seals, and for the same basic reason: to consume lots of calories that build up fat reserves quickly. As the salmon run progresses, a bear may eat only the eggs before discarding the fish. The rest of the salmon doesn't go to waste, however, but is eaten by gulls, eagles, and younger bears.

In addition to salmon, brown bears hunt for other types of food. In the spring and early summer, young cervids—deer, caribou, elk, and moose—are a favorite prey for grizzlies. Often a bear will search likely areas for fawns or calves that are bedded down. The bear slowly works its way back and forth through an area, stopping often to sniff, look and listen. Researchers in Yellowstone found that grizzlies there hunt elk calves at night, as well as during the day, using this method. A grizzly may also try to sneak as close as possible to a young animal and then suddenly charge. Once young cervids are about six to eight weeks old, they can usually outrun a bear and are safe from this type of attack.

Lemmings, pocket gophers, mice, and ground squirrels are tasty little morsels as far as a brown bear is concerned, and worth the effort of digging them out. A ground squirrel colony after the excavations of a determined grizzly often appears as though an army of shovel-wielding maniacs has been busy: holes may be so large that the grizzly disappears from sight while digging them. A grizzly may make these rodents a large part of its diet: one Alaskan female brown bear ate 396 ground squirrels in one year, 189 of those during late fall.

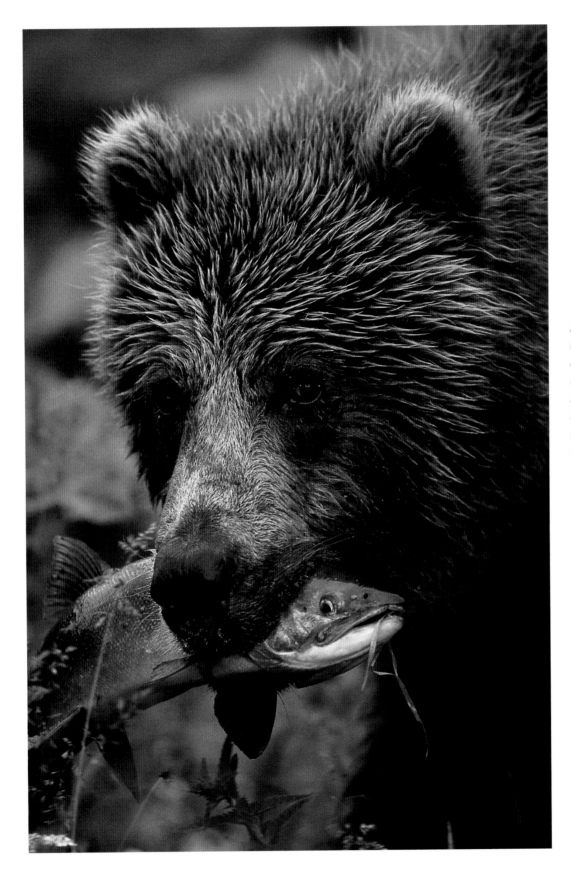

Shall we fear that knowing [the grizzly] too well may diminish [her] mysterious qualities? No. Indeed intimacy should heighten our sense of awe, if only because she is, more clearly the better we know her, so immitigably other. And there will always be plenty of her that will not yield to our craving to understand.

—Thomas McNamee
The Grizzly Bear

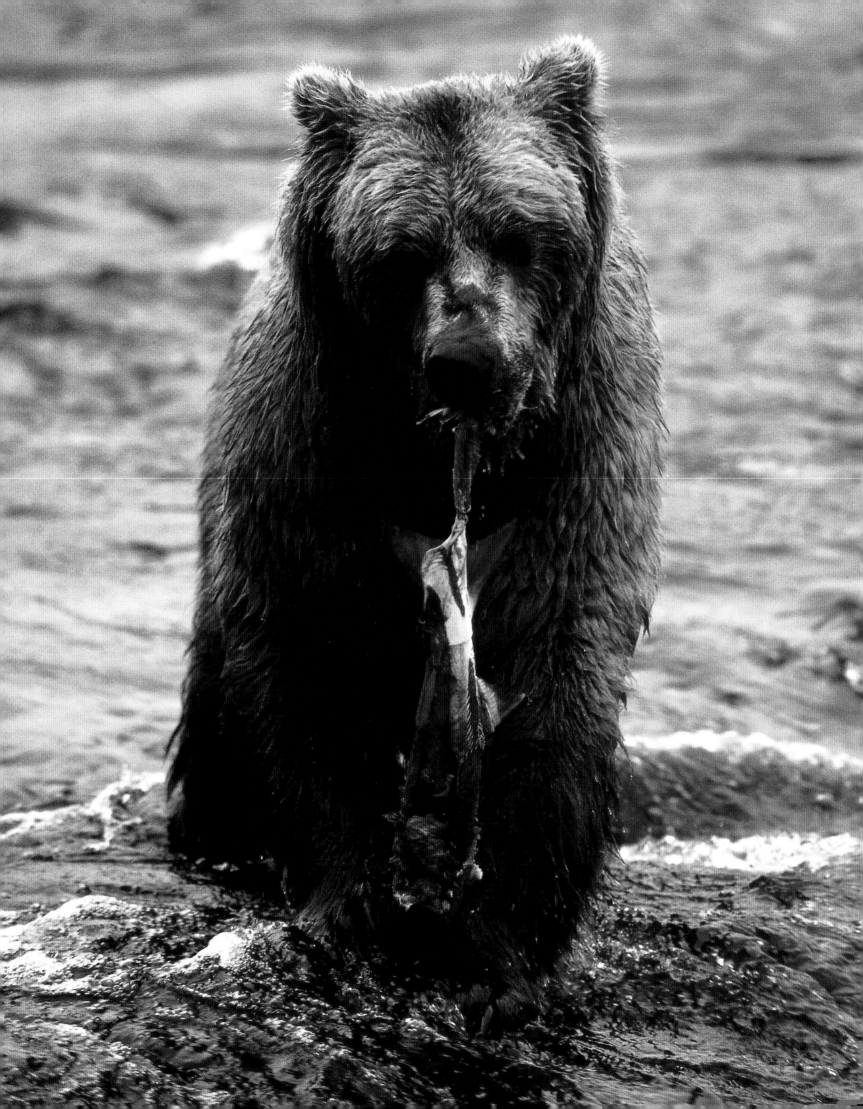

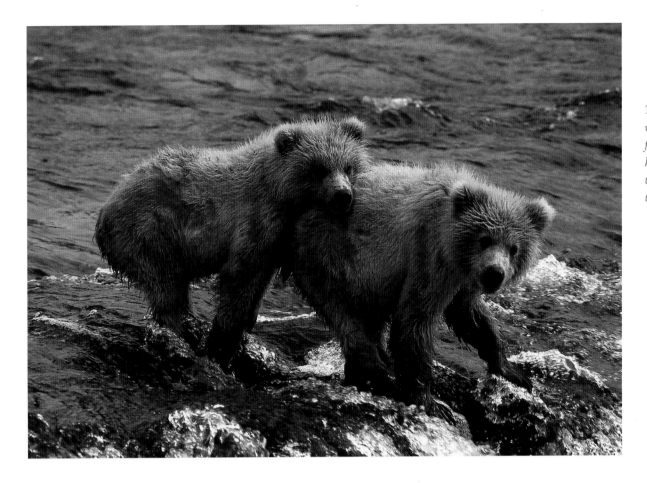

Two brown bear siblings work on their salmon fishing technique. They have a lot to learn before they are ready to be on their own.

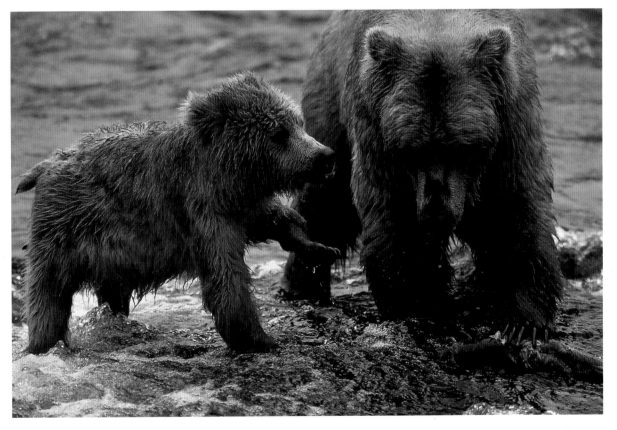

[There are] ... three fundamental rules of grizzly bear cubhood: follow mother; obey mother; have, within those constraints, as good a time as possible.

—Thomas McNamee,
The Grizzly Bear

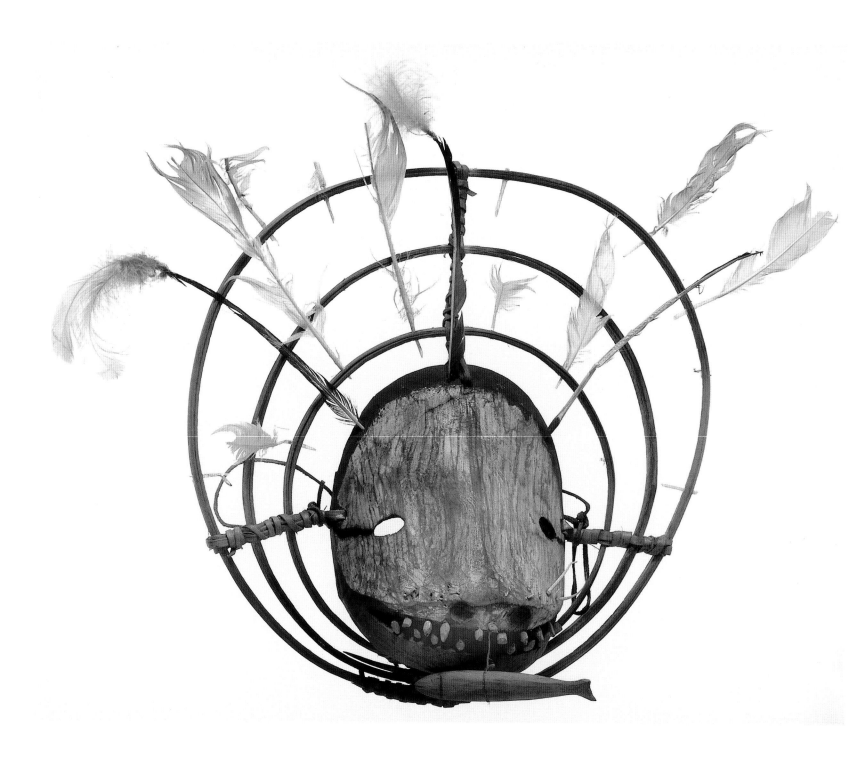

Grizzly Bear Spirit Realm Mask

*This Bering Sea Eskimo mask shows a grizzly
bear spirit with its preferred food, a salmon.*

The deltas of the Anderson and Mackenzie Rivers in Canada's Northwest Territories hold large waterfowl nesting colonies. To the consternation of ornithologists monitoring the birds, brown bears periodically raid the colonies for the eggs. But, as Wayne Lynch reported in *Bears*, five brown bears took waterfowl depredation to a new level in 1986. The bears destroyed 5500 to 6000 brant and snow geese nests and 100 glaucous gull nests in the process of eating about 24,000 eggs. The ornithologist watching the site found only one bright spot in the whole scenario: the bears paid for eating that many eggs with a really nasty bout of diarrhea.

Black bears like eggs, too, although their choice of *whose* eggs may seem a little reckless. Researchers monitoring clutch success of alligator nests in the Okefenokee Swamp found that predators cleaned out more than half of the nests, despite the fact that mama alligators lie near their nests and usually defend them vigorously. Describing the situation in *Bears*, Wayne Lynch wrote that surveillance cameras revealed the most common nest bandits were black bears, who just climbed onto the nest mound and sat there eating egg after egg. The area around the predated nests showed no wounded bears or alligators, no blood or other signs of a struggle. In the true spirit of scientific investigation, Howard Hunt, curator of reptiles at the Atlanta Zoo and the man responsible for the surveillance cameras, walked up to an active alligator nest in the area to see if the guardian mother would defend it. She did. Hunt left the nest, only to return later the same day—this time dressed in a bear suit and crawling on all fours. Mama alligator rapidly left the nest although whether she was avoiding a bear or a man crazy enough to crawl up to an alligator while dressed as a bear is unknown.

Black bears are the least carnivorous of the three bear species we have been discussing, but they are opportunists and will take food where they find it. They have been seen flipping over bison chips to eat the crickets underneath, and dining on a snapping turtle caught in the midst of laying her eggs. These unusual examples illustrate one of the nice things about being an omnivore, as brown and black bears are: you can take advantage of whatever food comes along, even if it wasn't what you set out to find in the first place. Thomas McNamee, in *Grizzly Bear*, describes how grizzlies raid squirrels' caches of whitebark pine cones to eat the pine nuts. The bears smash the cones with their paws or teeth, then lick up the nuts from among the debris. However, as McNamee adds, "with singularly ursine fair-mindedness, [the bears] will often also smash and eat the squirrels themselves."

Most of us can visualize bears as predators—killing seals, catching salmon, even smashing squirrels—without feeling fear because we know we are safe in our urban surroundings. Imagine, though, that you and I are somewhere on the coast of Alaska and the salmon are spawning. We'll just hike up that stream over there and have a look at the fish. We can't hear very well because the stream is noisy and the thick brush prevents us from seeing very far in front of us. After swatting insects and struggling through the bush for a while, we pop out into a small opening and there, right in front of us, are a mother grizzly and her two cubs. Suddenly, the concept of the bear as a predator doesn't seem so abstract.

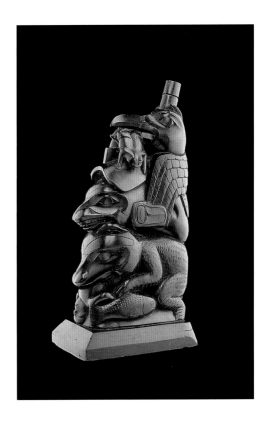

Haida Argillite Figure

At the base of this Haida argillite carving, the artist placed a bear atop a salmon, linking the two in art as they are in nature.

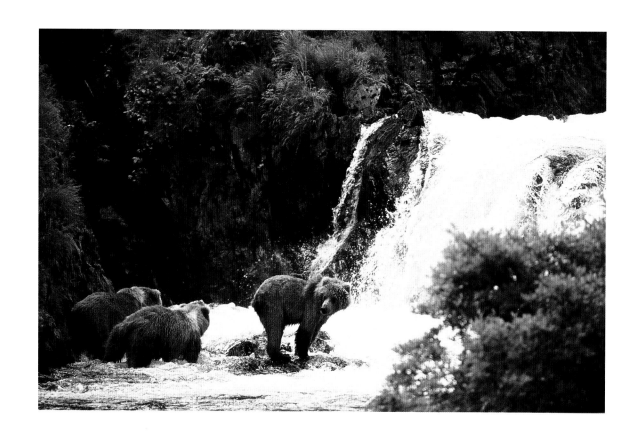

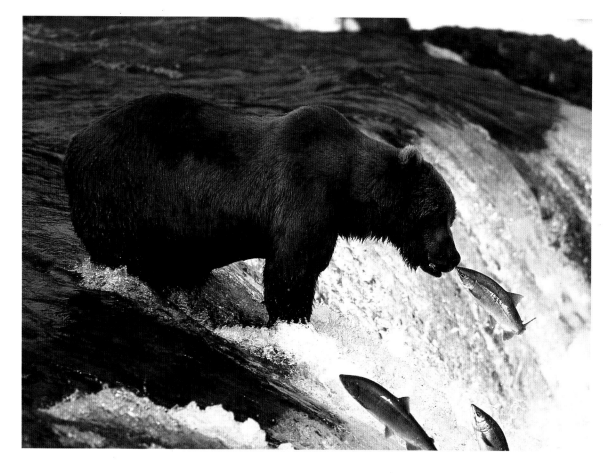

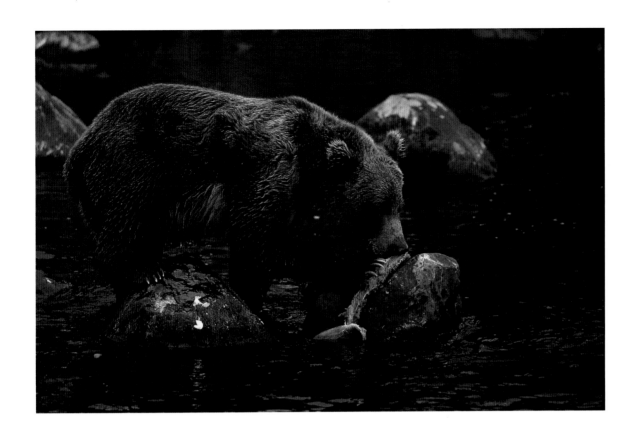

WHEN BEARS ATTACK HUMANS

Strictly speaking, this topic should not be included in the subject of "bear as hunter" since "hunting" rarely seems to be a bear's motive for attacking humans. The person being attacked, however, undoubtedly feels like prey at the time. Why do bear attacks, although a very minor cause of injury and death when compared to other hazards, attract so much attention when they happen? The thought of being bitten and clawed, and perhaps eaten, by a bear taps into some deep-seated fears for most people. Moreover, many humans have been separated from direct contact with the wilderness for so long that they consciously or unconsciously view it as a benevolent place where happy animals lead herbivorous lives for our viewing pleasure—an illusion that is resoundingly shattered by news of a person being mauled by a grizzly. Accounts of bear encounters and attacks have been presented in a more factual, balanced manner in recent years, but pop culture has a long history of drawing on the shock value of these incidents, presenting bears as deliberate people-eaters in everything from firearms advertisements to feature movies.

Portrayal as a man-eating menace by the way, is not a new public-relations problem for bears. An old tale from Iceland presents a view of the polar bear as a very intelligent hunter of humans:

> A man walking along a road near some mountains chanced to look at a knoll. Lying upon the knoll looking down on the man was a great polar bear. The man carried a long, stout staff tipped with a sharp point, and having seen this, the bear allowed him to pass unchallenged. A mile or so down the road, the man met another traveler headed in the opposite direction. This traveler was unarmed so, after warning him about the bear ahead, the man gave him his staff for protection. The now-armed traveler passed without incident by the bear on the knoll. However, the sharp-eyed bear recognized the staff and so tracked down the first man and killed him.

Before the advent of modern firearms, anyone who lived in an area inhabited by bears needed to exercise caution in potentially dangerous situations. Arctic people, for example, avoided attracting polar bears into their village by not leaving a blood trail when dragging seals home across the ice. Well aware of the potential consequences of an encounter, early people quickly surrendered disputed turf, such as berry patches, salmon streams, or animal carcasses, to the bear. They acknowledged a mother bear's ferocity in protecting her cubs and tried to avoid provoking defensive attacks. Those brave enough to hunt bears with primitive weapons knew that a wounded bear was extremely dangerous. Most modern bear attacks seem to stem from the same situations, or from unexpectedly encountering a bear who is as surprised as the person. However, bear attacks are often complex events and can be difficult to understand or explain. Rather than attempting to explain them or discuss preventive and defensive measures (see "Recommended Reading" for titles on this subject), what follows is a look at how some peoples who dealt with the possibility of bear attacks on a regular basis, throughout their lives, coped with the danger.

Each year in late winter or early spring, the Kutenai people held a Grizzly Bear ceremony for the express purpose of obtaining immunity from grizzly bear attacks. During the cer-

Tlingit Pipe

The shamanic theme of this small Tlingit tobacco pipe is unusual: most pipes from this region depict clan crest animals. The image of a bear devouring a human symbolizes the spiritual transformation that occurs when a person becomes a shaman. The shaman's ability to transcend death is indicated by the emaciated state of the human figure.

emony, whose origin was traced back to the Kutenai legend you read earlier, the participants wished the bear good luck in the upcoming summer and asked the same for themselves. The people also asked the bear not to send sickness upon themselves or their children.

For help during a bear attack, the Ainu sometimes called upon another powerful animal. A divine wolf, clothed in white, lived on the eastern side of the mountains with the good bears. If a person was chased by a bad bear, he could call loudly for the wolf, who would quickly come to kill the bear and save the man.

Sometimes only a few "chosen" people were saved from bear attacks. Some stories from (unspecified) native people of the southeastern United States illustrate this somewhat Biblical concept. This particular tale bears a strong resemblance to the story of Passover:

> One day while out hunting deer, a man of the Bear clan met a bear in the woods. "Are there many of your clan in the village?" asked the bear. The man told him the number. Then the bear said, "Because you are of my clan I will tell you this. Four days from now, I will come to the village and kill all the people. You Bear people must hang up a white cloth: I will not kill anyone who does this." The bear then disappeared back into the forest.

> The man told the other members of the Bear clan what they should do but not all of them believed him. On the morning of the fourth day, many bears, big and small, came to the village. The people took their guns to try and kill the bears but it was no use. When it was over, only those who had hung out a white cloth still lived.[1]

There is no explicit reason for the killings, but one possibility stands out: lack of respect. In story after story from culture to culture, ancient people repeatedly stressed the need to respect animals in general and bears in particular. It seems rather paradoxical, then, that the bear ceremonies and rituals which most strongly emphasized this belief centered around activities that appear extremely disrespectful of the bear: hunting and killing it.

I have known several persons to be maimed or killed in battles with bears, but in every case it was not the bear that began the fight … He doesn't want much, only the wildest and most worthless parts of the mountains and marshes, where, if you will let him alone, he will let you alone, as a rule.

—Joaquin Miller, *True Bear Stories*

Haida Knife

The carving on the hilt of this Haida knife depicts a bear consuming a human.

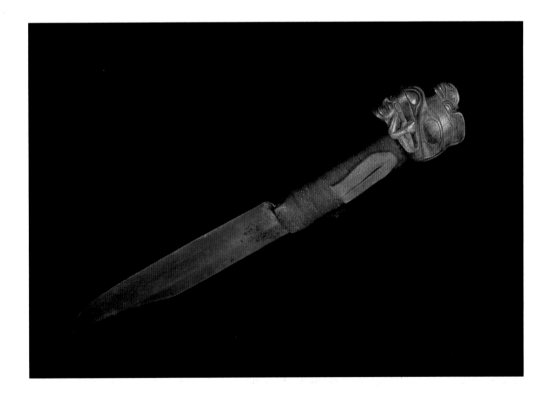

One day, while the people of the village were out hunting, some of them saw a white bear but the others could not see it. One of the men eventually killed the white bear so they joyfully carried the carcass back to the village and divided it amongst themselves. After the bear had been cooked and eaten, the men played ball and had a good time celebrating their successful hunt.

After watching them for a while, one man stepped forward and said, "You are all glad but you should not be—it is wrong." He went off alone to walk in the forest and think. Suddenly a big bear appeared before him. "Your people killed my chief," said the bear, "and now I am going to kill them. If you believe what I tell you, tell your people and take those who believe you to the other side of the creek." The man ran back to the village and told the people what had happened. Only a few believed him and followed him across the creek.

From where he sat, the man could see the village and he watched as a lone bear walked into the village. The people killed it. Another came and they killed it. Then another bear came, then two more, then three, then four—more and more bears poured into the village until they had killed all the people and destroyed the village.

When it was over, the man walked out to meet the bear who had warned him earlier. "You may kill and eat us when you need to," said the bear, "and we will not hurt any of you."

—A story from the southeastern United States,
retold from Swanton (1929)

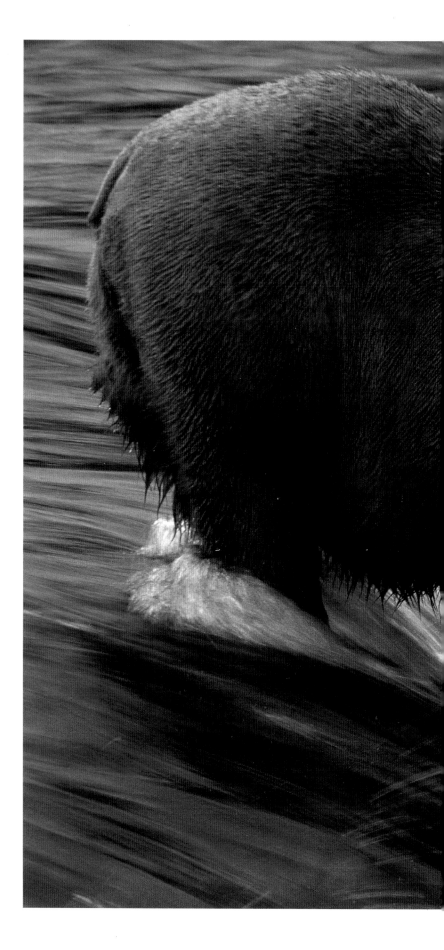

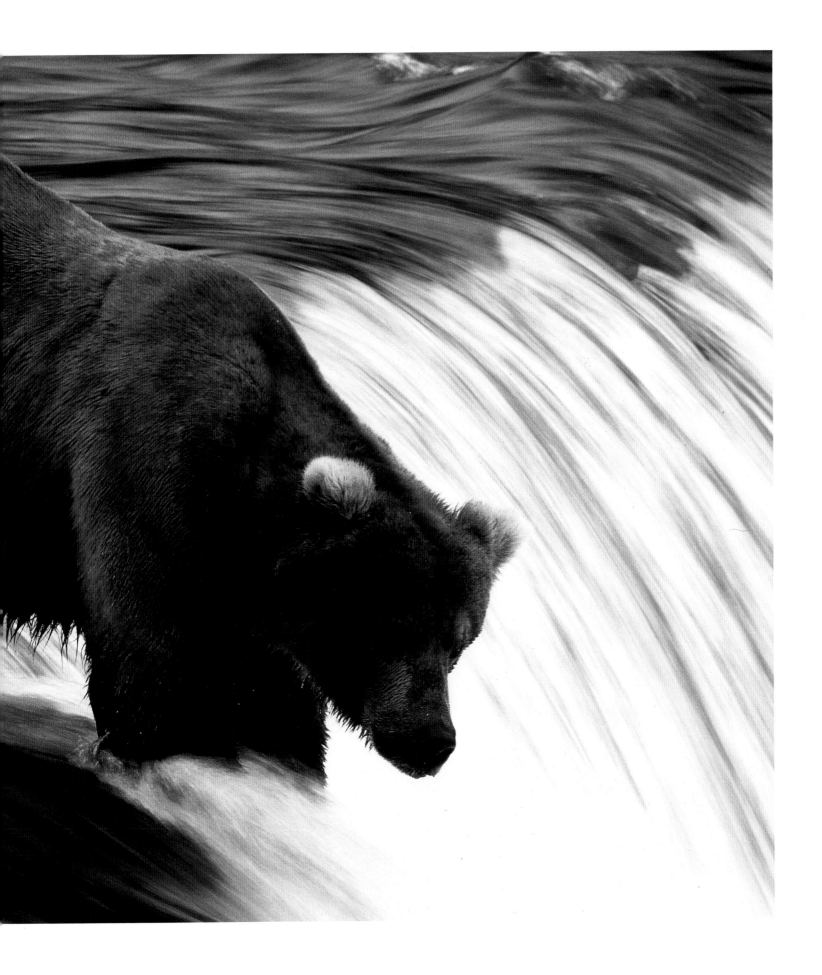

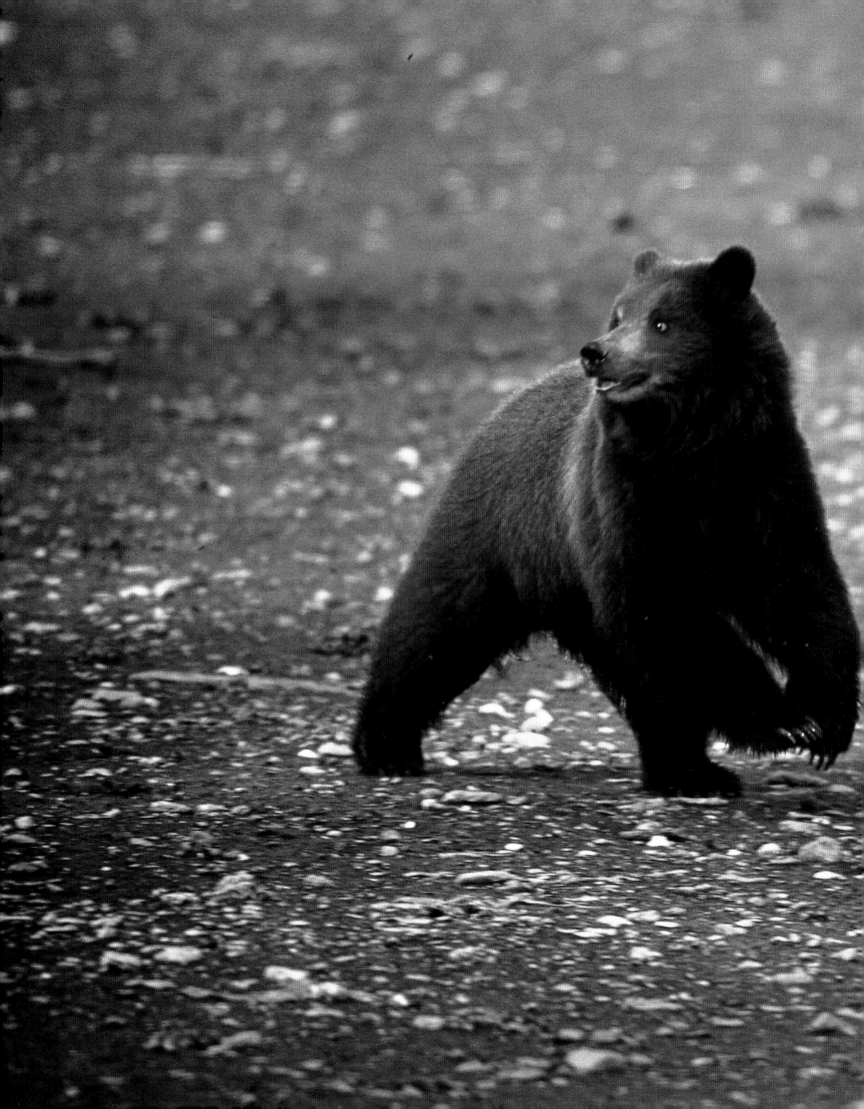

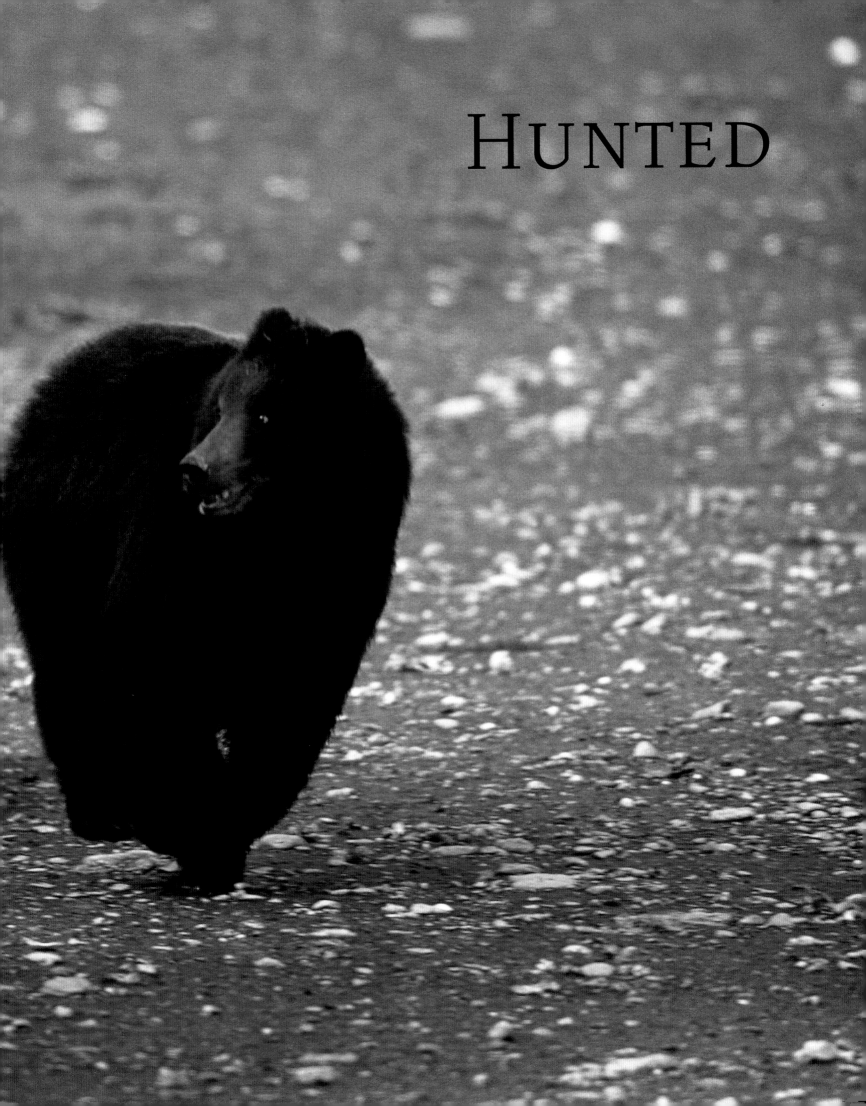

HUNTED

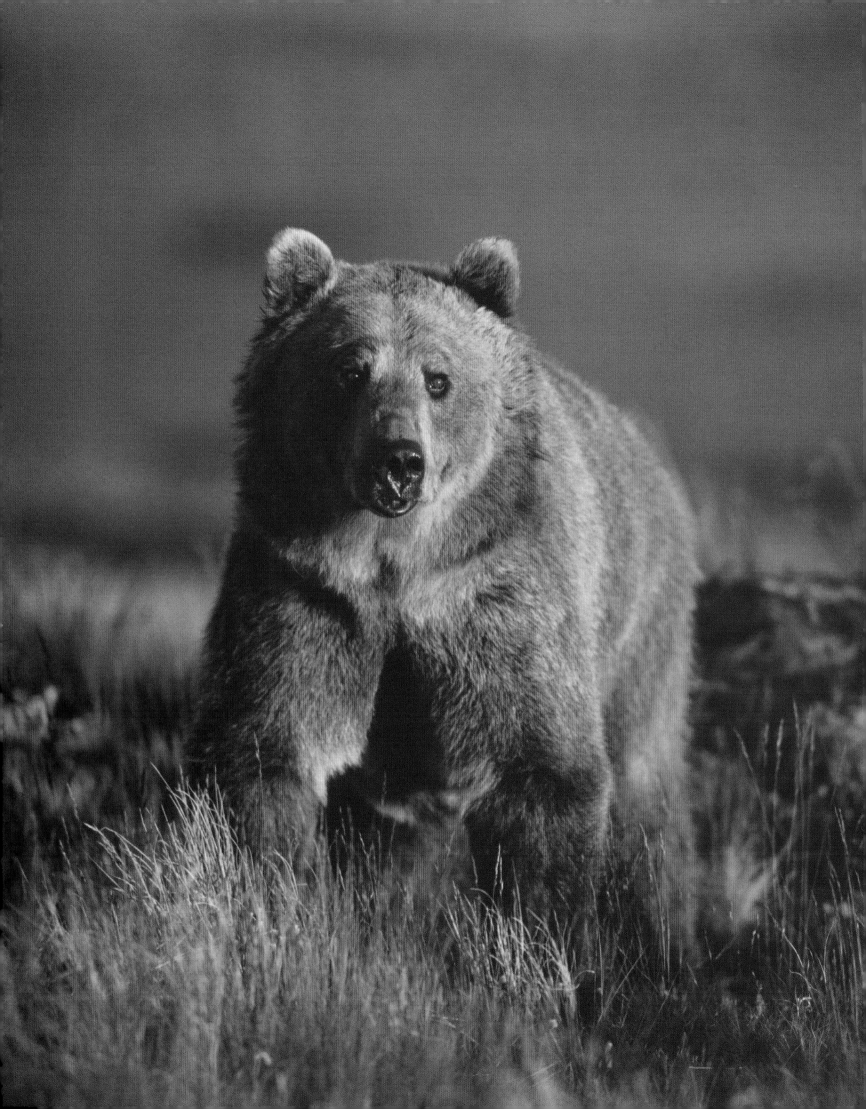

Grandfather, come out. I am sorry that I must kill you.
—Cree hunter's call to the bear in its den

Some peoples, including the Apache, Blackfoot, Yavapai, and Isleta Pueblos, had strict taboos against killing bears. To many others, however, the bear was a prized but dangerous quarry. They used its fat for food and medicine, and its skin, claws, and other body parts for ceremonial purposes. Bear meat was not everyday fare but cause for a special feast. Often the main reason for killing a bear was to obtain some of the animal's healing or war powers. Sometimes the bear's death was an integral part of rites deemed necessary for an entire group's continued good luck, health, or prosperity.

Bears are still highly valued as game animals—just take a look at any trophy hunting magazine and count the bear hunting advertisements. While the motive for killing a bear today might still be described as an acquisition of power, the means of acquiring it and the end uses for it have changed considerably. The main beneficiary of any power derived from the bear is no longer the group, but the individual.

Historically, the act of killing a large predator implied virility and courage. It still does for some people, even though today's weapons and hunting methods make it possible for hunters possessing neither of these qualities to proudly hang a bear head on their wall or throw a bearskin rug on their floor.

Is there a difference between killing a bear with a club or with a modern rifle? Is it better to kill a bear to acquire its power than to kill a bear to acquire its head as a trophy? To the individual bear involved, of course, the end result is the same—death. There are, however, two main differences between killing bears in ancient times and killing bears today.

The first change is simply numbers: more bears are being killed today than in ancient times. While some bear populations can sustain this level of predation, others cannot, and it is important that we distinguish between the two. The second difference lies in the attitude and motivation of the hunters in each case. Paul Shepard and Barry Sanders wrote, in *The Sacred Paw* "When ritual evaporates or it is forgotten, what remains appears to be brutish and savage. This is perhaps best seen in an activity like hunting. Without a profound respect for the sacredness of the animal's life, hunting devolves into mere butchery." Today, only bear hunters who truly respect their quarry can legitimately consider themselves part of an honorable tradition that began long, long ago.

The grizzly went out as the American rifle came in. I do not think he retreated. He was a lover of home and family, and so fell where he was born. For he is still found here and there, all up and down the land, … but he is no longer the majestic and serene king of the world. His whole life has been disturbed, broken up …

—Joaquin Miller, *True Bear*

… while I have by no means become an anti-hunter, I have come to realize how vastly more there is to be learned about these marvelous creatures than merely the most destructive spot to hit them with the slug from a high-powered rifle.

—Harold McCracken,
The Beast That Walks Like A Man

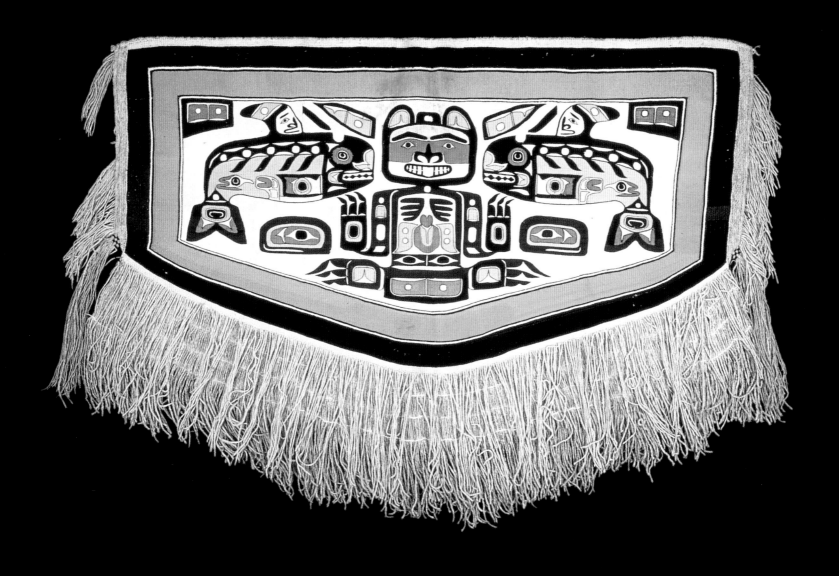

Tlingit Chilkat Blanket

Intricately woven by tribes of the Northwest Coast, Chilkat blankets were an important part of their ceremonial regalia. The Tlingit made their blankets of mountain goat wool and cedar bark, weaving in the traditional crests and other figurative imagery that represented clan heritage and family history. A bear is depicted as the central image of this Chilkat blanket.

Worn by a dancer in the flickering firelight of a winter ceremony, the blanket symbolized and affirmed the identity and history of the clan, and through the dancer's movements the woven animals came to life.

Step back in time and imagine that you must kill a bear using only primitive weapons. Not only will you be in extreme physical danger but, because of the powerful nature of the bear's spirit and its relationship to humans, you will be in grave spiritual jeopardy as well. Aua, an Iglulik Inuit, explained to Knud Rasmussen:

> The greatest peril of life lies in the fact that human food consists entirely of souls. All the creatures that we have to kill and eat, all those that we have to strike down and destroy to make clothes for ourselves, have souls like we have, souls that do not perish with the body, and which therefore must be propitiated, lest they should revenge themselves on us ...

To minimize the considerable risks involved, people followed carefully circumscribed rituals before, during, and after bear hunts. Underlying nearly all of the ceremonies was the need to be certain that the bear was pleased by the hunter's behavior so that, when it returned to its home to be reincarnated, the bear's spirit would speak well of the hunter. Otherwise, the hunter might never again have luck finding game. He could also be made ill or even killed by the bear's angry spirit. Rites were conducted by various peoples for other types of game, but none were as elaborate or widespread as those for the bear. Some bear hunt rituals, particularly those performed over the bear's carcass, appeared in very similar forms among many peoples, while others were unique to certain groups. The bear ceremony of the Ket people of Siberia, for example, preserved some very archaic features unseen elsewhere. For many peoples, killing a bear was a deeply spiritual act.

BEFORE THE HUNT

Hunting, for many early peoples, was literally a matter of life and death. They needed to hunt successfully in order to survive, and therefore they did whatever they could to help ensure that success. Many groups had general pre-hunt rituals that included sweating, fasting, and praying. Rituals performed specifically before bear hunts were much less common but did exist.

Among the Shasta, preparations differed depending on whether the quarry was to be black bear or grizzly bear. Black bear hunts required Shasta men to use a sweat-lodge, with aromatic fir-twigs on the coals, for five days before the hunt. Before setting out after a grizzly bear, Shasta men performed a war dance, just as they would when preparing to attack a human enemy. The Lapp (Sami) bear hunter consulted a magic drum to see if it forecast good luck; if not, he stayed home. He also avoided contact with women, who were regarded as unclean mainly because of menstruation, before beginning the hunt. A Tlingit bear hunter purified himself before the hunt by fasting and bathing. He refrained from saying what he hoped to kill because bears could hear everything that was said.

It was widely believed that bears heard what was spoken about them. For this reason, as well as to show respect, many people used a variety of euphemisms when referring to the bear; hunters were particularly careful. Some of these bear "code" names you have already seen, such as Grandfather and Cousin, but there were many more including Old Man, Honey Paws, Black Food, Short Tail, He Who Owns the Chin, Food of the Fire, Old Man in the Fur

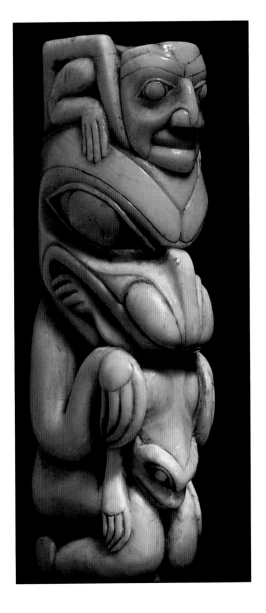

Ivory Dagger Hilt

This beautifully sculptured Haida dagger handle of walrus ivory shows a bear holding a frog.

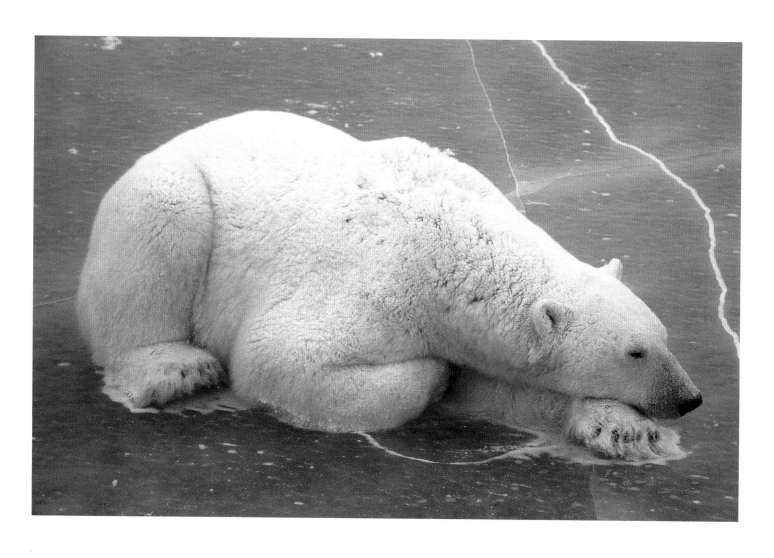

The Tahltan say that
when people step on a bear's tracks,
the bear knows because it feels
as though sparks have fallen on it.

When asked by Knud Rasmussen to define life's greatest pleasure, an elderly Greenland Inuk replied, "To run across fresh bear tracks and to be ahead of all other sledges."

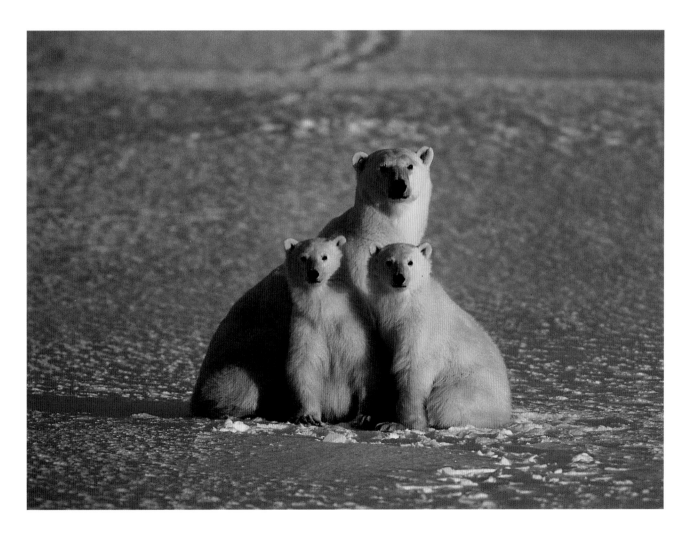

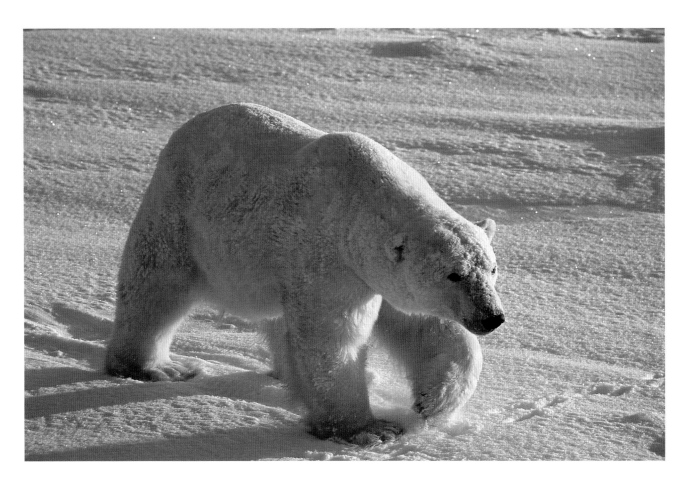

Coat, and Crooked Tail. Any discussion among the hunters about their plans or the bear was often couched in riddles. Furthermore, the subjects were rarely mentioned in front of women for fear that one of the hunters' wives might be capable of transforming into a bear, endangering them all. The words "hunt" and "kill" and direct mention of the bear's den or tracks were also avoided. Not only did the bear hear everything but it remembered any disrespectful behavior and punished the guilty party.

Richard Davids, in *Lords of the Arctic*, tells of the experience of McGill University professor George Wenzel, who accompanied Inuit friends on polar bear hunts in 1979. Almost all the hunters cautioned Wenzel that ridiculing or belittling a bear during a hunt would bring bad luck. Once, when Wenzel absentmindedly commented that a bear had been foolish not to run until the snow machines got close, two of the men stopped their work of skinning the bear and asked him not to speak that way. Days later at Resolute Bay, while Wenzel was drinking tea with a group of families, the chief commented to Wenzel on the incident, saying that he thought Wenzel would have known better. However, the chief said, it probably wouldn't have a serious effect since Wenzel wasn't an Inuk.

Before a hunt could commence, a bear had to be found. Polar bears were tracked down on foot, often with the help of dogs; they might also be lured in by the hunter with seal blood or pieces of blubber. Brown bears and black bears were often killed in their dens in

winter or early spring. By using this strategy, hunters knew the location of their quarry ahead of time and had the advantage of surprising a groggy bear rather than taking on an alert, and more dangerous, foe. Hunters found dens by following bear tracks in late fall or, more commonly, by searching in winter for good denning habitat and looking for signs such as bits of grass on the snow or discolored snow near a den entrance. In some cultures, including the Munsee-Mahican group of the Algonquians, someone dreamed of the den location and described it to the hunters, enabling them to find the specific bear they were meant to kill. Some of the Cree people of Canada said that it was *Memekwisiw*, Spirit Master of the Bears, that visited a hunter in a dream to reveal a den's location.

A final important piece of preparation was the hunters' selection of weapons. Before the arrival of guns, the choices were few and primitive—all, except bows and arrows, required the hunter to get very close to the bear. However, even after guns were available, they were often avoided as being not "right for" or worthy of the bear. Axes and clubs were the weapons of choice for many people. The hunters dispatched the bear with a blow to the head as it emerged from its den. The Iroquois believed that using a war club this way was the only acceptable method of killing a bear. The Cree preferred fighting a bear hand-to-paw using a club, axe, or spear. The Carrier people of central British Columbia and others used spears, while the Penobscot of Maine told of their earliest bear hunters, working in groups of three or four, using knives lashed to poles. Tlingit hunters sometimes used bows and arrows to kill bears but they also had a special spear used in war or for hunting bears. This consisted of a six- to eight-foot-long hemlock or spruce shaft tipped with a double-edged blade made of slate, native copper, or, when it became available, iron. A guard at the base of the blade kept it from piercing the bear's body too deeply, and so kept the hunter out of range of the bear's claws. The spears that Inuit hunters used for polar bears were similar: five- or six-foot-long shafts tipped with jade, copper, or perhaps a flake of meteoric iron.

The people who would remain at home during the hunt might also have responsibilities. In some cultures, such as that of the Tlingit, it was important that a hunter's wife and children behave properly while he was hunting. Otherwise, they could bring him bad luck or even cause his death. Eventually, when all had completed their spiritual and physical preparations, the hunters were ready to seek their quarry.

TAKING A BEAR'S LIFE

How did ancient peoples reconcile respecting the bear with killing it? At least part of the answer lies in the fact that many cultures believed the bear was, or would become, a willing sacrifice if treated properly. One aspect of this belief appears in the dream revelations of den locations: the bear hunt was ordained by a higher power. Viewing the bear as a willing victim helped to assuage the discomfort that people felt about killing an animal that many considered a relative or at least a powerful fellow member of their spiritual community. Rituals surrounding the death of the bear made frequent references to the hunt's sacrificial nature, and emphasized the people's respect for the bear and its spirit.

You were the first to die, greatest of beasts.
We respect you and shall treat you accordingly;
No woman will eat your flesh,
No dog insult you.
May the lesser animals all follow you
And die by our traps and arrows.
May we now kill plenty of game.
May the goods of those we gamble with
Follow us as we leave the play,
And come into our possession.
May the goods of those we play lehol with
Become completely ours,
Even as a beast that we have slain.

—Bear Song of the Lillooet Indians of British Columbia, chanted over the slain bear

In some cultures, the hunters' journey to the den was a formal ceremony. Lapp bear hunters traveled in a solemn procession, led by the man who had located the bear. He carried a pole tipped with a ring made of brass, the sacred metal of the Lapps. Next came a "sorcerer" accompanied by the man who would actually slay the bear. Other dignitaries followed, including those carrying materials necessary for the rites that would follow the killing.

Among the people who hunted the polar bear, there was little, if any, formal ceremony immediately preceding the kill. The hunters had to approach the bear in the open and kill it with a spear or harpoon, without being killed themselves. Charles T. Feazel, in *White Bear*, describes the techniques these intrepid men used:

> When the bear reared up on its hind legs, the Inuk would strike. Or the hunter might stand like a matador, stolidly facing a charging bear. At the last possible moment, the Inuk would thrust his spear into the bear's neck and leap to one side. Another hunter, using a slightly longer spear, might calmly face Nanook's headlong rush or rearing fighter's stance, plant the butt of his weapon in the snow, and impale the bear as it charged. Although this incredible one-on-one with a creature standing ten feet tall on its hind legs is a mark of Inuit manhood, no Inuk would claim it as unusual bravery—it is simply the way you hunt bears.

For many bear hunters, rituals began when they arrived at the den with the ceremony of calling out the bear. Several groups, including the Shasta, Carrier, and Thompson in western North America, and the Malecite (Maliseet), Abenaki, Penobscot, Montagnais-Naskapi, and Micmac in northeastern North America, made a speech to the bear, asking it to come out and be killed. In *Giving Voice to Bear*, David Rockwell describes the scene as a Cree hunter reached the den, and waited outside with his club ready:

> "Grandfather, it is already warm! Time for you to come out now." If the bear did not come out, he called to it again, "Grandfather, I've found you so show me your head!"

If the bear refused to answer to "Grandfather," the hunter would try "Grandmother." He would poke the bear with a pole or throw sticks into the den. Eventually, the bear would rouse itself and begin to growl. The hunter continued to ask the bear to come out and allow itself to be killed. When the bear finally charged from the den, the hunter struck it hard on the head with his club. If he was lucky, the bear died at once. If not, the hunter had to hit the bear again and again until it was dead.

The number of hunters involved in actually killing the bear depended on both custom and circumstance. Hunters might work in groups but in many cases the hunt came down to

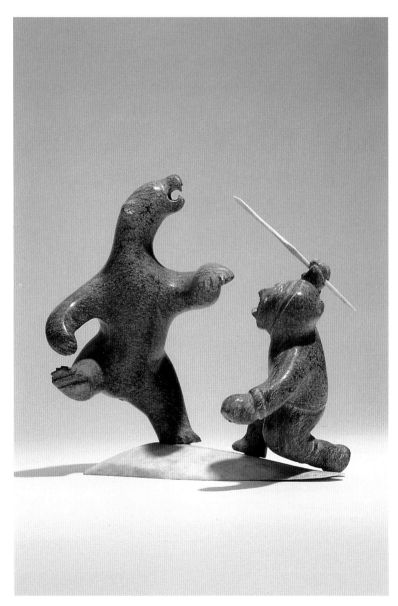

Bear and Hunter
John Kaunak created this contemporary sculpture.

an encounter between one man and one bear. This was sometimes the hunter's choice because many believed one could obtain great power by killing a bear single-handedly.

Once the bear was dead, a number of things might happen immediately. If the bear was killed inside its den, the Koyukon people pulled it out by hand, never using a rope or a chain. Then they slit its eyes so that the bear could not see the men around it as they began to cut up the carcass. If Pueblo hunters were hunting as a group, the first person to touch the bear was considered to have killed it, whether he actually did or not. The second person to touch it became his "brother," and the two were bonded in a special, lifelong relationship.

Many people apologized to the bear, explained the reason for its death, and asked its spirit to speak well of them. An Abnaki hunter might say, "I have killed you because I need your skin for my coat and your flesh for my food. I have nothing else to live on." An Ottawa hunter might ask the bear's forgiveness while offering compliments: "Do not leave with an evil thought against us because we have killed you. You have intelligence and can see for yourself that our children are starving. They love you. They wish you to enter their bodies. And is it not a glorious thing to be eaten by the children of chiefs?" The Lapps thanked the bear for allowing itself to be killed without breaking their weapons and without harming them.

As well as apologizing to the bear for having to kill it, some people tried to shift the blame entirely by telling the bear that they were not the ones who killed it and naming a scapegoat. Blame-shifting was common in Siberia, where a typical example might go something like this: "Do not blame me, Grandfather; it was the Russians (or any European) who killed you through me. I am truly grieved, do not be angry with me."

Some people asked for power from the bear. The Shuswap people, living on the northern part of the plateau between the Rocky Mountains and the coast ranges, chanted over the dead bear:

> O thou greatest of animals,
> Man among beasts,
> Now my friend,
>> Thou art dead!
> May thy mystery make all the other animals
> Be like women when I hunt them!
>> May they follow thee,
>> And fall to me
>> Easy prey!

Ket hunters, whose bear rituals retained ancient elements, goaded the bear from its den and killed it with an axe-blow to the head, taking care not to spill any blood onto the ground. The hunters asked the bear not to be angry and invited it to be their guest at the coming

Now you have come to take pity on me so that I may obtain game, that I may inherit your power of getting easily with your hands the salmon that you catch …

—Kwakiutl hunter's prayer
to a slain grizzly bear

Hunter Killing Bear

Sculpture by George Kopak Tayarak depicts the courage required of the Inuit hunter who wishes to kill a polar bear face to face.

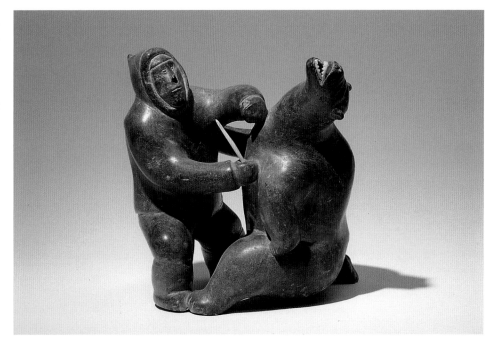

A Medicine Man's Story

Needing a bearskin in my medicine-making, I went, at the season when the leaves were turning brown, into the White-Clay hills. All the thought of my heart that day was to see a bear and kill him…. Coming suddenly to the brink of a cliff I saw below me three bears. My heart wished to go two ways: I wanted a bear, but to fight three was hard. I decided to try it, and, descending, crept up to within forty yards of them, where I stopped to look around for a way of escape if they charged me. The only way out was by the cliff, and as I could not climb well in moccasins I removed them. One bear was standing with his side toward me, another was walking slowly toward him on the other side. I waited until the second one was close to the first and pulled the trigger. The farther one fell; the bullet had passed through the body of one and into the brain of the other. The wounded one charged, and I ran, loading my rifle, then turned and shot again, breaking his backbone. He lay there on the ground only ten paces from me and I could see his face twitching. A noise caused me to remember the third bear, which I saw rushing upon me only six or seven paces away. I was yelling to keep up my courage and the bear was growling in his anger. He rose on his hind legs, and I shot, with my gun nearly touching his chest. He gave a howl and ran off. The bear with the broken back was dragging himself about with his forelegs, and I went to him and said, 'I came looking for you to be my friend, to be with me always,' Then I reloaded my gun and shot him through the head. His skin I kept, but the other two I sold."

— Bear's Belly, Arikara Medicine Man
as recorded by Edward S. Curtis in 1908

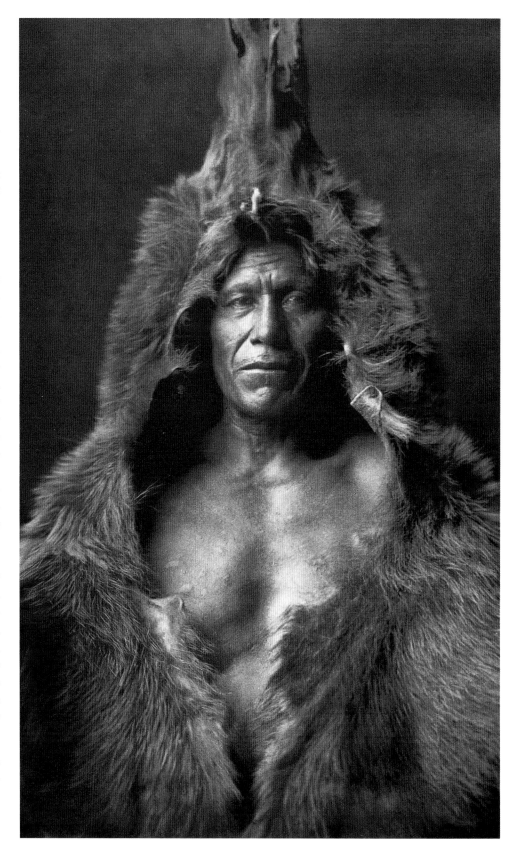

celebration. The right front paw of the bear was cut off and used to determine which particular dead man's soul this bear contained. To do this, the men threw the paw into the air three times and asked a question each time. If the paw fell palm up, the answer was "yes." First, the men determined to which clan the soul belonged. Then they looked at the carcass for some mark, such as a scar, that reminded them of someone. Once they determined who the bear was, they asked how many days their guest would stay, thus determining the length of the feast to be held. After the questioning was over, the powerful right paw was kept as a special talisman.

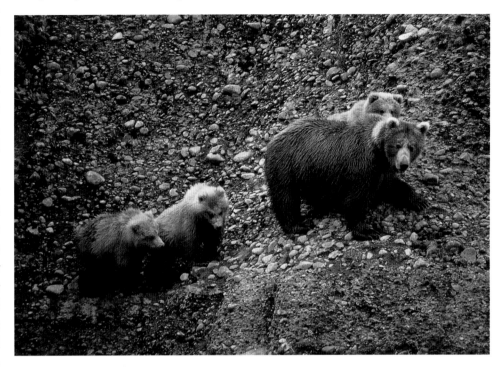

Next, Ket hunters cut up the rest of the bear on the spot. The cutting was done in a specific manner, beginning by opening the carcass with a slit from the throat down. This reversal of the procedure normally used on game was used by many people to show special consideration for the bear. The bear was skinned, and the head removed from the body. The men removed the internal organs from the carcass, and burned the bowels, lungs, and stomach. Among the Kureika Ket, according to E. A. Alekseenko, a piece of the bear's heart was dipped in blood and given to a boy, who said as he ate it, "You are strong, my father who brought you down is stronger than you; I shall be still stronger, my heart will be stronger than his ..." The rest of the bear's body was cut apart—the ribs, shoulders, and back had to be taken out intact because cutting of any of those bones was not allowed. When the cutting was done, the rest of the bear's heart, the liver, and some fat were cooked in a copper kettle over a fire that was built for the purpose. Each hunter ate a piece of heart and liver, and took three pieces of fat with him when the men dragged the now-dissected bear home.

After a Cochiti Pueblo hunter killed a bear, he built a fire near the carcass. The other men of the pueblo saw the smoke and staged a mock attack on the spot, uttering war cries as they approached. On arriving, each man struck or shot the bear. Following the attack, all left for the village, singing war songs as they went. The man who killed the bear carried its skin. By this time the paws and forelegs of the bear had been removed and presented to the medicine men. The left paw and forearm, believed to be the most powerful, went to the medicine man who had arrived first.

The group moved through the village in a specified pattern, singing. Women struck at the skin and threw corn meal onto it. The killer gave the skin to one of the medicine societies to clean. When it had been properly cared for, the bear skin would be returned to him.

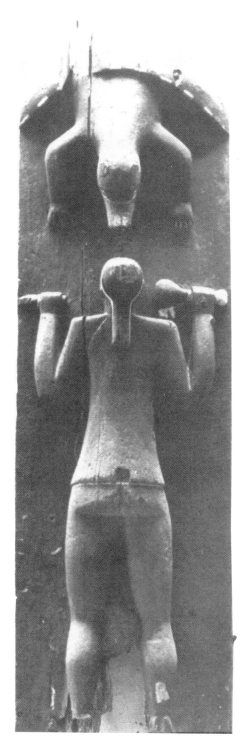

Coast Salish House Board

*This Coast Salish house board shows
a hunter approaching the bear in its den.*

Everyone who went to meet the hunter received some of the bear meat, which had to be cooked and eaten immediately. When a person had eaten bear meat, he made black marks under his eyes with charcoal. These marks remained until the bear skin had been cleaned and returned to the hunter.

The bear's bones were carefully disposed of either by throwing them into the river or by placing them in certain shrines. The bear's skull was buried as an offering.

The basic pattern of events at Cochiti after a bear was killed—procession, feast, disposal of remains—was common. In some cultures, however, the rites were far more elaborate.

RITES FOR THE SLAIN BEAR

When the hunters carried the bear's body into the village, the women might greet them with songs and dance, as many of the Siberian peoples did. They also sometimes sprinkled the hunters and bear with snow or water in a joyful purification rite. Lapp women spit alder-bark juice through a brass ring onto the hunters and the bear. They also sprinkled this juice onto the bear, hunters, dogs, reindeer pulling the sledge carrying the bear, the tent or hut where the bear would be skinned, and, later, on any children who carried the women's portion of the meat to them. Alder-bark juice protected the people from any baneful powers that might be lingering near the bear.

Among other peoples, there were different reactions to the bear's arrival. Mistassini Cree women covered their faces in the bear's presence. Micmac women and children fled as the men carrying the bear approached the lodge where further rites would be held, and did not return until the men had entirely consumed the bear's flesh. In many cultures, women were forbidden to eat bear meat or could eat only certain parts of the bear. Dogs were rarely, if ever, allowed to touch either the bear's meat or its bones, as it was considered disrespectful. It was a capital crime for a dog to steal a bone when the Lapps were cutting up a bear: the dog had to surrender a bone from its own body in restitution.

Arctic peoples believed that the polar bear's *inua*, or soul, was more powerful and dangerous than that of any other animal. It was customary to make several passes over the bear's carcass with the skinning knife, allowing the inua time to prepare itself, before making the initial cut. For five days after a female bear was killed (four days for a male), the bear's inua lingered on the tip of the hunter's spear where it remained a danger. To prevent the bear's spirit from becoming "crooked" or evil, people did no work inside the house and hung the bear's skin outside, surrounded by tools. If the bear was female, women's tools such as sewing equipment and skin scrapers were used. For a male bear, knives, harpoons, and other men's tools were carefully set out. The people also placed offerings to the bear's spirit on the skin. The dances and gift-giving ceremonies that followed a successful bear hunt might continue for more than a week.

In other cultures, the bear might be butchered immediately, with perhaps just the head or skin used during ceremonies, or the entire carcass might be kept intact until later. Often, the entire carcass was brought indoors, but the ordinary door was not considered appropriate

for this purpose. Instead the bear entered through a specially-made door, or in the case of the Gilyaks (Nivkh), through the smokehole of one of their mainly underground homes.

The next step in many cultures was for the bear carcass, or skin and head, to be placed before the hearth and decorated. The Ojibwa people placed silver and wampum on the bear's head. The peoples of Labrador used feathers, beads, and vermilion pigment to decorate both the head and paws. The Assiniboin also decorated the head. Among some of the peoples of the Pacific Northwest, the bear's head and skin were laid out to rest in state as a chief's body would have been. The head was sometimes painted with red ochre or had eagle down placed upon it.

Several peoples ceremonially fumigated the bear. In the forests along the upper Ottawa River in Canada, Algonquin people smoked tobacco over the head after placing some between the bear's teeth, and later smoked over both the head and skin. Among Siberian peoples, it was common to cense the bear using smoke from smoldering birch tinder and beaver skin.

Rather than decorating the bear itself, some Ket drew an image of the bear on birch bark and adorned that with bits of copper representing collars and bracelets. Another piece of birch bark was fastened over the first and the whole thing placed in a freshly painted chest near the entrance to the tent where the celebration was being held, with the bear's head pointing outward. The bear's snout—nose, lips, and a piece of skin from the forehead—was placed in front of the birch bark effigy. The bear's gallbladder, and sometimes its eyes and penis, were placed behind the birch bark. Also in the chest was a ring formed from a peeled cedar twig; hanging from it were bits of fish glue, a piece of the bear's tongue, a small piece of copper, and a small bunch of twigs (the "bear's ribs"). The copper was given to the bear to solder its bones back together and the glue to reattach its flesh.

Before the feasting began, Ket hunters took turns telling the story of the hunt and imitating the bear. All the while they held the bear's snout in front of their face like a mask. Again and again, the snout was warmed over the fire and handed to the next man. When every hunter had performed, the men asked the bear to give them success in hunting, and freedom from illness and bad luck.

Throughout most bear ceremonies, the bear was treated as an honored guest who had to be fed and entertained. Songs were sung, dances were performed, and through it all, the spirit of the bear looked on. When feasting began, food and drink were often set before the bear.

The act of eating bear meat had its own set of rules. The parts of the bear were often cooked and served in a particular order. Who could eat what was usually rigidly specified. In some cultures, the feast atmosphere was solemn, while in others it was more festive. In many cultures, bear meat required an "eat-all" feast—every morsel of the meat had to be consumed before the feast could be concluded. Even when this was not the case, bear meat was never thrown away.

When the feasting was done and the ceremonies near their conclusion, people continued to take care not to anger their departing guest. Sometimes a Siberian bear feast ended

Now you have come to take pity on me so that I may obtain game, that I may inherit your power of getting easily with your hands the salmon that you catch …

—Kwakiutl hunter's prayer to a slain grizzly bear

Effigy Pipe

A bear waits to gaze back at the smoker who uses this Eastern Ojibwa maplewood pipe bowl.

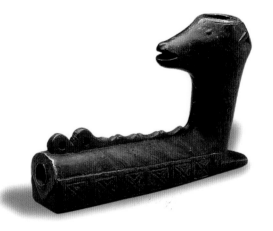

129

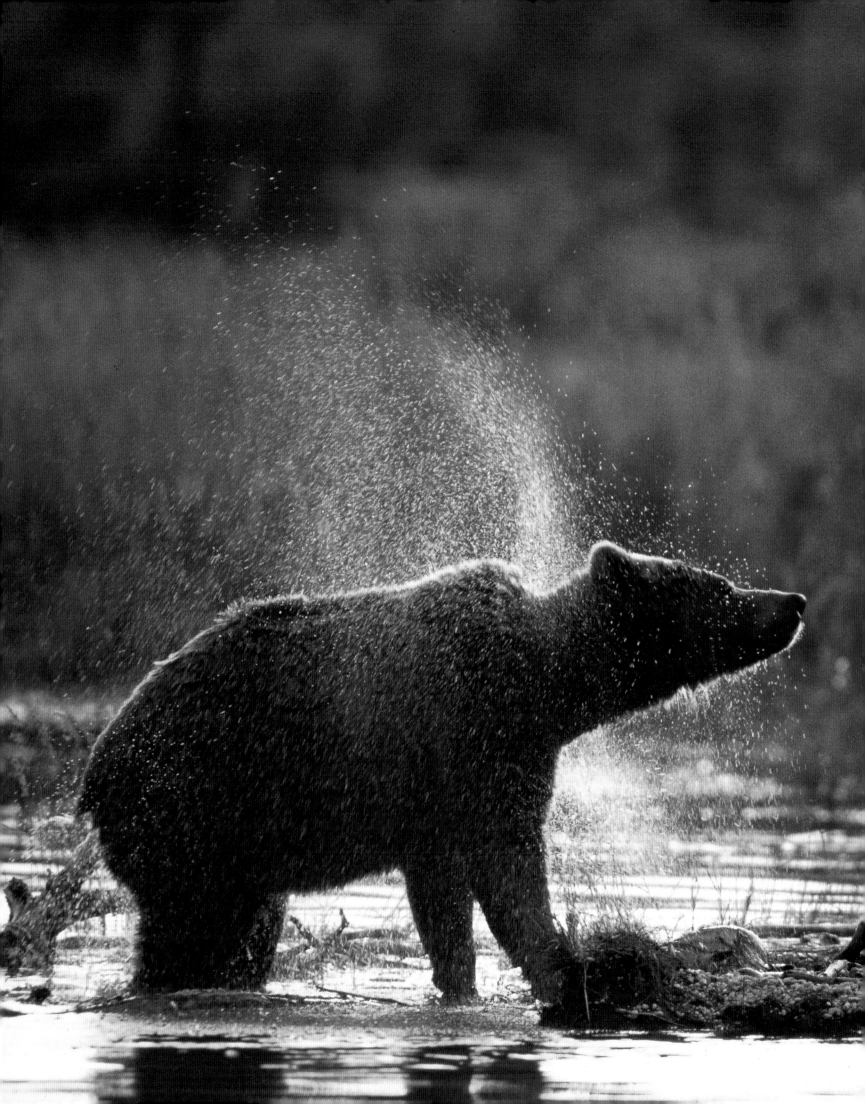

Animals are a part of a natural order that includes man, and the differences between them lie chiefly in outward form. Animals are motivated as men are motivated, live in societies as men live, act as men act, and their destinies are intertwined. Their value is symbolized in many ways in myth, ceremony, names, belief, taboo, and casual conversation. It is around the bear, however, that these attitudes have clustered and reached their fullest expression.

— Joseph B. Casagrande
"Ojibwa Bear Ceremonialism: The Persistence of a Ritual Attitude" in *Acculturation in the Americas*

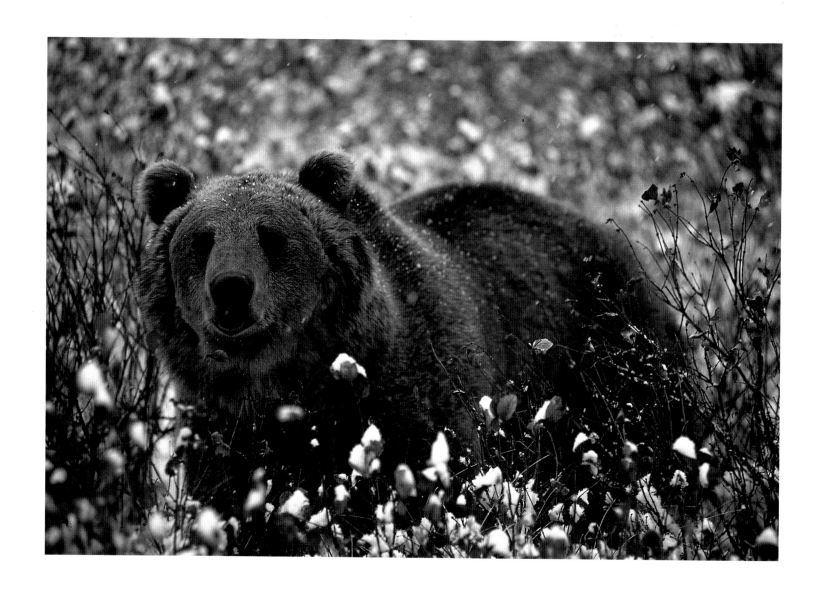

When confronted by a bear,
the Indian cannot be sure if the bear is a man
in bear form or vice versa.

—Joseph Epes Brown, *Animals of the Soul*

with a snowball fight in which even the bear got a face full of snow as it was being carried from the house. This mock blizzard was probably intended to divert the bear's attention from the fact that the feast was over and it was leaving, which might have displeased it.

Throughout the preparation and consumption of the bear meat, people tried very hard to avoid damaging any of the bones. The intact preservation of the bear's bones, along with the Ket's gifts to the bear of copper and glue, was important because of the belief that the bear would be reborn. If the people did anything to hinder this process, it would displease the bear and bring about misfortune. Therefore, when the feasting was over, the bear's bones were disposed of carefully, usually by burying them. Belief in the bear's reincarnation was probably another key to resolving any conflicting feelings about killing the bear.

The honors paid to the bear were often concluded by either hanging its skull from a pole or tree, or placing it in some other type of shrine. In *Native American Myths and Legends*, Bill Sheshekwin, a member of the Chippewa (Ojibwa) people, gave a brief but telling description of past practices:

> Back in the old days, Indians would hang up a bear's head after it was killed.... They thought the bear was something very special. They thought highly of the bear and decorated it with ribbons, gave it tobacco, and hung the bones up in a tree.

As we have seen, many early people "thought the bear was something very special." When they killed it, they went to extraordinary lengths to ensure the bear's spirit forgave them and carried only good words about them home to the spirit world. They maintained a respectful and conciliatory attitude towards other, more common, prey animals as well. To these people, it was a logical thing to do because of the close relationship between humans and other animals.

It is very difficult to imagine the amount of courage it must have taken to go after a bear, particularly a grizzly, armed only with a spear or an axe. Yet some people risked their physical and spiritual safety on a regular basis, believing that the chance to share the power of the bear was worth the dangers involved. For some people acquiring the bear's power was not merely desirable—it was essential if the cycle of life was to continue.

Tlingit Clan-emblem Hat

The animal portrayed in this beautiful hat has been identified as a bear because of its upraised paws. As with many artifacts, however, we may never be certain of its true identity or meaning.

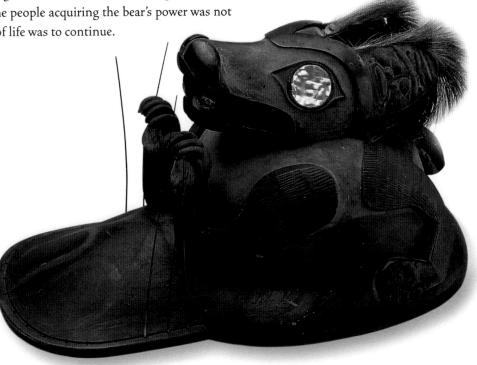

CHEROKEE BEAR BROTHERS

In the far distant past, a terrible famine nearly destroyed the Cherokee people. After scouring the forests for food and coming up empty-handed, the elders called everyone together. "This may be the end of our people," they said, "for there is no food to be found. Go home to be with your clans."

There are only seven clans now but at that time there were eight. After the people had come together in their clan towns and talked about the problem facing them, the eighth clan came to speak with the elders. "We have come to offer hope and a solution for our people's hunger. We will die so that our brothers and sisters may live," they said and walked away into the forest. When they returned several days later, it was nearly impossible to recognize them. They walked on all fours and their bodies were covered with long black hair—they had become bears. The remaining people killed them and ate them, giving thanks.

It was difficult for some people to kill the bears. One hunter, finding a bear family in the woods, said "I cannot kill you. You are my brothers." The bears walked up to him and said, "Do not worry. You are meant to kill us. You will eat our bodies but our souls will return to the Upper World to be given new flesh. Then we will return so that we may nourish you again."

That is why when hunters kill a bear, they kneel beside the slain animal and say, "Thank you, my brother."

— A retelling of a Cherokee myth from
Native American Myths and Legends

SHARING THE POWER
OF THE BEAR

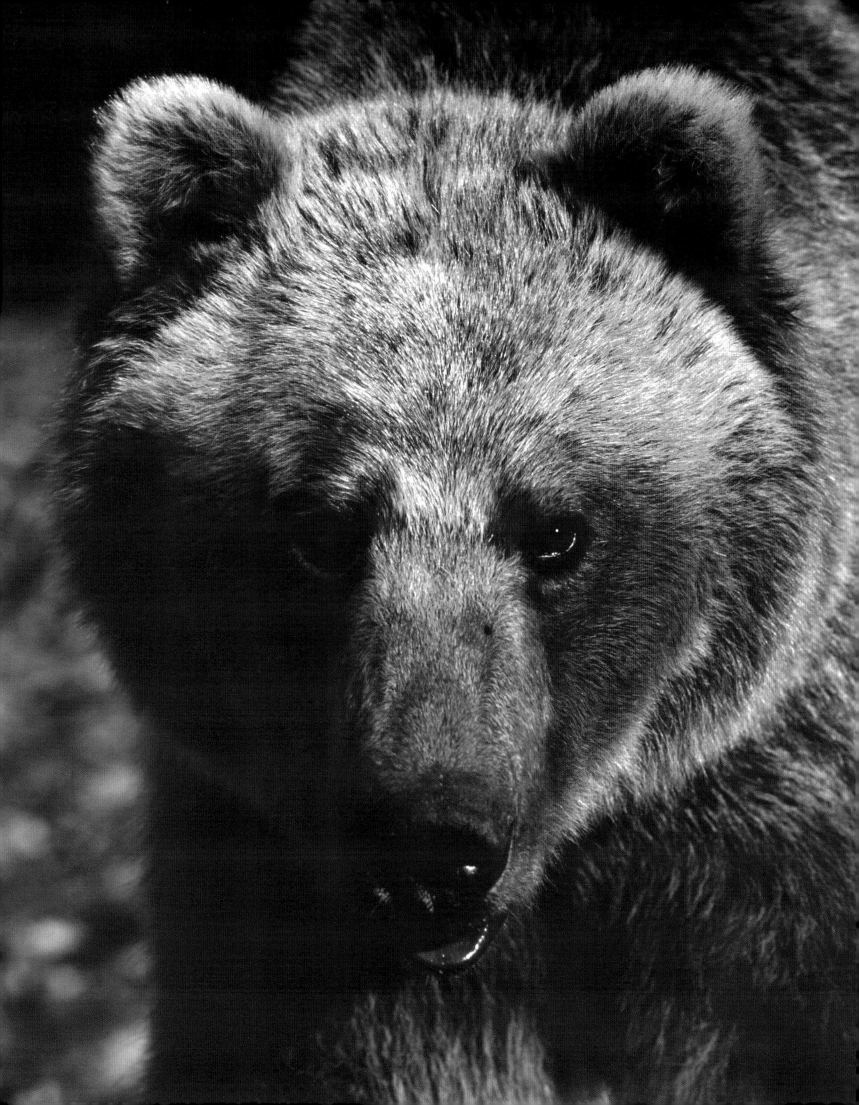

A dancing grizzly-bear spirit ... gave me songs and the power of beholding a holy thing: he gave me his claws, claws that are holy.

— *Words of a Winnebago (Ho-Chunk) shaman*

The power to heal injury, the ability to hunt successfully—we have seen that early people believed they could acquire these capabilities from bears by performing the proper rituals. They believed bears possessed other powers and properties, which they sought to share also.

Long ago, thirty warriors traveled to the country of their enemies. Each evening during the journey, one of the warriors cast an offering of tobacco into the fire saying, "I challenge whatever will fight me to a contest." The chief of the party rebuked the man, "Do not make such a rash challenge. We do not wish to encounter any unnatural creatures." The warrior ignored this advice and continued his prayers and offerings for ten evenings.

On the morning following the tenth night, the party had just resumed traveling when an enormous grizzly bear came charging towards them. The warrior who had issued nightly challenges sat and watched as his comrades shot arrows at the bear. The bear merely swatted the arrows aside, becoming more and more enraged. The warriors prepared to flee but the one who had wished for a fight announced that he would battle the bear alone.

After the other warriors had reached a safe vantage point, the man stepped into the path of the great bear. As the beast drew near, it seemed puzzled by the warrior's lack of fear. Finally, the bear sprang forward to seize the man. The warrior dodged the bear's claws and sprang onto its back. He hammered the bear's head and back with blows of his hatchet, quickly killing the animal.

The other warriors returned and their victorious friend told them, "You must all take 'medicine' from this bear because it is large, enchanted, and very, very old." They cut up the bear and each man took some of its bones before burning the rest of the bear to ashes in a fire they built on the spot. As each warrior picked up his "medicine" bones, he made a request, saying "May I be a good hunter," or "May I be a good swimmer," or "May women love me," and so on, depending on each man's desires.

They say the man who asked for the love of women got far more than he wished. Women peered into his windows and doors, and whenever he left his house they seized him and embraced him, each woman wanting to have him all to herself. Eventually, they literally tore the man to pieces in their struggle to possess him.

— *A retelling of "The Grizzly Bear," an Iroquois legend recorded by anthropologist John Napoleon Brinton Hewitt*

Killing the bear was one method of obtaining its powers. In some cases, however, the death of the bear was not just a means to an end, but the essential culmination of ceremonies that reaffirmed and renewed the ties between heaven and earth.

THE CELESTIAL BEAR COMES DOWN TO EARTH

In the firmament is the visible form of the celestial bear, the constellation of Ursa Major; on earth, the bears of the forest. The sky bear is eternal, the earth bears perish or are killed by men and return in spirit form to the realm above, whence they descended when born in their dens. And among them was one, who, each year, was destined to become a vicarious sacrifice to attest the devotion of men to the creed of their ancestral priesthood.

— Frank G. Speck and Jesse Moses describe the essence of the Munsee-Mahican Bear Ceremony, from "The Celestial Bear Comes Down to Earth"

In the scenario which took in sky and earth moved the dramatic actors which never ceased playing their eternal parts, whether as living or spiritual entities. Among those actors were the bears.

— Speck and Moses "The Celestial Bear Comes Down to Earth"

The Munsee-Mahican Delaware people once lived in what are now Pennsylvania and New York. Each year in late January or early February, they celebrated the most important event in their annual ceremonial cycle. The Bear Ceremony was a world renewal rite, which confirmed the unending unity of all beings and reinforced the relationship between earth dwellers and those who inhabited the sky. The Munsee-Mahican saw the Great Bear, *Ursa Major*, as part of a cosmic hunt very similar to that spoken of by their neighbors, the Iroquois. Each year, they believed, the celestial bear came to earth and assumed the form of an earthly bear. When they sacrificed this special bear, its spirit served as their messenger to the Supreme Being and the spirit world. They performed the sacrifice inside the Big House.

The Big House was a large rectangular building measuring approximately 15 by 9 meters (50 by 30 feet) with the long axis lying east to west. This structure represented the universe: its dirt floor was the earth; its ceiling was the sky; its four walls were the four directions. The center pole, fashioned from a whole tree trunk, symbolized the mythical world tree that stretched from earth to sky. In the same way, the center pole reached from the Big House up to the Supreme Being. There were two entrances to the building, on the east and west sides. Two fires burned inside, at points halfway between each door and the center pole, with a smokehole cut in the roof over each fire. Beside each door hung a carved wooden mask that faced the center pole. At the east door, the mask was white; at the west door, red. On the center pole, hung two more masks: a red one facing east, a white one facing west. (In other words, within the Big House, two white masks faced west while two red masks faced east.) The colors were identified with the two directions, as well as with the twofold nature of the world: life and death; earth and sky; male and female. During the Bear Ceremony women remained on the eastern side of the Big House, while the men occupied the western half. Anthropologist Frank G. Speck described the celestial symbolism of the Big House during the Bear Ceremony:

> The Munsee-Mahican Big House is a sky projection upon earth, specifically the constellation Ursa Major projected upon the floor of the Big House sanctuary. The interior furnishings of the sanctuary and the stations formally occupied by the ceremonial officials correspond to the position of the stars forming the constellation. The acts and movements of the ritual

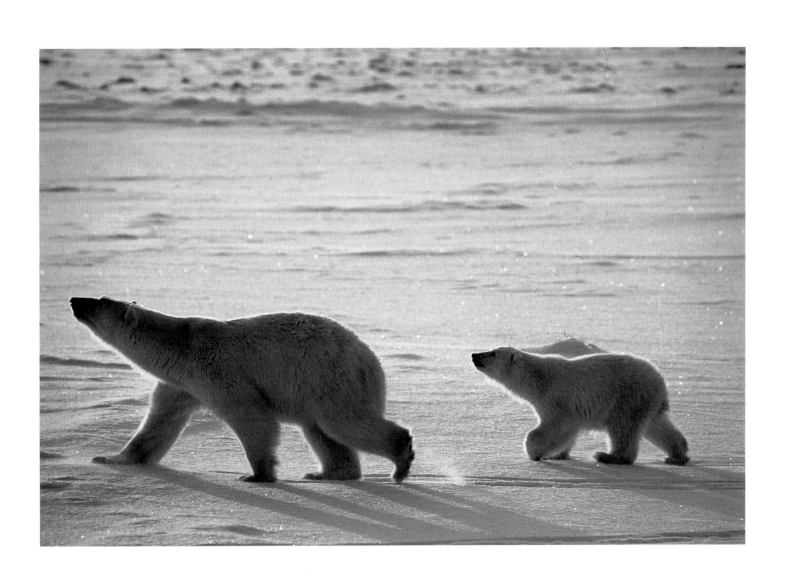

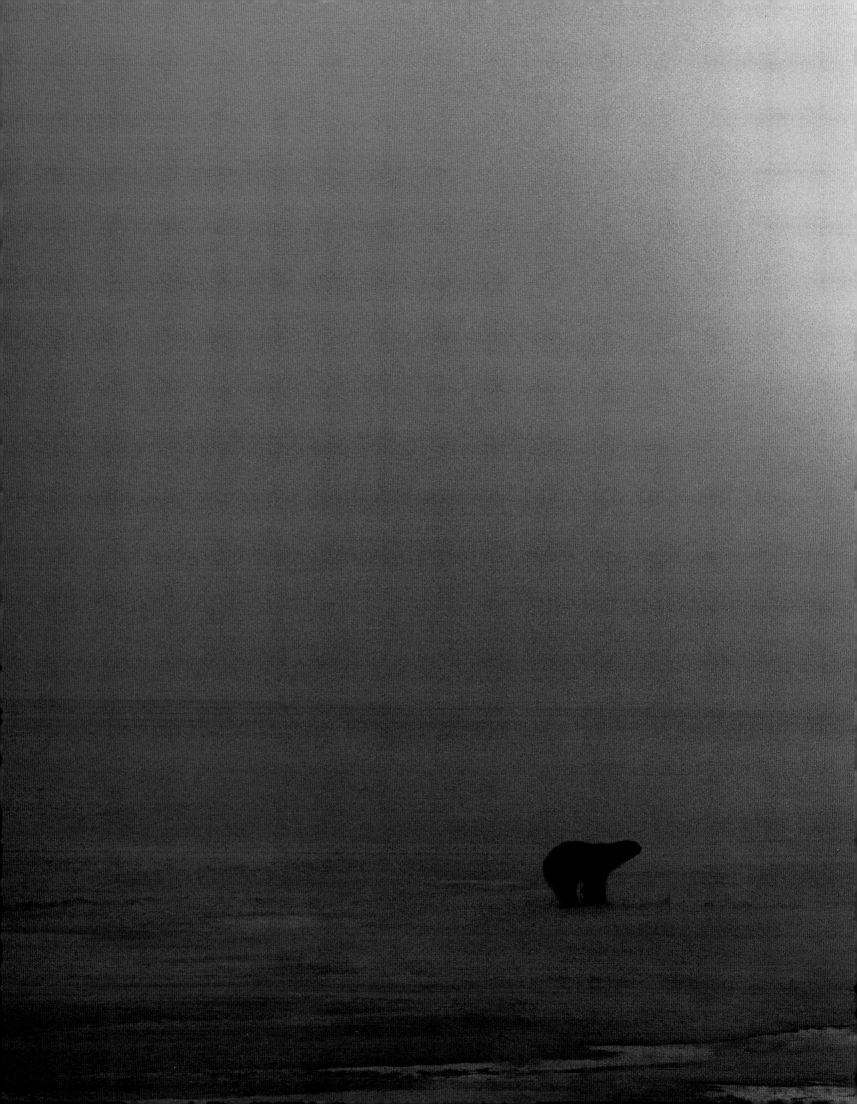

performers parallel the movements of Ursa Major as the events of the annual life cycle of the earth-bear symbolically rotate with those of the Sky Bear ...

This correspondence between the regular movements of the Great Bear and the annual cycle of earthly bears is something we have encountered before, but here it acquired a greater significance. For the Munsee-Mahican people, the Bear Ceremony ensured that both of these cycles, and thus the cycle of life, continued.

Signs in the sky signaled that the time for the festival had arrived. A woman favored by the spirits dreamed of the chosen bear's hibernating place, and conveyed this information to thirteen men who left in the dark to reach the bear's den at daybreak. Outside the den, the men called to the bear, explaining his role as sacrifice in the coming ceremony. After goading the bear from his den, the men drove the animal ahead of them back to the Big House, in through the east door, and to the center pole. There, the chief killed the bear with a blow to the head and, when beginning to skin it, made the initial cut in the opposite direction of that used for regular game. The bear's skin was tied around the center pole beneath the masks that hung there, where it remained until replaced with a new one the following year. The meat was taken to be cooked, and the bones were collected to be burned near the end of the ceremony.

The Bear Ceremony lasted for twelve nights and the bear's meat was served as sacred food each night. The performances that made up the ceremony were held only at night, beginning on the night of the bear's death. Ethnographer Karl Schlesier believes that the reason for holding the rites at night only was so the celestial bear could look down from the northern sky through the smokeholes into the Big House.

Speck wrote that the main reason the Bear Ceremony was not held after 1850 was that the Munsee-Mahican people had converted to Christianity. Schlesier presents a more intriguing, if less pragmatic, hypothesis: "In a world emptied of old symbolism and old physical form, an earth bear, acting under the instruction of a celestial bear, no longer reached a dreamer open to the dream." In a rapidly changing world, the faithful messenger who had traveled from earth to sky for so long could no longer find his way.

Half a world away, however, bears served as spirit messengers for another people—the Ainu of Japan.

Haida Frontlet

Worn on the forehead, this Haida frontlet was a very important part of a chief's regalia. The open cup on top, formed of sea lion whiskers, was filled with eagle down that would spill out as the chief danced, conveying blessings.

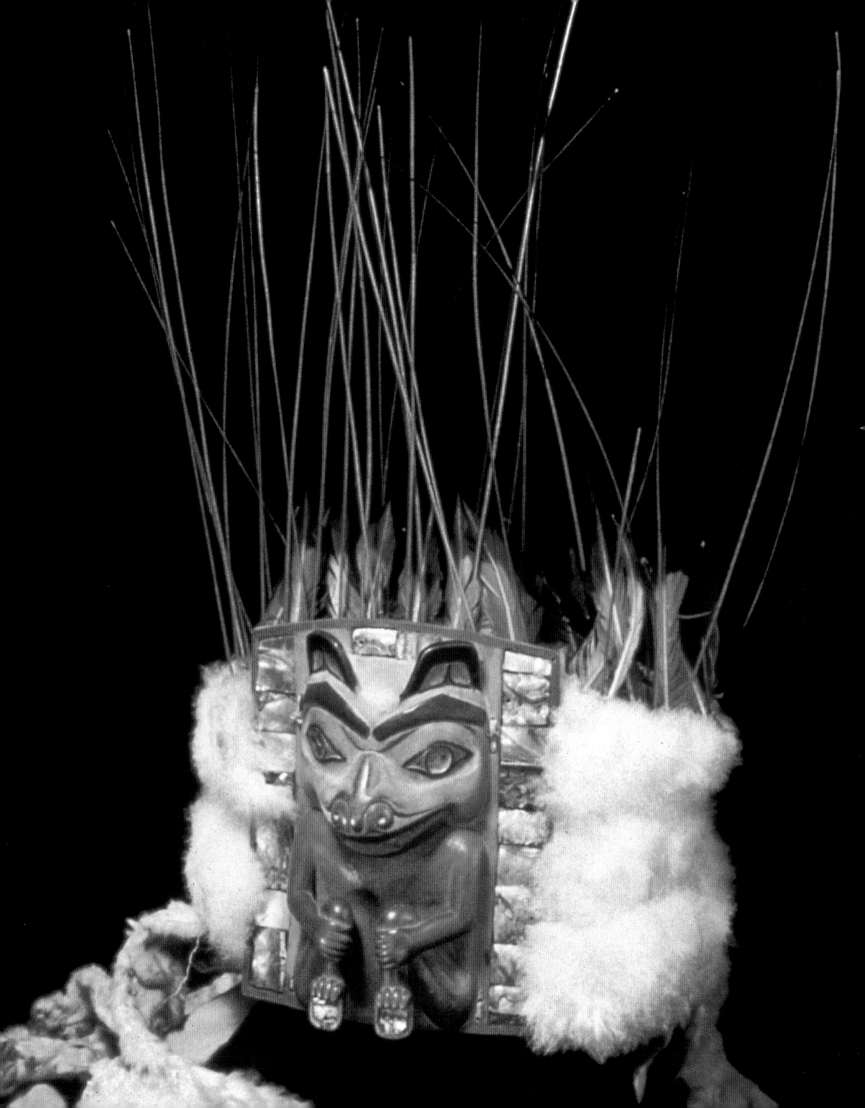

SENDING THE DIVINE ONE HOME

O thou divine one, thou didst come into this world for us to hunt.... We have nourished thee and brought thee up with great pains and care, and all because we loved thee so much. Now, as thou hast grown big, we are about to send thee to thy parents.... Please speak well of us and tell them how kind we have been to thee. We beseech thee to return to us once more, that we may again entertain thee.

—Ainu address to the caged bear at the beginning of the iyomante,
as reported by missionary John Batchelor

The Ainu people once lived on many of the islands around the border of the southern half of the Sea of Okhotsk, north of Honshu. Those living on Hokkaido were the most numerous and best known; their descendents live there today.

The Ainu believed that all living and nonliving things were the earthly forms of visiting gods. Therefore, it was necessary to send these spirits back to their world, after offering them prayers and gifts, and beseeching them to return soon. The Ainu performed these sending ceremonies for each thing that they used or killed, including trees, fish, and broken pots.

To the Ainu, the bear was the *kamuy*, or god, of the mountains. When this god visited the earth it dressed in fur and flesh as a gift to the Ainu. The Ainu showed their gratitude by the manner in which they sent the spirit home. Sending ceremonies performed for bears took two forms: a simple ritual performed on the spot by successful bear hunters after the kill, and the much more elaborate and important *iyomante*.

To begin preparation for an *iyomante*, hunters captured a bear cub. John Batchelor, who spent several years living with the Ainu in the late 1800s, wrote that the honor of hosting an *iyomante* was so great that men willingly risked their lives in order to obtain a cub. The men took the cub back to the village where it was raised as part of the family: nursed, played with, told stories, and taken out of its log cage for exercise.

Details of the *iyomante* varied from village to village but the general pattern of the ceremony was the same. When the bear was judged old enough for its spirit to be sent home, the elders sent word to nearby villages. Women began preparations for the feast while men carved and hung up *inau* (wood curls, carved from a green stick, that probably represented a form of spiritual power).

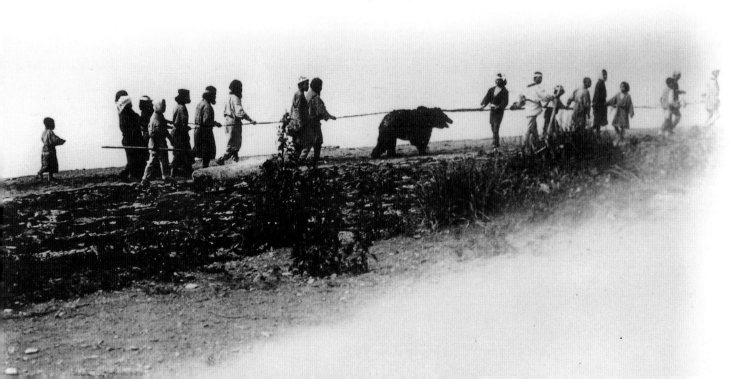

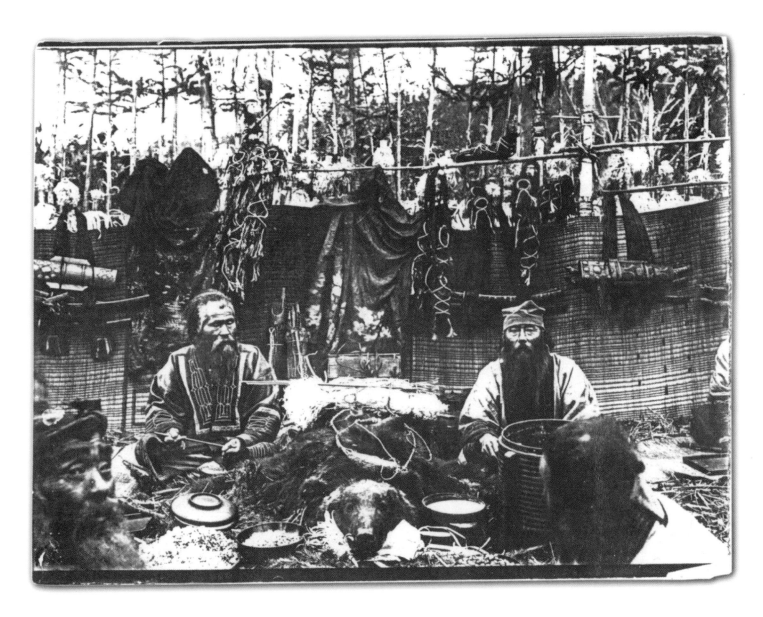

At the start of the ceremony, for which the people dressed in their best clothes, the men made a speech to the bear telling it of its role in the coming ceremony and then took the animal from its cage. They restrained it with leashes as women danced around it, singing "*Kamuy* is leaving. He is going home." Men "shot" the bear with ceremonial wooden arrows; the first arrow was shot by the giver of the feast and had his initials carved on it so that *kamuy* would know his host. The bear became excited or, more likely, enraged, when these arrows hit it. The Ainu believed this showed the bear's joy at returning home.

The men then killed the bear, either by shooting it with ordinary arrows or by placing its neck between two poles and strangling it. The bear was skinned, including its head down to very near the nose, and then beheaded, leaving the head just barely attached to the skin. The head, decorated with *inau*, and the skin were passed through a special window into the house. There, the vestiges of the bear presided as guest of honor at a feast that included its own flesh.

The Iyomante Feast

The bear, represented by its head and hide, is an honored guest at the iyomante feast in this historic photo from Sakhalin Island.

In "The Concepts Behind the Ainu Bear Festival" Kyōsuke Kindaichi writes, "In Ainu belief, there is no god greater than the bear, therefore it is impossible to suppose that they offer it as a sacrifice to a greater god. Killing a bear is a sacred act, by which they let him return to his home, as a god: it is really an act for which the bear should be thankful.

As the ceremony continued through the night and into the next day, *kamuy* was offered prayers and drinks of *sake* by elders along with feasting and entertainment. The Ainu began singing a long heroic epic but left it to be finished at the next *iyomante* as an enticement for *kamuy* to return.

Finally, the Ainu shot a flight of flower arrows to guide the bear's spirit home. Then they adorned its skull, now separated from the skin and stripped of flesh, with *inau* and placed it on a fence-like sacred altar called a *nusa*. The new skull was not alone on the *nusa,* for beside it hung the skulls of bears and other animals who had been guests at earlier ceremonies.

The Ainu believed that by performing sending ceremonies, particularly the *iyomante*, they guaranteed that the cycle of renewal between the earthly world and the spiritual world would remain intact. They also believed, as did many other peoples, that the bear was willing to sacrifice itself for the good of all.

Not every ceremony involving bears and the cycle of life was of such cosmic importance. For some people, life's rhythm, evinced each year in the bear's spring awakening, was an inspiration to dance.

BEAR DANCES

During a springtime long ago a Ute man dreamed of a great bear who had not yet awakened from his winter sleep. Realizing that if the bear did not wake up and eat, it might starve, the man woke the sleeping bear. In gratitude for this act of kindness, the bear took the man to a clearing in the woods where the bears had gathered to dance in celebration of the winter's end. The bears taught the Ute man their dance and when he returned to his people, he shared it with them. Each spring the Ute celebrate the waking of the bears and the friendship between their peoples.

— A retelling of an origin story of the Ute Bear Dance from People of the Shining Mountains *by Charles S. Marsh*

The Ute Bear Dance was traditionally performed over a period of four to ten days in late winter, near the end of February or the beginning of March—about the time when bears usually left hibernation in the Great Basin area. The sponsoring group, who invited others to take part, built a large, round, brush-walled enclosure for the dance and organized the festivities. A specially appointed Bear Dance Chief was in charge of the event.

The dance enclosure, which represented a bear's cave, was usually about 30 meters in diameter (98 feet) and had only one opening in the walls, which were approximately two meters high (7 feet). The all-male musicians took their places on one side of the enclosure. Their instruments were notched sticks or bones, called *moraches*, that were placed on a resonator. In early days, the resonator was a drum or box placed over a hole in the ground; later a sheet of tin on a wooden frame served the same purpose. When the musicians rubbed hard sticks up and down on the moraches, the resonator magnified the sound to produce a powerful rhythm that seemed like many drums beating or many bears growling. With this as accompaniment, singers sang brand new Bear Dance songs and possibly some handed down for generations. The music was meant to awaken the bears from their winter sleep.

Grizzly Bear Dancer's Claws

Claws such as these were worn during the Kwakiutl winter ceremony on the hands of an initiate performer of the Grizzly Bear Society.

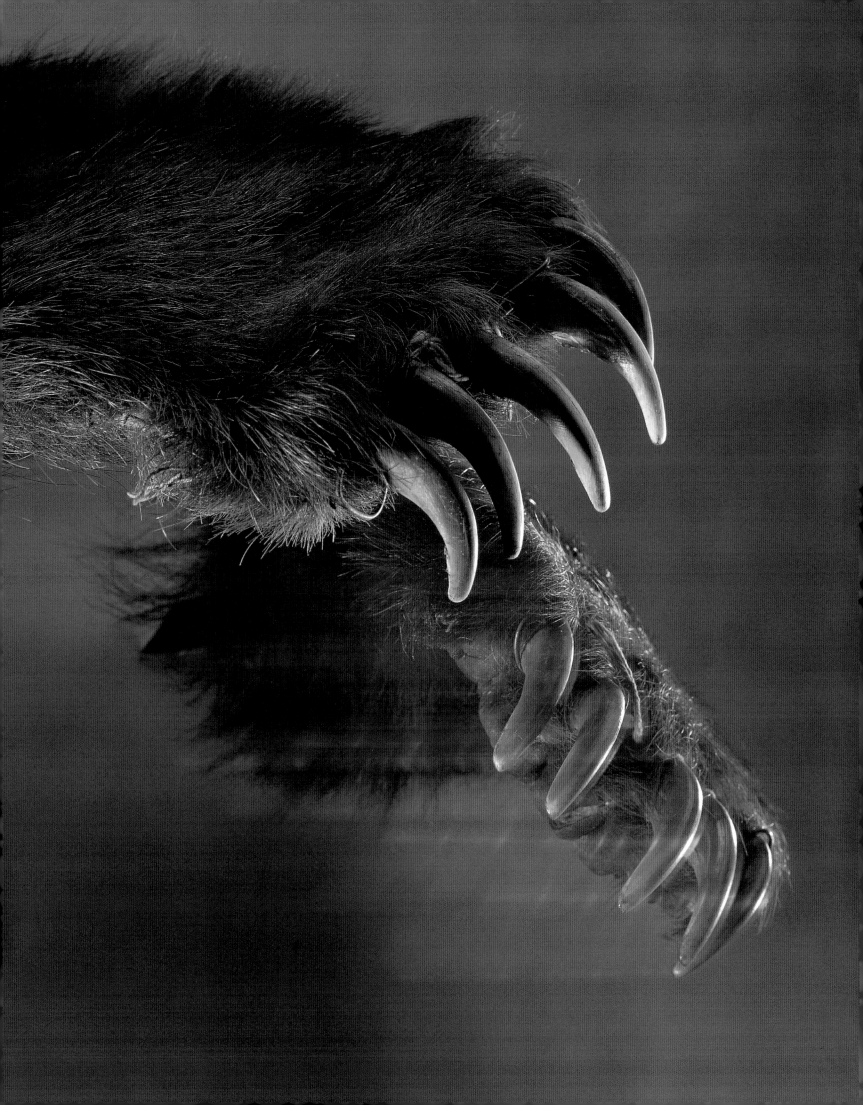

Arikara Medicine Ceremony — The Bears

As the entire fraternity danced, there was evident uneasiness and excitement, and constant watching of the entry-way. A warning shout was heard among the dancers as from the entrance dashed two or three men hotly pursued by two Bears. The dancers fled in every direction, pursued by the Bears, who skilfully simulated the actions of real animals. Even as the Bears chased the dancers, brave individuals tried to slip up behind and strike them with sticks. To succeed in this was regarded as a great deed, since it imparted some of the medicine strength of the Bear.

After a time the Bears returned to the lodge as though it were their den, and the dancers crept stealthily up to the entrance, peeping in, but carefully listening for any movement. Suddenly there was a cry, and out rushed the Bears again, and so great was the apparent fright of the dancers that they fell over one another in their eagerness to escape. This incident was repeated thrice, and then forth came the Bears and two Buffalo, the latter also mimicking the actions of real animals. Four times they appeared together, and then a dancer slipped up and gave the pipe to one of the Bears. With apparent feeling and fear the Bear took a puff at the pipe and emitted a grown of anguish: his power was broken.

—Edward S. Curtis, photograph and ceremony
description from *The North American Indian*,
Volume V, page 74 (1908).

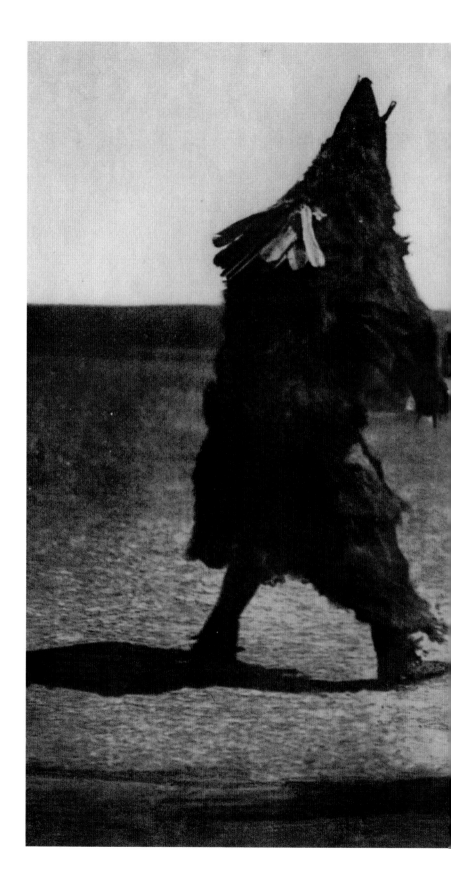

150

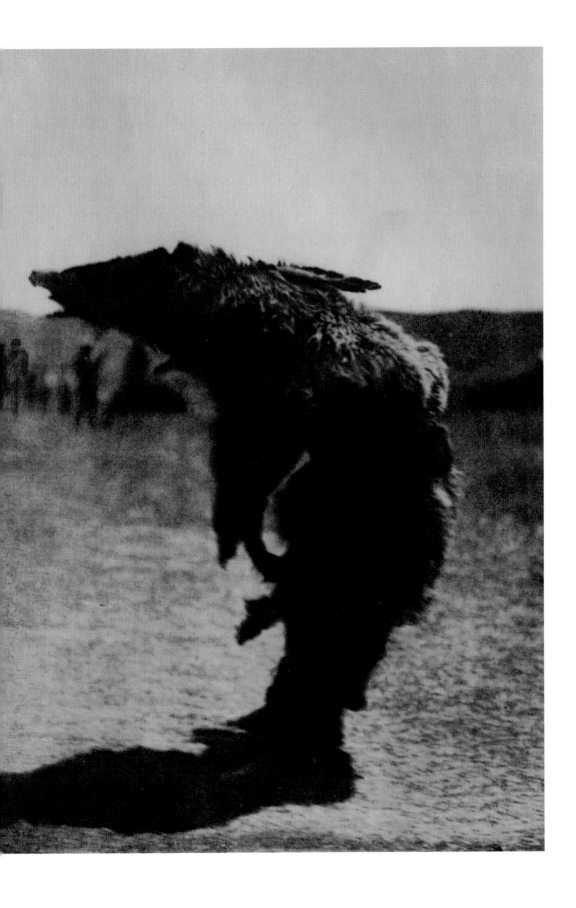

Anthropologist Verner Z. Reed, who witnessed a Bear Dance in 1893, wrote that the Ute people believed that the immortal bears and the people living beside them in the Land Beyond knew when preparations were being made for a Bear Dance, and prepared for a spirit Bear Dance at the same time. Some of the spirit bears visited the sleeping earthly bears to tell them it would soon be time to awaken.

The dancing lasted only a few hours on the first day but continued for longer and longer periods as the celebration progressed. This was done because bears awakened gradually from hibernation, moving sluggishly at first. Inside the enclosure, it was the woman who chose her partner, as the female bear chooses her mate. Anyone inside the enclosure had to dance if asked, and a woman could choose any man.

The actual dancing began with a line of women facing a line of men. Both lines began to move in the simple steps of the dance—three steps forward, three steps back. One at a time, couples broke from the line and moved across the enclosure with light, springy steps—first one way, then back. If by chance someone fell, the music and dancing stopped immediately. The fallen person stayed still until a medicine man came out and, with passes of a *morache* and a stick, counteracted the ill-fortune that could result from the incident. At the end of a dance set, men and women retired to their respective sides of the enclosure.

The Ute Bear Dance might have had serious spiritual aspects at its beginning but by all accounts it had long been a happy, social occasion: a chance for the people to renew acquaintances and perhaps for the young people to do a little shy courting.

Other peoples held Bear Dances, too, although these differed from that of the Utes. The Bear Dance of the Northern Maidu people of California, which featured a bearskin-clad impersonator of the animal, was a pacification ritual designed to make bears less likely to attack hunters. The Cherokee Bear dance symbolized the bear hunt and was usually performed as part of a larger series of dances.

Charles Eastman, a Santee Sioux (Dakota), described the Bear Dance of his people as "an entertainment, a religious rite, a method of treating disease—all in one. A strange thing about it was that no woman was allowed to participate in the orgies, unless she was herself the bear." The bear was played by a person who had been commissioned by the bear to become a medicine man. He rushed from a "den" to attack approaching hunters. Whoever touched the bear without being touched by him was said to gain the power to overcome a foe on the field of battle. As in the Ute Bear Dance, falling was considered an evil omen—in this case foretelling the sudden death of the person who fell or of a close relative. At the conclusion of the dance, the "bear" had fulfilled his obligation to his patron and was publicly proclaimed a medicine man.

The power of the bear was usually sought to be used for good. With any kind of power, resisting the temptation to exploit it for evil was apparently too much for some people.

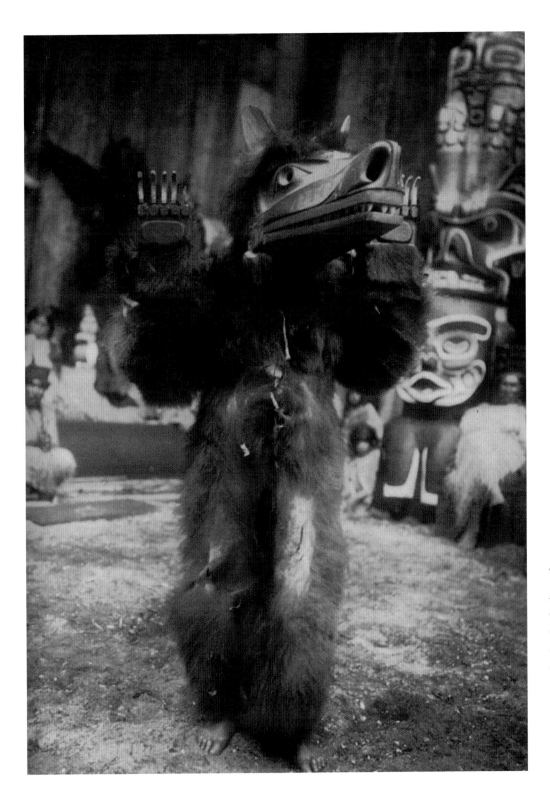

The Grizzly-Bear – Kwakiutl

It is the duty of bear dancers to guard the dance house and to punish those who fail to observe rules governing the privileges of the hamatsas. In former times, it is said, such a lapse was not seldom punished with death.

—Edward S. Curtis, *The North American Indian*, Volume X, page 157.

153

Dark Powers from the Bear

They receive their power from bears, transform themselves into bears, and are almost invulnerable, or if killed likely to come to life again, and are much dreaded as ferocious avengers or even aggressors.

—*Anthropologist A. L. Kroeber writing about bear shamans found among some California peoples*

Describing the path men took to become such beings, Kroeber wrote:

> [They] began by repeated dreaming of bears. Young bear women took them to the woods and lived with them. Sometimes an actual bear was said to carry the man off in the body.... Sometimes, it seems, a man deliberately sought the power. He would swim in the pool formed where an uprooted tree had stood. On emerging he would dance toward and back from a tree which sang to him, and growl and scratch the bark of this as bears are believed to do in their dances. Hair would begin to grow over his body, and finally he became a bear.

During the rest of his training by other bear shamans, the initiate ate the same foods that bears ate, and sometimes went to live with bears temporarily.

Although the bear shamans were feared because of their aggressive nature, they were not considered innately evil. Among the Yuki people of northwestern California, bear shamans cured bear bites and worked to avenge wrongs to the community. A Yuki bear shaman always carried beads so that, should he be killed, the beads could be used to pay for an appropriate burial.

The far more sinister Bear-Walkers of the Wisconsin Potawatomi people gained their power from the Tree Creature. This malevolent being assumed the guise of a chipmunk to study humans and learn their weaknesses. Then it tempted and tricked a person into accepting possession of a Bear-Walker bundle and its power, which carried an obligation to do the bidding of the Tree Creature. The bundles, usually wrapped in bear skin, were considered to be very evil and could contaminate innocent people who came in contact with them. When not in use, the bundles were buried for safekeeping. Bear-Walkers, who could be men or women, used the charms in the bundle to protect themselves, to acquire wealth, and to take revenge on people who failed to treat them with respect. Capable of causing illness and death, Bear-Walkers could even get revenge for some disrespectful act committed by the recently deceased. For four days after death, a dead person's soul was vulnerable to a Bear-Walker, who might visit the grave to resurrect and mutilate the body. Bear-Walkers roamed through the night in a variety of forms, the most common being a bear that emitted a glowing fire from its mouth.

Among the Pomo people of California, the bear's power was also twisted into an evil form. Anthropologist Bertha Parker Cody wrote, "The bear doctor of the Pomo was a malignant character who believed his life was especially charmed against fatal attack. He was not a true doctor, or shaman, and never effected a cure, but merely practiced his magic in secrecy, killing and plundering for his own satisfaction." The Pomo bear doctor, or *gauk buraghal* (literally "man bear"), waylaid and killed hunters to steal their possessions, carrying special weapons for this purpose. Bear doctors might know one another but they operated indepen-

The bear, like the tree, seems to die but, in the spring, is discovered not to have died.... Like the tree, with its roots, trunk and limbs in different layers of the cosmos, the bear is seen in the stars in the night sky, underground as the sleeper, and on earth as an animal.

—Paul Shepard and Barry Sanders,
The Sacred Paw

Copper Shield

Copper shields, a symbol of great wealth for Northwest Coast peoples, marked the high rank of their owners and were exchanged between chiefs at feasts. This very large shield, 117 centimeters (47 inches) tall, is decorated with the female grizzly bear crest of talented shield engraver Albert Edward Edenshaw.

dently. One bear doctor might attack another, or another's family. However, each bear doctor's depredations were limited to four victims a year. Should he attempt to kill a fifth, he would lose his powers, be captured and punished.

The bear doctor could be a man or woman, and was usually middle-aged or old. He gained his power by donning a special suit constructed of a bearskin lined with soaproot fiber and sometimes reinforced with wooden rods. A woven basket fitted to the wearer's head served as a foundation over which the skin of the bear's head was stretched. Two small baskets half-filled with water were tied under the jaws or the armpits of the suit. When the wearer of the suit moved, the sound of the sloshing water was supposed to resemble the noise made by a walking bear's internal organs. Before putting on the suit, the wearer wrapped four wide belts of shell beads around his vital areas. Together, beads and suit functioned as body armor. The bear doctor's suit was said to endow him with great endurance and the ability to travel rapidly over great distances. Like the Yuki bear shaman, the Pomo bear doctor always carried beads, in addition to those he wore as armor. Instead of financing a proper funeral, however, the Pomo bear doctor's beads were used to bribe anyone who discovered his secret into keeping quiet.

Haida Sea Bear Crest Hat

There is quite a bit of conjecture on just how much of the information about Bear-Walkers and bear doctors reflected actual practices, and how much was superstition. The important thing may be not how much *was* true but how much people *believed* to be true—and that applies to all beliefs about the powers of bears.

A warrior who believed that he could draw upon the strength, ferocity, and invulnerability of the grizzly certainly entered battle with a different attitude than one who believed he could rely only upon his own resources. It is not surprising, therefore, that early people often sought the bear's help in overcoming their enemies.

The Warrior's Bear

The sometimes aggressive nature of the bear, together with its strength and perceived ability to recover from great injuries made it an ideal guardian spirit and source of power for warriors. The particular role it played varied from culture to culture.

To the people of Taos pueblo, Bear was a true war god. Warriors prayed to the spirit Red Bear, who apparently wasn't identified with earthly bears. They asked him to give them power and bravery, and to keep them from being overpowered by their enemies. While a war party was out, the Bear Society chief sang in his *kiva* to help bring them success.

On the Great Plains, Hidatsa people told of bear gods that offered help to their warriors:

A Hidatsa warrior, named Four Bears, dreamed that he should go to capture six men and a white horse. He asked eight holy men to help him with this quest. Before the attack, Four

Bears gathered with the holy men. They spoke of their dreams and asked their gods for help.

Bears Heart, who owned a grizzly bear bundle, said, "Yellow grizzly bear: my god: my father gave you to me. He gave me an arrow that came from Two Men back when time began. Let me hit one enemy with that arrow and let me strike another myself."

Married-by-Carrying-Water, who was also the owner of a grizzly bear bundle, held out his sacred lance and spoke of the silver grizzly bear. He told the men how he had been out walking near the forest edge when a bear attacked him. He hit the bear on the head with his stone axe, and the bear cried, "Don't hit me again!" He drew back his axe and the bear reached behind his head. Drawing forth a red feather, he gave it to the man, saying "Whenever you meet the enemy, hit them with your lance, even if they are pointing guns at you. They will not be able to hurt you. If another man asks to borrow the lance to use against the enemy, give him both the lance and the feather to ensure his success. And when you strike the enemy, cut off a piece of the lance, take it to the west side of camp, and point it to the west as an offering to me." [1]

Despite their belief in the power of the bear, the Hidatsa did not believe that enemies drawing on this power were invulnerable.

During a battle between the Hidatsa and the Sioux, the Sioux selected a man who impersonated a bear to lead the next attack because he was so brave and his bear powers kept him from being shot. Among the Hidatsa was Black Shield, a very good shot who had the gun as his medicine. When the Bear-man led the Sioux attack, Black Shield shot at him but the Bear-man did not fall, and Black Shield knew that the Bear-man's powers were great.

Once when Black Shield dreamed of his gun, his gods told him that, should his life be in extreme danger, he should hold the gun to the north. Then he should pour shot from his right ear, powder from his left ear, and put the two into the gun while he sang a special song used only in the direst emergencies.

Black Shield now did this and when he shot the Bear-man again, the Bear-man fell down. The Sioux stopped fighting and carried his body away. [2]

The same characteristics that made bear power good for warriors were not always desirable in other circumstances. The Skidi Pawnee told of a young man who killed a grizzly bear, acquiring both its skin and its power. He also acquired a strong, warlike nature and, because of this, declined when his people asked him to become their chief.

Some of the most detailed and intriguing stories of bears giving humans war weapons and powers were told by the Blackfoot people to describe the origins of their powerful Bear Spear, Bear Knife, and Bear Lodge. There are several versions of these stories; this is a retelling of one recorded by anthropologist Clark Wissler that explains how all three medicine objects came to the Blackfoot:

A young man was hunting in early spring when a blizzard sprang up. He became lost, feeling his way through the brush until he found a warm spot, which turned out to be a bear's den. He crept farther and farther into the den until he heard a bear growl. He stopped and prayed to the Bear. The Bears had a cub who said to his father and mother, "Take pity on this young man. Do not harm him." His parents agreed on the condition that the young man receive some of the cub's powers.

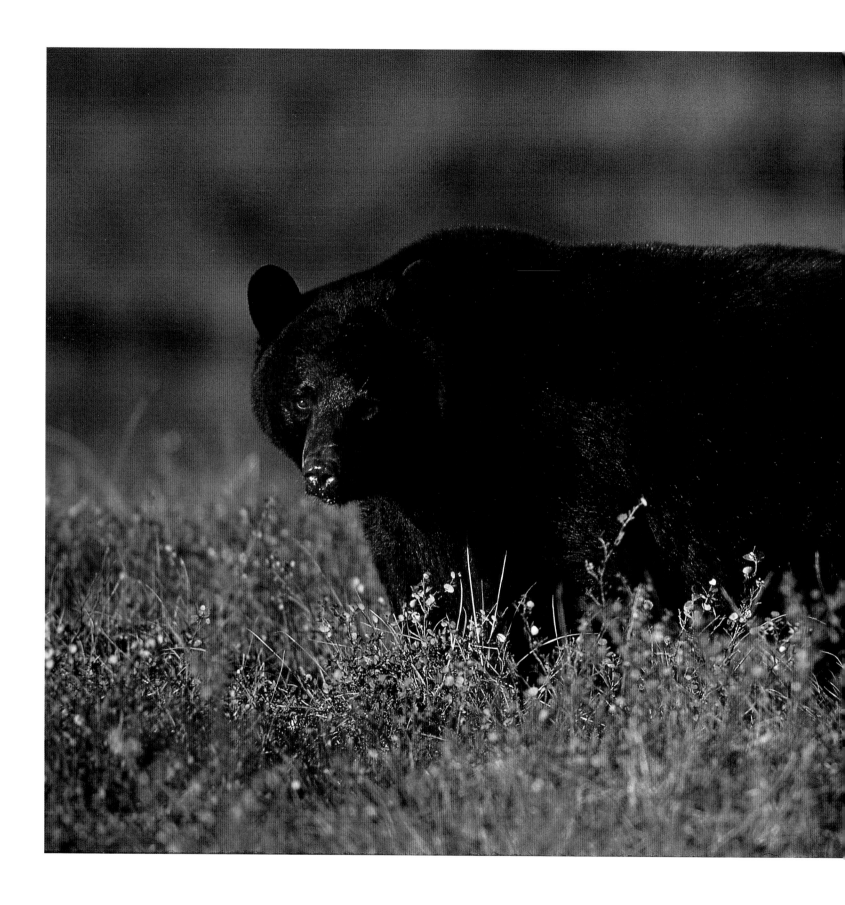

Song of the Black Bear

My moccasins are black obsidian,
My leggings are black obsidian,
My shirt is black obsidian,
I am girded with a black arrowsnake.
Black snakes go up from my head.
With zigzag lightning streaming out from the ends of my feet I step.
With zigzag lightning streaming from my knees I step.
With zigzag lightning streaming from the tip of my tongue I speak.
Now a disk of pollen rests on the crown of my head.
Gray arrowsnakes and rattlesnakes eat it.
Black obsidian and zigzag lightning stream out from me in four ways.
Where they strike the earth, bad things, bad talk does not like it.
It causes the missiles to spread out.
Long life, something frightful I am.
Now I am.
There is danger where I move my feet.
I am a whirlwind.
There is danger when I move my feet.
I am gray bear.
When I walk, where I stop, lightning flies from me.
Where I walk, one to be feared I am.
Where I walk, Long Life.
One to be feared I am.
There is danger where I walk.

— Navajo song from *The Sacred: Ways of Knowledge*

The cub invited the man inside the lodge. Now the man could see that he was inside a lodge that was painted and decorated. Its door was a bearskin. The cub and the man were seated. In front of the man was a pile of branches with very sharp thorns. The cub said, "I will give you my knife," and told the man to remove his clothes.

As the young man sat there, the bear mixed paint and began to sing before a small fire: "On the earth I want to sit. It is powerful." He held the knife to his breast and smudged it in the smoke. He continued to sing "The ground where I sit is holy. The ground is our medicine."

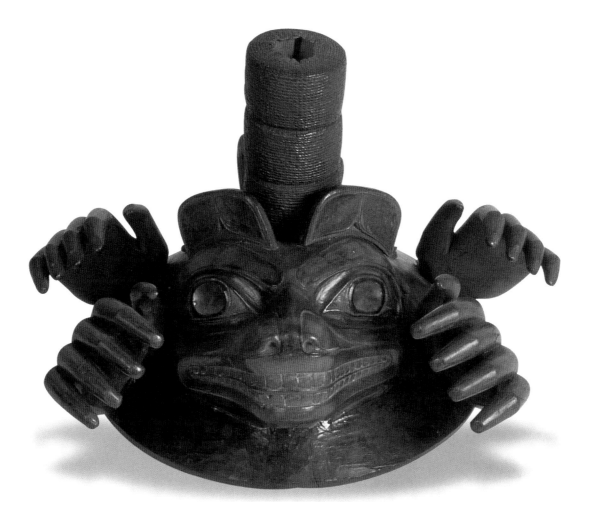

Tsimshian Nagunaks Headdress

In Tsimshian mythology, Nagunaks was Chief of the Undersea World and, as this headdress shows, had a face like Bear. It was believed his red hands cradled human souls until it was time for them to be reincarnated.

The bear rubbed red paint on his hands and face, took black paint and made marks to represent a bear-face, and put a bear claw on each side of his head. He sang "Bear-man says, 'It is medicine. I want it.'" He put on a necklace of bear paws, singing, "Bear is looking for something to eat." Then the bear grabbed the young man as if to eat him.

Throughout this the bear had been singing, repeatedly smudging the knife and adding to his regalia. As the bear reached the last words of his song, he grabbed his knife and thrust it into the ground singing, "I am looking for someone to kill." The bear pretended to stab the man,

then grabbed him and threw him face down upon the sharp thorns. Holding the man there, the bear painted him.

Then, lifting him from the thorns, the bear dressed the man in his own regalia. Holding the man's hand, the bear continued to paint him. He laid the man face down and slapped his back with the flat blade of the knife. This was repeated four times with the man facing each of the four directions. Then the bear threw the knife at the man, who caught it. If the man had failed to catch the knife, he wouldn't have been given it.

The bear told the man that he must sleep in the woods for seven days. And he gave the man a song to sing whenever he chased an enemy: "I will run after him. He will fall. I will stab him." The bear also said that the man must never dodge an enemy's bullet or he would be killed. He said the man must always keep in pursuit of the enemy for if he turned back, he would die. After the young bear had finished with the man, the adult bears gave him two more presents.

The father-bear gave the man a lance with bear claws for rattles and a necklace of bear-claws to go with it. First he enacted a rite similar to the one for the knife, and when he threw the lance into the ground, the father-bear sang, "Underneath is a bear; he has sun power." He threw the man onto the thorns and painted him as before. Then the father-bear threw the lance at the man, who caught it. Had he failed to do so, he would not have been given it. Then the father-bear repeated the instructions that had been given with the bear knife.

The mother-bear gave the man a painted lodge, which shows a picture of a bear. The owner of this lodge, which is still among the Northern Blackfoot, also possesses anklets, wristlets, and head ornaments made of bear claws. The song the mother-bear sang as she smudged the lodge was: "The earth is our home. It is medicine." As she painted the man she sang, "Be not afraid. Never turn back. Think of the one you kill and eat." She told the man that this lodge must always have a bearskin for a door, just like that of the lodge in which they now sat.

The man returned to his people and did everything as the bears had instructed him. Over the years, he killed many enemies with the knife, and whenever the bear-knife was transferred to a new owner, he had to undergo the same ritual that the man had endured in the bears' lodge.

The association of bears and warriors has a long history in Europe as well. The Old Norse sagas tell of Bodvar Biarki, a loyal follower of Hrolf, an early Danish king:

> You could say that bears ran in Bodvar's family: before he was born, his father's wife changed his father, Biorn, into a bear as punishment for rejecting her sexual advances, and as a bear he was killed by hunters and dogs. Before this grim end, Biorn lived in a cave with a girl named Bera and could still assume his human form at night. After Biorn's death, Bera gave birth to three sons: the first was part man, part moose; the second had dog's paws for feet; and the third was Bodvar, who appeared perfectly normal. However, in a final battle with King Hrolf against evil supernatural powers, Bodvar's heritage proved itself.

> At the battle front, no one could find Bodvar. He seemed to have disappeared. Bodvar's absence was soon forgotten, however, because a great bear moved before King Hrolf's forces, keeping near the king. The enemies' weapons failed to harm the bear as he slew them with his teeth and claws.

> While all of this was going on, Bodvar's loyal friend, Hjalti had gone to seek him out. Finding Bodvar sitting motionless in his tent, Hjalti berated him for deserting the king in his time of

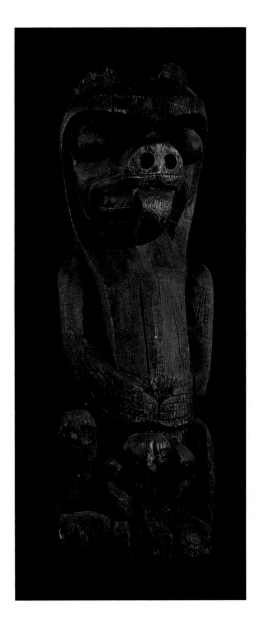

Grizzly Bear Figure

In this Kwakiutl wooden figure, a grizzly bear merges with a representation of a copper. The bear was probably an important crest animal of the family that owned the figure and the copper was an overt symbol of wealth. By showing both, this sculpture represented a powerful, affluent family.

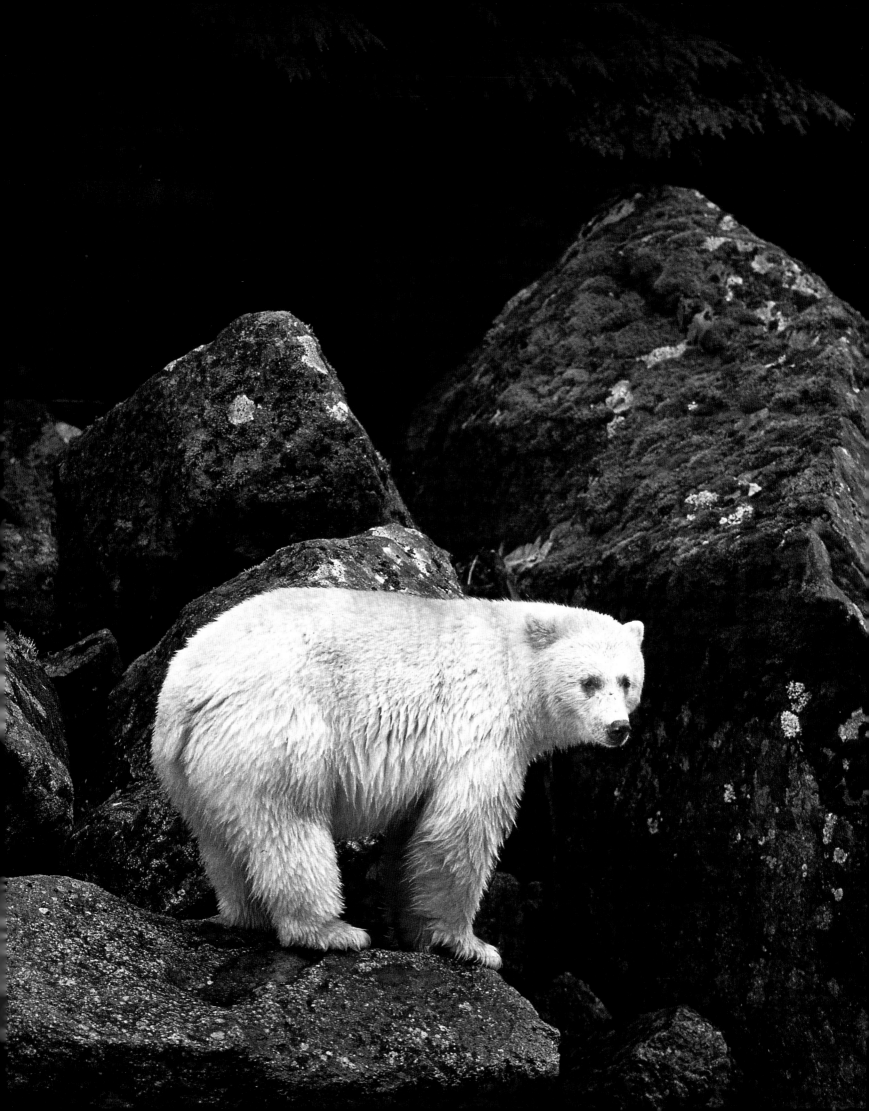

need. Finally, Bodvar shook his head as if to clear it and said he could help the king more by being where he was, but at Hjalti's urging the two returned to the battlefield. There they found that the bear had gone, and the tide of the battle had turned back against King Hrolf and his followers. Bodvar and Hjalti died, defending their king to the last.[3]

Another old Norse story tells of Orvar-Odd, who was marooned with the crew of his ship on an island off the Baltic coast. Hostile mainland people threatened the small group so Orvar-Odd set up the head and skin of a bear, propping them up with a stick. When a giantess attacked Orvar-Odd's party, he placed embers in the bear's mouth and then fought off the giantess with magic arrows.

Bear skins appear to have been considered particularly potent war magic by many peoples. The term *berserker* may have originally referred to fierce warriors who wore bear skins into battle. Later, Polish knights wore whole bear skins with stuffed heads on their armor; the bear's paws were set in silver or gold and used as ornament. Not as fancy but no less potent was the garb worn by bear shamans of the Cahto people of California. Cahto bear shamans were renowned for their ability to kill enemies in battle. The Cahto believed that it was the bear skins worn by the shamans that endowed them with superhuman speed and made them invulnerable.

The belief that an animal's powers can be transferred to humans through conduits derived from the animal's physical essence is probably one of the oldest human superstitions, arising in the minds of hunters who crouched near ancient fires. As hunter, healer, heavenly being, prey, protector, and progenitor, the bear has been an integral part of our history, and its future remains entwined with ours.

The creamy white Kermode bears, which are actually black bears, were believed to be especially powerful by the native peoples who shared with them the forests of coastal British Columbia.

... for many of us the world would be a poorer place without bears. We keep bears not because they are an essential part of nature but because of what they do for the human mind, body, and soul.

—Stephen Herrero, *Bear Attacks: Their Causes and Avoidance*

Our explorations of times past have shown us so much that possesses meaning and beauty today. It is sobering to realize that only a tiny fraction of the songs, stories, and artifacts of ancient times have made the long journey to us. That thought should spur us to preserve what we have today, especially those most fragile treasures of all—the living ones. Dependent on our desires and decisions, bears and all living things need our understanding, appreciation, and consideration. With our help, the treasures of yesterday and today can inspire generations to come. My wish is that people may have the chance to experience the power and beauty of earthly bears for as long as the Great Bear continues her heavenly prowl.

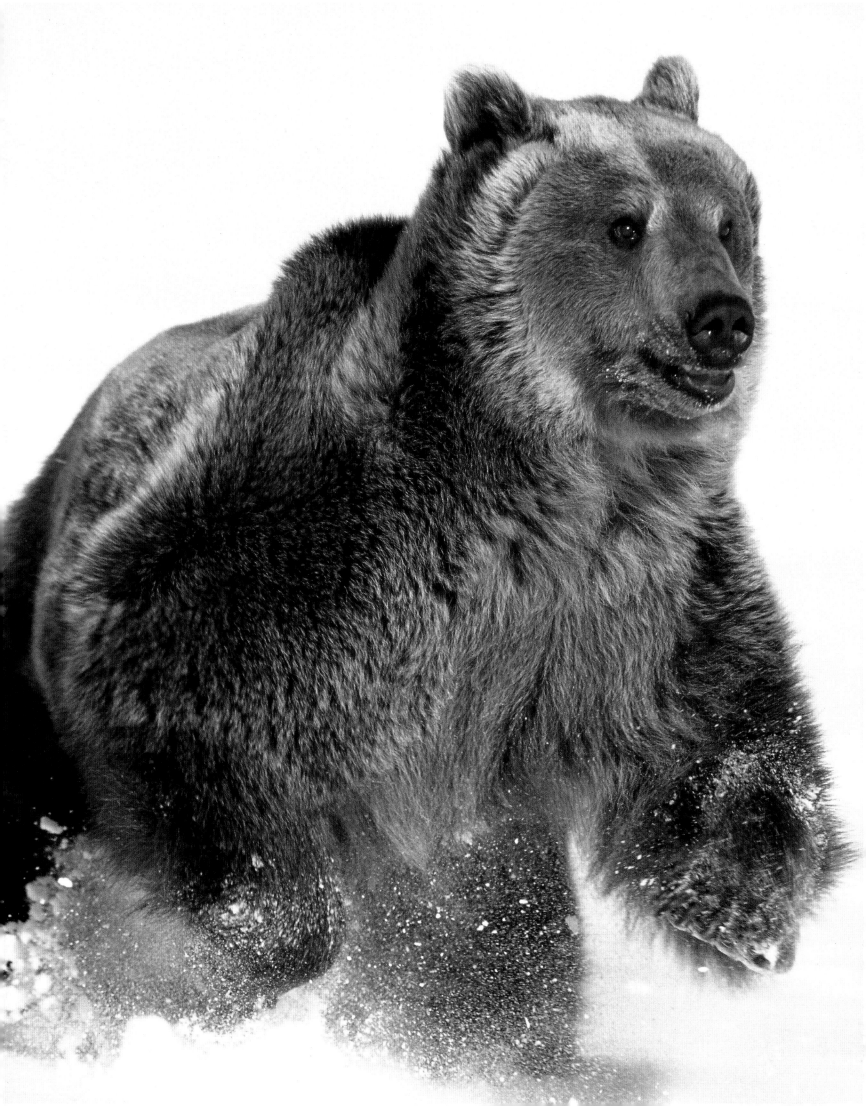

As some of you may know, this is my second project with Dan Cox. I would like to thank him for the privilege of being able to work again with his amazing images, and for his willingness to listen to new ideas. Authors are rarely so fortunate in their creative partners. Also thank you to Dan and to Bret Hicken for one of the strangest research trips I have ever taken. Gentlemen, your unwavering pursuit of your goals was an inspiration to me.

Thank you to Gary Chassman for his perseverance, to Beth Gibson for her enthusiasm, and to Robert Yerks and Jill Schwenderman for capturing the true spirit of this book in their beautiful design. Thank you to Euan Bear for her gentle editing, and to Hannah Gregory for handling the image acquisitions. Thank you also to Christopher Cardozo for allowing us to use some of his wonderful National Curtis photographs. I am grateful to Julie Cox, who somehow made time in her busy life to help me with photograph requests. I would like to thank the people of the Ute Mountain Ute tribe in Towaoc, Colorado for graciously allowing us to experience their annual Bear Dance, and especially for asking Dan and Bret to actually dance. To Troy Hyde and Rick Meyer, thank you for answering bear questions. Thank you to Dr. Peter Rowley-Conwy of the University of Durham for up-to-date information on bears and early humans. Any errors in the text are, of course, solely mine. In Washington, DC I was assisted with great kindness by Jake Homiac and Robert Leopold at the Smithsonian's National Anthropological Archives and Felicia Pickering at the Smithsonian's Museum Support Center—thank you all for your patience. Also thank you to Leo G. Waisberg and Tim Holzkamm for finding Frances Densmore's letter and sharing it with me. Closer to home, I was fortunate to have invaluable help from several friends: Cory Cox, Marlene Kozak, and David and Cathryn Miller. I also received essential assistance and advice from Dr. Vivian Gooding. Thank you's are due to the staff at Rusty Macdonald Library, as well as the Interlibrary Loan Staff at Frances Morrison Library, for their uncomplaining assistance in acquiring a wide range of materials. My sister, Jane, supplied a terrific growling grizzly to guard my office. I must also thank three small friends, Agatha, Dorothy, and Clara: it is much more enjoyable to pore over vast quantities of reference material when there is a plump guinea pig asleep on your lap. I did suffer the loss of a few pages, however, thanks to the dietary preferences of two other members of our household, rabbits Teddy and Benjamin. Thanks for not eating any library books, guys! To my husband, Glen, who once again lived with the periodic labor pains involved in producing a book: thanks for bearing with me.

APPENDIX
THE SHAPES BEHIND THE STORIES

Information taken from:

Servheen, C.; Herrero, S.; and Peyton, B. (compilers). 1999. *Bears: Status Survey and Conservation Action Plan*. IUCN/SSC Bear and Polar Bear Specialist Groups. Gland, Switzerland and Cambridge, UK: International Union for Conservation of Nature and Natural Resources.
Brown, Gary. 1993. *The Great Bear Almanac*. New York: Lyons & Burford.

Species: *Ursus americanus*

Common Names: American black bear, cinnamon bear, glacier bear, Kermode bear

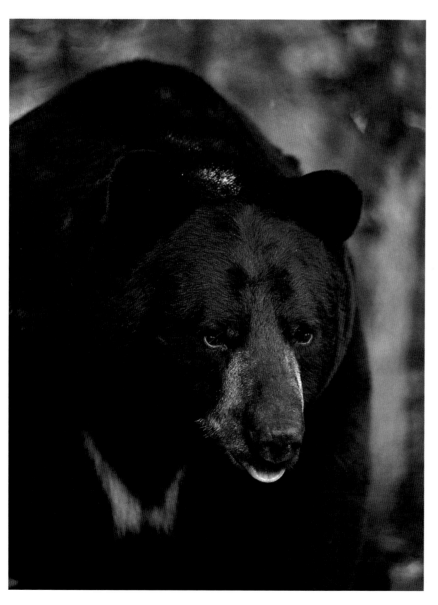

Range: Canada (Alberta, British Columbia, Manitoba, New Brunswick, Newfoundland, Northwest Territories, Nunavut, Nova Scotia, Ontario, Québec, Saskatchewan, Yukon); United States (Alabama, Alaska, Arizona, Arkansas, California, Colorado, Connecticut, Florida, Georgia, Idaho, Kentucky, Louisiana, Maine, Maryland, Massachusetts, Michigan, Minnesota, Mississippi, Missouri, Montana, Nevada, New Hampshire, New Jersey, New Mexico, New York, North Carolina, Oklahoma, Oregon, Pennsylvania, South Carolina, South Dakota, Tennessee, Texas, Utah, Vermont, Virginia, Washington, West Virginia, Wisconsin, Wyoming); Mexico

Average Size of Full-grown Male:

Weight: 60–270 kilograms (125–600 pounds)
Average Weight: 113 kilograms (250 pounds)

Height at Shoulder: .8–.9 meters (2.5–3 feet)

Length—Nose to Tail Tip: 1.2–1.8 meters (4–6 feet)

Average Life Expectancy: 18 years; 31 years oldest recorded in wild

Species Status / Estimated Population: Overall population stable, United States stable to decreasing; Canada population 327,200–341,000; United States population 186,800–206,750; Mexico population unknown

Species: *Ursus arctos*

Common Names: brown bear, grizzly bear, Kodiak bear, red bear, Gobi bear, Hokkaido brown bear

Range: Canada (British Columbia, Alberta, Northwest Territories, Nunavut, Yukon Territory); United States (Alaska, Idaho, Wyoming, Montana, Washington); Europe (Austria, Bulgaria, Finland, France, Greece, Italy, Norway, Sweden, Poland, Romania, Slovakia, Spain, Bosnia/Herzegovina, Croatia, Macedonia, Montenegro, Serbia, Slovenia); Asia (mainly Russia, China, Japan, Mongolia)

Average Size of Full-grown Male:

 Weight: 160–410 kilograms (350–900 pounds);

 Average Weight: 220 kilograms (490 pounds)

 Average Weight / coastal brown bears : 330 kilograms (725 pounds), much larger than interior grizzlies

 Height at Shoulder: .9–1.5 meters (3–5 feet)

 Length—Nose to Tail Tip: 2.1–3 meters (7–10 feet)

Average Life Expectancy: 20-25 years; 34 years oldest recorded in wild

Species Status/Estimated Population: several very small populations at high risk including France (< 10), Mongolia (< 30), Pakistan; North America population 58,000 with 900 in lower 48 states; Europe population less than 15,000; Asia population 122,000

Other Information: Russia, with over 100,000 brown bears, has far more than any other country and apparently exceeds all of the other populations put together.

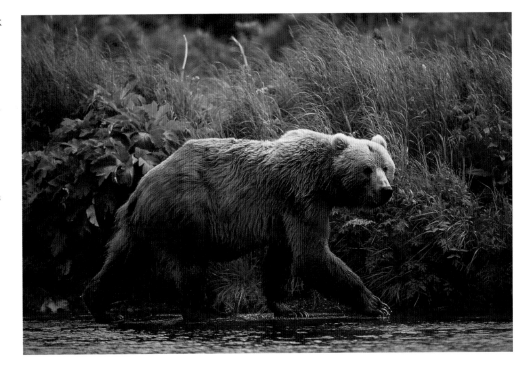

Species: *Ursus maritimus*

Common Names: polar bear, nanook, sea bear, white bear

Range: circumpolar areas of Canada, United States, Norway, Greenland, and Russia

Average Size of Full-grown Male:

Weight: 400–680 kilograms (900–1500 pounds);

Average Weight: 520 kilograms (1150 pounds)

Height at Shoulder: may be over 1.5 meters (5 feet)

Length—Nose to Tail Tip: may be over 2.4 meters (8 feet)

Average Life Expectancy: 25 years; 34 years, 8 months oldest recorded in wild

Species Status/Estimated Population: stable; world population probably 22,000-27,000

Other Information: Polar bears are difficult to census by country because they roam over so much territory.

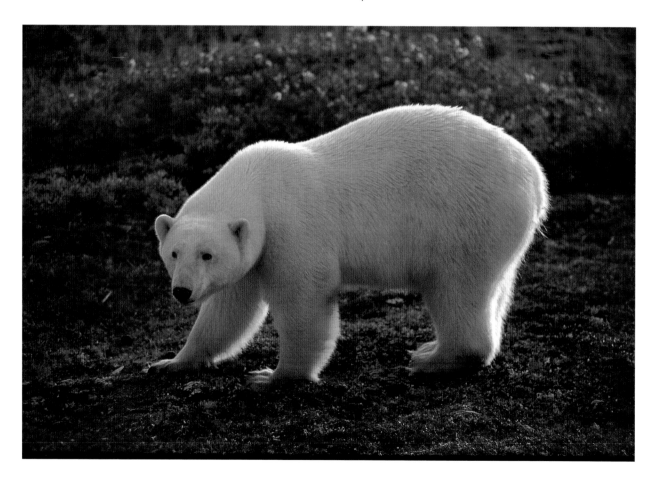

FOR MORE INFORMATION ABOUT HOW YOU CAN HELP PROTECT BEARS AND THEIR HABITAT, CONTACT:

Sierra Club Grizzly Bear Ecosystems Project
Box 1290 Bozeman, MT 59047
Phone: 406-582-8365 · email: wildgriz@aol.com

RECOMMENDED READING

FOR INFORMATION ABOUT BEAR ATTACKS:

Herrero, Stephen. 1985. *Bear Attacks: Their Causes and Avoidance*. New York: Lyons & Burford.

Shelton, James Gary. 1994. *Bear Encounter Survival Guide*. Self-published.

Shelton, James Gary. 1998. *Bear Attacks: The Deadly Truth*. Hagensborg, BC: Pogany Productions.

FOR MORE DETAILED INFORMATION ON BEAR CEREMONIES:

Hallowell, A. Irving. 1926. "Bear Ceremonialism in the Northern Hemisphere." *American Anthropologist* n.s. 28 (1): 1-175.

Speck, Frank G., and Jesse Moses. 1945. *The Celestial Bear Comes Down to Earth: the bear sacrifice ceremony of the Munsee-Mahican in Canada as related by Nekatcit*. Scientific Publications Number 7. Reading, PA: Reading Public Museum and Art Gallery.

FOR MORE INFORMATION ON SPECIFIC BEAR SPECIES:

McNamee, Thomas. 1984. *The Grizzly Bear*. New York: Alfred A. Knopf, Inc.

Servheen, C., Herrero, S., and Peyton, B. (compilers). 1999. *Bears: Status Survey and Conservation Action Plan*. IUCN/SSC Bear and Polar Bear Specialist Groups. Gland, Switzerland and Cambridge, UK: International Union for Conservation of Nature and Natural Resources.

Stirling, Ian. 1988. *Polar Bears*. University of Michigan Press.

Walker, Tom. 1993. *River of Bears: The Famed Bears of Alaska's McNeil River*. Stillwater, MN: Voyageur Press.

FOR GENERAL BEAR INFORMATION AND TRIVIA:

Brown, Gary. 1993. *The Great Bear Almanac*. New York: Lyons & Burford.

NOTES

When the World Was Young
1. These authorities include Dr. Peter Rowley-Conwy (Reader, Department of Archaeology, University of Durham, UK) and Dr. Ian Tattersall (Chairman, Department of Anthropology, American Museum of Natural History).
2. Joseph Addison's translation as cited in Allen (1963).
3. Retold from Voth (1905).

Bear People
1. Vasilevich as cited in Schlesier (1987).
2. Vasilevich as cited in Schlesier (1987).
3. Retold from McCracken (1955) and Miller (1900).
4. Retold from Leeming (1994).
5. Retold from Wissler (1909) and Wissler (1947).
6. Retold from Boaz (1917).
7. Vacar (1999).
8. Rogers as cited in Lynch (1993).
9. Bierhorst (1985).
10. McNamee (1984).

Healers
1. Moerman (1998).
2. Clark (1966).
3. Retold from Grinnell as cited in McCracken (1955).
4. Retold from Bowers (1965).

Hunters
1. Story retold from Swanton (1929).

Sharing the Power of the Bear
1. Retold from an account by Bears Arm in Bowers (1965).
2. Retold from an account by Four Dancers in Bowers (1965).
3. Retold from Davidson (1978).

Photographs on the following pages were taken under controlled conditions: page numbers 12, 21, 33, 71, 132, 136–137, 138, and 164.

Select Bibliography

Adamson, Thelma. [1934] 1969. *Folk-Tales of the Coast Salish*. Memoirs of the American Folk-Lore Society, vol. 27. Reprint, New York: Kraus Reprint Co.

Ainu. 1999. Special exhibit at the National Museum of Natural History, Smithsonian Institution, Washington, DC.

Alekseenko, E. A. 1968. The cult of the bear among the Ket (Yenisei Ostyaks). In *Popular Beliefs and Folklore Tradition in Siberia*, ed. V. Diószegi. Bloomington, IN: Indiana University.

Allen, Richard Hinkley. 1963. *Star Names: Their Lore and Meaning*. Replica of 1899 work published by G. E. Stechert under the former title: *Star-Names and Their Meanings*. New York: Dover Publications.

Bacon, Ellis S. 1980. Curiosity in the American black bear. In *Bears: Their Biology and Management*. A selection of papers from the Fourth International Conference on Bear Research and Management, Kalispell, MT, USA, February, 1977. Clifford J. Martinka and Katherine L. McArthur, eds.

Barrett, S. A. 1917. Pomo Bear Doctors. *University of California Publications in American Archaeology and Ethnology*, 12 (11): 443–465.

———. 1952. Material Aspects of Pomo Culture, Part One. *Bulletin of the Public Museum of the City of Milwaukee* 20 (1): 1–260.

Batchelor, John. 1892. *The Ainu of Japan*. London, UK: The Religious Tract Society.

———. Circa 1927. *Ainu Life and Lore*. Tokyo: Kyobunkwan. Reprinted by Johnson Reprint Co., New York, 1971.

Beck, Peggy V., Anna L. Walters, and Nia Francisco. 1995. *The Sacred: Ways of Knowledge, Sources of Life*. Tsaile, AZ: Navajo Community College Press.

Beckwith, Martha Warren. [1938] 1969. *Mandan-Hidatsa Myths and Ceremonies*. Memoirs of the American Folk-Lore Society, vol. 32. Reprint, New York: Kraus Reprint Co.

Benedict, Ruth. 1931. *Tales of the Cochiti Indians*. Washington, DC: Bureau of American Ethnology Bulletin 98.

Bierhorst, John. 1985. *The Mythology of North America*. New York: William Morrow and Co.

Boas, Franz. [1888] 1974. *The Central Eskimo*. Originally published as part of *Bureau of American Ethnology 6th Annual Report (1884–1885)*. Toronto: Coles Publishing Co.

———. [1898] 1976. *The Mythology of the Bella Coola Indian*. Reprint, New York: AMS Press.

———. [1916] 1970. Tsimshian Mythology. *Bureau of American Ethnology 31st Annual Report*, pp. 29–1037. New York: Johnson Reprint Corporation.

———. [1932] 1973. *Bella Bella Tales*. Memoirs of the American Folk-Lore Society, vol. 25. Reprint, Millwood, New York: Kraus Reprint Co.

———, ed. [1917] 1969. *Folk-Tales of Salishan and Sahaptin Tribes*. Memoirs of the American Folklore Society, vol. 11. Reprint, New York: Kraus Reprint Co.

Bowers, Alfred W. 1965. *Hidatsa Social and Ceremonial Organization*. Washington, DC: Bureau of American Ethnology Bulletin 194.

Brinton, Daniel G. [1884] 1969. *The Lenâpé and Their Legends; with the Complete Text and Symbols of the Walam Olum, a New Translation, and an Inquiry into Its Authenticity*. Reprint, New York: AMS Press.

Brown, Gary. 1993. *The Great Bear Almanac*. New York: Lyons & Burford.

Brown, Joseph Epes. 1992. *Animals of the Soul*. Rockport, MA: Element, Inc.

Bruchac, J. 1992. *The Native Stories from Keepers of the Animals*. Saskatoon, SK: Fifth House.

Buchalczyk, Tadeusz. 1980. The brown bear in Poland. In *Bears: Their Biology and Management*. A selection of papers from the Fourth International Conference on Bear Research and Management, Kalispell, MT, USA, February, 1977. Clifford J. Martinka and Katherine L. McArthur, eds.

Bunzel, Ruth Leah. 1992. *Zuñi Ceremonialism* (complete reprint of 3 studies [Zuñi Ceremonialism, Zuni Origin Myths, Zuñi Ritual Poetry] published in 1932 in the *Forty-seventh Annual Report* of the Bureau of American Ethnology, 1929–1930, by the Smithsonian Institution, Washington, DC) Albuquerque, NM: University of New Mexico Press.

Callaway, Donald, Joel Janetski, and Omer C. Stewart. 1986. Ute. In *Handbook of North American Indians*, vol. 11, *Great Basin*. 1986. Washington, DC: Smithsonian Institution.

Campbell, Joseph. 1983. *The Way of the Animal Powers*. vol. 1, *Historical Atlas of World Mythology*. London: Summerfield Press.

———. 1988. *The Way of the Animal Powers. pt. 1. Mythologies of the Primitive Hunters and Gatherers. pt. 2. Mythologies of the Great Hunt*. vol. 1, *Historical Atlas of World Mythology*. New York: Harper & Row.

Casagrande, Joseph B. 1967. Ojibwa bear ceremonialism: The persistence of a ritual attitude. In *Acculturation in the Americas*, Sol Tax, ed. New York: Cooper Square Publishers.

Cavendish, Richard, ed. 1994. *Man, Myth and Magic*. North Bellmore, NY: Marshall Cavendish.

Clark, Ella Elizabeth. 1958. *Indian Legends of the Pacific Northwest*. Berkeley, CA: University of California Press.

———. 1964. *Indian Legends of Canada*. Third ed. Toronto: McClelland and Stewart.

———. 1966. *Indian Legends from the Northern Rockies*. Norman, OK: University of Oklahoma Press.

Cody, Bertha Parker. 1940. Pomo bear impersonators. *Masterkey* 14: 132–37.

Collinder, Björn. 1949. *The Lapps*. Princeton, NJ: Princeton University Press.

Collins, Henry B., Frederica De Laguna, Edmund Carpenter, and Peter Stone. 1973. *The Far North*. Washington, DC: National Gallery of Art.

Connealy, Helen. 1997. Bitter harvest. In *Asiaweek*, October 3. http://cnn.com/ASIANOW/asiaweek/97/1003/feat2.html [Accessed December 30, 1999.]

Cornelius, Geoffrey. 1997. *The Starlore Handbook*. Toronto: General Publishing.

Cotterell, Arthur. 1996. *The Encyclopedia of Mythology*. London: Anness Publishing Ltd., Lorenz Books. [This edition by Acropolis Books, n. p.]

Craighead, Frank C., Jr. 1979. *Track of the Grizzly*. San Francisco, CA: Sierra Club.

Craighead, John, J. 1995. *The Grizzly Bears of Yellowstone*. Washington, DC: Island Press.

Crow-wing. [1925] 1964. *A Pueblo Indian Journal 1920–1921*. Memoirs of the American Anthropological Association, no. 32. Reprint, New York: Kraus Reprint Co.

Curtis, Edward S. [Circa 1907–30] 1970. *The North American Indian*, 20 volumes. Reprint, New York: Johnson Reprint Corporation.

Curtis, Martha E. 1952. The black bear and white-tailed deer as potent factors in the folklore of the Menomini Indians. *Midwest Folklore*, 2: 177–190.

Cushing, G. F. 1977. The bear in Ob-Ugrian folklore. *Folklore*, 88 (2): 146–159.

Davidson, H. R. Ellis. 1978. Shape-changing in the Old Norse sagas. In *Animals in Folklore*, Porter, J. R., and W. M. S. Russell, eds. Ipswich, UK: D. S. Brewster Ltd.; Totowa, NJ: Rowman and Littlefield for the Folklore Society.

de Camões, Luis. [1655] 1940. *The Lusiad*. Translated by Richard Fanshawe. Reprint, Cambridge, MA: Harvard University Press.

De Laguna, Frederica. 1990. Tlingit. In *Handbook of North American Indians*, vol. 7, *Northwest Coast*. Washington, DC: Smithsonian Institution.

Densmore, Frances. 1918. *Teton Sioux Music*. Bureau of American Ethnology, Bulletin 61.

———. 1918. Letter to Dr. Fewkes. *Bureau of American Ethnology Correspondence*, Box 27, Densmore, National Anthropological Archives, Smithsonian Institution, Washington, DC.

———. [1928] 1987. *Uses of Plants by the Chippewa Indians*. Bureau of American Ethnology Annual Report 44. Reprinted as *Indian Use of Wild Plants for Crafts, Food, Medicine, and Charms*. Ohsweken, ON, Canada: Iroqrafts, Ltd.

———. 1953. The belief of the Indian in a connection between song and the supernatural. In Bureau of American Ethnology, Bulletin 151, *Anthropological Papers*, 37, pp. 217–223.

Diószegi, V. 1968. The three-grade amulets among the Nanai (Golds). In *Popular Beliefs and Folklore Tradition in Siberia*, ed. V. Diószegi. Bloomington, IN: Indiana University.

Dixon, Roland B. [1905] 1982. The Northern Maidu. *Bulletin of the American Museum of Natural History* 17 (3). Reprint, New York: AMS Press.

———. [1907] 1982. The Shasta. *Bulletin of the American Museum of Natural History* 17 (5). Reprint, New York, AMS Press.

Dorsey, George A. [1904] 1969. *Traditions of the Skidi Pawnee*. Memoirs of the American Folk-Lore Society, vol. 8. Reprint, New York: Kraus Reprint Co.

Dorsey, J. O. 1889. Teton folk-lore notes. *Journal of American Folklore* 2: 133–139.

Drury, Nevill. 1989. *The Elements of Shamanism*. Shaftesbury, Dorset, UK: Element.

Dumarest, Father Noël. [1919] 1964. *Notes on Cochiti, New Mexico*. Memoirs of the American Anthropological Association, vol. 6 (3). Reprint, New York: Kraus Reprint Co.

Eastman, Charles A. 1911. *Indian Boyhood*. Garden City, NY: Doubleday, Page & Co.

Edmonds, Margot. 1989. *Voices of the Winds*. New York: Facts on File, Inc.

Ewers, John C. 1955. The bear cult among the Assiniboin and their neighbors of the northern plains. *Southwestern Journal of Anthropology* 11(1): 1–14.

———. 1978. Bear Tipi of Chief White Man. *Murals in the Round: Painted Tipis of the Kiowa and Kiowa-Apache Indians*. Washington, DC. Smithsonian Institution Press.

Feazel, Charles T. 1990. *White Bear*. New York: Henry Holt & Co.

Fitzhugh, William W. and Susan A. Kaplan. 1982. *Inua*. Washington, DC: Smithsonian Institution Press.

Folk, G. Edgar, Hunt, Jill M., and Mary A. Folk. 1980. Further evidence for hibernation of bears. In *Bears: Their Biology and Management*. A selection of papers from the Fourth International Conference on Bear Research and Management, Kalispell, MT, USA, February, 1977. Clifford J. Martinka and Katherine L. McArthur, eds.

Frachtenberg, Leo J. 1913. *Coos Texts*. Columbia University Contributions to Anthropology, 1. New York: Columbia University Press.

Frazer, J. G. 1911. Hunters and fishers tabooed. In *The Golden Bough*, Part II: Taboo and the Perils of the Soul. London, UK: Macmillan and Co.

———. 1912. Killing the sacred bear. In *The Golden Bough*, Part V, Volume II: Spirits of the Corn and of the Wild. London, UK: Macmillan and Co.

Frost, Robert. 1969. *The Poetry of Robert Frost*. Edward Connery Lathem, ed. New York: Holt, Rinehart and Winston.

Gifford, Edward Winslow. [1936] 1965. Northeastern and Western Yavapai. *University of California Publications in American Archaeology and Ethnology*, 34: 247–354. Reprint, New York: Kraus Reprint Co.

———. 1932. The Southeastern Yavapai. *University of California Publications in American Archaeology and Ethnology*, 4: 177–252.

Goddard, Pliny Earle. [1904] 1964. Hupa Texts. *University of California Publications in American Archaeology and Ethnology*, 1 (2): 89–368. Reprint, New York: Kraus Reprint Co.

———. 1933. *Navaho Texts*. New York: Anthropological Papers of The American Museum of Natural History, 34 (1).

Graceva, G. N. 1996. A Nganasan shaman costume. In *Shamanism in Siberia*, Vilmos Diószegi and Mihály Hoppál, eds. Budapest: Akadémiai Kiadó.

Hagar, Stansbury. 1900. The celestial bear. *Journal of American Folklore* 13: 92–103.

Hallowell, A. Irving. 1926. Bear ceremonialism in the northern hemisphere. *American Anthropologist* n.s. 28 (1): 1–175.

Handbook of North American Indians, vol. 8, *California*. 1978. Washington, DC: Smithsonian Institution.

Handbook of North American Indians, vol. 11, *Great Basin*. 1986. Washington, DC: Smithsonian Institution.

Handbook of North American Indians, vol. 7, *Northwest Coast*. 1990. Washington, DC: Smithsonian Institution.

Harms, Dale R. 1980. Black bear management in Yosemite National Park. In *Bears: Their Biology and Management*. A selection of papers from the Fourth International Conference on Bear Research and Management, Kalispell, MT, USA, February, 1977. Clifford J. Martinka and Katherine L. McArthur, eds.

Hawthorn, Audrey. 1979. *Kwakiutl Art*. Seattle, WA: University of Washington Press. First published in 1967 under title: *Art of the Kwakiutl Indians and Other Northwest Coast Tribes*.

Herrero, Stephen. 1985. *Bear Attacks: Their Causes and Avoidance*. New York: Lyons & Burford.

———, ed. 1972. *Bears—Their Biology and Management*. Selection of papers and discussion from Second International Conference on Bear Research and Management, University of Calgary, Alberta, Canada, November 6–9, 1970. Morges, Switzerland: IUCN.

Hewitt, John Napoleon Brinton. n.d. *The Grizzly Bear*. Smithsonian Institution National Anthropological Archives Manuscript 433.

Hultkrantz, Ake. 1981. *Belief and Worship in Native North America*. Syracuse, NY: Syracuse University Press.

———. 1987. *Native Religions of North America*. New York: HarperCollins.

Jorgensen, Joseph G. 1986. Ghost dance, bear dance, and sun dance. In *Handbook of North American Indians*, vol. 11, *Great Basin*. Washington, DC: Smithsonian Institution.

Kálmán, B. 1968. Two purification rites in the bear cult of the Ob-Ugrians. In *Popular Beliefs and Folklore Tradition in Siberia*, ed. V. Diószegi. Bloomington, IN: Indiana Univ.

Kindaichi, K. 1949. The concepts behind the Ainu bear festival (Kumamatsuri). *Southwestern Journal of Anthropology* 5: 345–350.

Kopper, Philip. 1986. *The Smithsonian Book of North American Indians*. Washington, DC: Smithsonian Books.

Kroeber, A. L. [1907] 1964. The Religion of the Indians of California. *University of California Publications in American Archaeology and Ethnology*, 4 (1906–1907): 319–356. Reprint, New York: Kraus Reprint Co.

———. 1922. Elements of culture in native California. *University of California Publications in American Archaeology and Ethnology*, 13 (8): 259–328.

———. [1929] 1976. The Valley Nisenan. *University of California Publications in American Archaeology and Ethnology*, 24 (1927–1930): 253–290. Reprint, Millwood, NY: Kraus Reprint Co.

———. [1932] 1965. The Patwin and Their Neighbors. *University of California Publications in American Archaeology and Ethnology*, 29 (1930–1932): 253–423. Reprint, New York: Kraus Reprint Co.

———. 1953. *Handbook of the Indians of California*. Berkeley, CA: California Book Co.

Kurath, Gertrude. The Iroquois bear society ritual drama. *American Indian Tradition* 8(2), pp. 84–85.

Kurten, Bjorn. 1968. *Pleistocene Mammals of Europe*. Chicago, IL: Aldine Publishing Co.

Landes, Ruth. 1968. *Ojibwa Religion and the Midéwiwin*. Madison, WI: University of Wisconsin Press.

Lange, Charles H. 1968. *Cochiti: A New Mexico Pueblo, Past and Present*. Carbondale, IL: Southern Illinois University Press.

Laubin, Reginald. 1977. *Indian Dances of North America*. Norman, OK: University of Oklahoma Press.Clifford J. Martinka and Katherine L. McArthur, eds.

Levy, Richard. 1978. Costanoan. In *Handbook of North American Indians*, vol. 8, *California*. Washington, DC: Smithsonian Institution.

Loeb, Edwin M. 1926. Pomo Folkways. *University of California Publications in American Archaeology and Ethnology*, 19 (2): 149–404.

Lynch, Wayne. 1993. *Bears*. Vancouver, BC: Douglas & McIntyre.

Marsh, Charles S. 1982. *People of the Shining Mountains*. Boulder, CO: Pruett Publishing Co.

Martinka, Clifford J., and Katherine L. McArthur, eds. 1980. *Bears: Their Biology and Management*. A selection of papers from the Fourth International Conference on Bear Research and Management, Kalispell, MT, USA, February, 1977. The Bear Biology Association

Mason, Edith Hart. 1949. Enemy bear. *Masterkey* 22: 80–85.

Mason, J. Alden. 1910. Myths of the Uintah Utes. *Journal of American Folklore* 23: 299–363.

———. [1912] 1964. The Ethnology of the Salinan Indians. *University of California Publications in American Archaeology and Ethnology*, 10 (1911–1914): 97–240. Reprint, New York: Kraus Reprint Co.

Matthews, Washington. [1897] 1969. *Navaho Legends*. Memoirs of the American Folklore Society, 5. Reprint, New York: Kraus Reprint Co.

Martin, Calvin. 1978. *Keepers of the Game*. Berkeley, CA: University of California Press.

McClintock, Walter. [1910] 1999. *The Old North Trail*. Reprint, Lincoln, NE: University of Nebraska Press, Bison Books.

———. 1923. *Old Indian Trails*. Boston, MA: Houghton Mifflin.

McCracken, Harold. 1955. *The Beast That Walks Like A Man*. Garden City, NY: Hanover House.

McGhee, Robert. 1996. *Ancient People of the Arctic*. Vancouver: University of British Columbia Press.

McNamee, Thomas. 1984. *The Grizzly Bear*. New York: Alfred A. Knopf, Inc.

McMillion, Scott. 1998. *Mark of the Grizzly*. Helena, MT: Falcon Publishing.

Miller, Joaquin. 1900. *True Bear Stories*. Chicago: Rand, McNally & Co.

Miller, Virginia P. 1978. Yuki, Huchnom, and Coast Yuki. In *Handbook of North American Indians*, vol. 8, *California*. Washington, DC: Smithsonian Institution.

Moerman, Daniel E. 1998. *Native American Ethnobotany*. Portland, OR: Timber Press.

Morrison, David A. 1995. *Inuit*. Hull, Quebec, Canada: Canadian Museum of Civilization.

Mother Earth, Father Sky. 1997. Amsterdam: Time-Life Books.

Murie, James R. 1981. *Ceremonies of the Pawnee*. Washington, DC: Smithsonian Contributions to Anthropology 27. Reprinted by University of Nebraska Press, Lincoln, for the American Indian Studies Institute, Indiana University, 1989.

Myers, James E. 1978. Cahto. In *Handbook of North American Indians*, vol. 8, *California*. Washington, DC: Smithsonian Institution.

Nelson, Richard K. 1969. *Hunters of the Northern Ice*. Chicago: University of Chicago Press.

———. 1983. *Make Prayers to the Raven*. Chicago, IL: University of Chicago Press.

Newcomb, Franc Johnson, Stanley Fisher, and Mary C. Wheelwright. [1956] 1974. A study of Navajo symbolism. *Papers of the Peabody Museum of Archaeology and Ethnology*, Harvard University, 32 (3). Reprint, Millwood, NY: Kraus Reprint Co.

Niblack, Albert P. 1890. *The Coast Indians of Southern Alaska and Northern British Columbia*. Washington, D. C.: n.p.

Opler, Morris Edward. [1938] 1976. *Myths and Tales of the Jicarilla Apache Indians*. Memoirs of the American Folklore Society, vol. 31. Reprint, New York: Kraus Reprint Co.

Parsons, Elsie Clews. [1926] 1969. *Tewa Tales*. Memoirs of the American Folk-Lore Society, vol. 19. Reprint, New York: Kraus Reprint Co.

———. [1929] 1969. *Kiowa Tales*. Memoirs of the American Folk-Lore Society, vol. 22. Reprint, New York: Kraus Reprint Co.

———. 1939. *Pueblo Indian Religion*. 2 vols. Chicago, IL: University of Chicago Press.

———. 1940. *Taos Tales*. American Folk-Lore Society Memoirs 34. New York: J. J. Augustin.

Paulson, I. 1968. The preservation of animal bones in the hunting rites of some North-Eurasian peoples. In *Popular Beliefs and Folklore Tradition in Siberia*, ed. V. Diószegi. Bloomington, IN: Indiana University.

Rasmussen, Knud. 1973. *Eskimo Poems from Canada and Greenland*. Translated by Tom Lowenstein. Pittsburgh, PA: University of Pittsburgh Press.

Reagan, Albert B. 1929. The bear dance of the Ouray Utes. *Wisconsin Archaeologist* 9 (3):148–150.

Reed, Verner Z. 1896. The Ute bear dance. *The American Anthropologist*, vol. IX, July, pp. 237– 244.

Rockwell, David. 1991. *Giving Voice to Bear*. Niwot, Colorado: Roberts Rinehart.

Salzer, Robert J. 1972. Bear-walking: A shamanistic phenomenon among the Potawatomi Indians in Wisconsin. *Wisconsin Archaeologist*, n.s. 53: 110–46.

Schaeffer, Claude E. 1966. Bear ceremonialism of the Kutenai Indians. *Studies in Plains Anthropology and History* 4: 1–54. Browning, MT: Museum of the Plains Indian (United States Department of the Interior Indian Arts and Crafts Board).

Schlesier, Karl H. 1987. *The Wolves of Heaven*. Norman, OK: University of Oklahoma Press.

Servheen, C., Herrero, S., and Peyton, B. (compilers). 1999. *Bears: Status Survey and Conservation Action Plan*. IUCN/SSC Bear and Polar Bear Specialist Groups. Gland, Switzerland and Cambridge, UK: International Union for Conservation of Nature and Natural Resources.

Shelton, James Gary. 1994. *Bear Encounter Survival Guide*. Self-published.

———. 1998. *Bear Attacks: The Deadly Truth*. Hagensborg, BC: Pogany Productions.

Shepard, Paul, and Barry Sanders. 1985. *The Sacred Paw*. New York: Viking Penguin.

Skinner, Alanson. 1914. Bear customs of the Cree and other Algonkin Indians of Northern Ontario. *Ontario Historical Society Papers and Records*, vol. 12: 203–209.

Speck, Frank G. [1937] 1980. *Oklahoma Delaware ceremonies, feasts and dances*. American Philosophical Society, Philadelphia, Memoirs, v. 7. Reprint, New York: AMS Press.

Speck, Frank G., and Leonard Broom. 1951. *Cherokee Dance and Drama*. Berkeley, CA: University of California Press.

Speck, Frank G., and Jesse Moses. 1945. *The Celestial Bear Comes Down to Earth*. Scientific Publications No. 7. Reading, PA: Reading Public Museum and Art Gallery.

Spence, Lewis. 1914. *The Myths of the North American Indians*. Toronto: McClelland & Goodchild.

Spier, Leslie. [1930] 1965. Klamath Ethnography. *University of California Publications in American Archaeology and Ethnology*, 30: x + 1–338. Reprint, New York: Kraus Reprint Co.

Spier, Robert F. G. 1978. Monache. In *Handbook of North American Indians*, vol. 8, *California*. Washington, DC: Smithsonian Institution.

The Spirit World. 1992. Alexandria, VA: Time-Life Books.

St. Clair, H. H. 1909. Shoshone and Comanche tales. *Journal of American Folklore* 22:265–282.

———. 1909. Traditions of the Coos Indians of Oregon. *Journal of American Folklore* 22:25–41.

Staal, Julius D. W. 1988. *The New Patterns in the Sky*. Blacksburg, VA: McDonald and Woodward.

Stefansson, V. 1906. Icelandic Beast and Bird Lore. *Journal of American Folklore* 19: 300–308.

Steward, Julian H. *A Uintah Ute Bear Dance, March, 1931*. Smithsonian Institution National Anthropological Archives Manuscript 3194.

Stirling, Ian. 1988. *Polar Bears*. University of Michigan Press.

Storer, Tracy I., and Lloyd P. Tevis, Jr. 1955. *California Grizzly*. Berkeley, CA: University of California Press.

Stringham, Stephen F. 1980. Possible impacts of hunting on the grizzly/brown bear, a threatened species. In *Bears: Their Biology and Management*. A selection of papers from the Fourth International Conference on Bear Research and Management, Kalispell, MT, USA, February, 1977. Clifford J. Martinka and Katherine L. McArthur, eds.

Swanton, John Reed. [1929] 1976. *Myths and Tales of the Southeastern Indians*. Washington, DC: Bureau of American Ethnology Bulletin 88. Reprint, New York: AMS Press.

Tattersall, Ian. 1999. *The Last Neanderthal*. Boulder, CO: Westview Press.

Teit, James. 1921. Tahltan tales. *Journal of American Folklore*, 34(134): 335–356.

———. 1926. Story of bear. *Journal of American Folklore*, 39: 450–459.

Tyler, Hamilton A. 1975. *Pueblo Animals and Myths*. Norman, OK: Univ. of Oklahoma Press.

Vacar, Tom. 1999. Hungry bears prefer meals in imported cars. http://cnn.com/US/9901/19/black.bears/ [Accessed December 31, 1999].

Vajnstejn, S. I. 1996. The *erens* in Tuva shamanism, In *Shamanism in Siberia*, Vilmos Diószegi and Mihály Hoppál, eds. Budapest: Akadémiai Kiadó.

Voth, H.R. 1905. *The Traditions of the Hopi*. Field Columbian Museum Publication 96, Anthropological Series, vol. 8. Chicago, IL: Field Columbian Museum.

Waldman, Carl. 1985. *Atlas of the North American Indian*. New York: Facts on File Pub.

Walker, Tom. 1993. *River of Bears*. Stillwater, MN: Voyageur Press.

Wallace, Anthony F. C. 1949. The role of the bear in Delaware society. *Pennsylvania Archaeologist* 19: 37–46.

Wallace, William J. 1978. Southern Valley Yokuts. In *Handbook of North American Indians*, vol. 8, *California*. Washington, DC: Smithsonian Institution.

Wissler, Clark. 1907. Some Dakota Myths. II. *Journal of American Folklore* 20: 195–206.

———. [1909] 1975. Mythology of the Blackfoot Indians. *Anthropological Papers of the American Museum of Natural History*, 2(1). Reprint, New York: AMS Press.

———. 1947. *Star Legends Among the American Indians*. New York: American Museum of Natural History, Science Guide No. 91.

Wood, Nancy, ed. 1997. *The Serpent's Tongue: Prose, Poetry and Art of the New Mexico Pueblos*. New York: Dutton Books.

PHOTOGRAPHY CREDITS

Pp 4–5 *Northwest Coast Indian Carving*, Courtesy of Department of Library Services, American Museum of Natural History; neg. #1572(2)

P 13 Edward S. Curtis, Courtesy of Christopher Cardozo

P 20 Cleveland Museum of Art; #1994.203

P 26 Courtesy of The Denver Art Museum; #1951.315

P 27 Canadian Museum of Civilization; VII-B-1556

P 28 Canadian Museum of Civilization; VII-C-273

P 29 Canadian Museum of Civilization; VII-C-339, VII-C-340

P 30 Top: Canadian Museum of Civilization; QiLd-1:2299
Center: Canadian Museum of Civilization; IV-E-767
Bottom: Courtesy of the New York State Historical Association, Fenimore Art Museum, Eugene & Clare Thaw collection; T-225.

P 32 Canadian Museum of Civilization; IV-C-2680

P 34 Smithsonian Institution Department of Anthropology; neg. #349-25C

P 42 Edward S. Curtis, Courtesy of Christopher Cardozo

Ps 44–45 Courtesy of the Burke Museum of Natural History and Culture; cat. #25.0/212

P 46 Canadian Museum of Civilization; VII-B-668

P 49 Winnipeg Art Gallery, attributed to Jonassie Kudluk; G-76-332

P 50 Winnipeg Art Gallery, attributed to Elisapee Kanangnaq Ahlooloo; 579.71

P 54 Top: Canadian Museum of Civilization; VII-E-57
Bottom: Canadian Museum of Civilization; VII-X-1458

P 55 Canadian Museum of Civilization; VII-C-78

P 67 Photograph by John Bigelow Taylor, Courtesy of the New York State Historical Association, Fenimore Art Museum, Eugene & Clare Thaw collection; T-192.

P 69 Canadian Museum of Civilization; VII-E-407

P 76 Smithsonian Institution Department of Anthropology; 80-147-93

P 77 Courtesy Department of Library Services, American Museum of Natural History; #19/448

Ps 78–79 Smithsonian Institution Department of Anthropology; neg. #77-7723

P 80 Courtesy of the Burke Museum of Natural History and Culture; cat. #1-2194

P 81 Canadian Museum of Civilization; VII-C-4

P 82 Top: Canadian Museum of Civilization; VII-B-669
Bottom: Canadian Museum of Civilization; VII-C-1800

P 83 Canadian Museum of Civilization; VII-C-1770

P 85 Smithsonian Institution, Department of Anthropology; #73-10981

P 87 Edward S. Curtis, Courtesy of Christopher Cardozo

P 89 Smithsonian Institution, Museum of Natural History, National Anthropological Archives; #596-D-45

P 100 Canadian Museum of Civilization; NhHd-1: 2665

P 101 Winnipeg Art Gallery; #429.71

P 106 Smithsonian Institution, Department of Anthropology; neg. #83-10920

P 107 Canadian Museum of Civilization; VII-B-748

P 110 Courtesy of the New York State Historical Association, Fenimore Art Museum, Eugene & Clare Thaw collection; T-200

P 111 Canadian Museum of Civilization; VII-B-113a

P 118 Smithsonian Institution, Department of Anthropology; neg. #85-1576

P 119 Photograph by John Bigelow Taylor, Courtesy of the New York State Historical Association, Fenimore Art Museum, Eugene & Clare Thaw collection; T-190

P 124 Winnipeg Art Gallery; #3088.71

P 125 Winnipeg Art Gallery; #G-72-151

P 126 Edward S. Curtis, Courtesy of Christopher Cardozo

P 128 Courtesy of the Museum of Anthropology, University of British Columbia; #A 50004

P 129 Courtesy of the New York State Historical Association, Fenimore Art Museum, Eugene & Clare Thaw collection; T13

P 133 Photograph by John Bigelow Taylor, Courtesy of the New York State Historical Association, Fenimore Art Museum, Eugene & Clare Thaw collection; T209

P 145 Seattle Art Museum; #91.1.46

P 146 Smithsonian Institution, National Anthropological Archives; neg. #83-16285

P 147 Smithsonian Institution, National Anthropological Archives; neg. #81-3596

P 149 Photograph by Lynton Gardiner, American Museum of Natural History; 4513-B (4)

Pp 150–51 Edward S. Curtis, Courtesy of Robert A. Yerks and Jill Eva Schwenderman

P 153 Edward S. Curtis, Courtesy of Christopher Cardozo

P 155 Canadian Museum of Civilization; VII-B-1595

P 156 Seattle Art Museum; #83.228

P 160 Canadian Museum of Civilization; VII-C-1764

P 161 American Museum of Natural History; #16-8250

P 176 Bear face from *Haida Argillite Box*, Canadian Museum of Civilization; VII-B-777

INDEX

Page numbers listed in bold indicate photographs or illustrations

The Sierra Club, founded in 1892 by John Muir, has devoted itself to the study and protection of the earth's scenic and ecological resources—mountains, wetlands, woodlands, wild shores and rivers, deserts and plains. The publishing program of the Sierra Club offers books to the public as a nonprofit educational service in the hope that they may enlarge the public's understanding of the club's basic concerns. The point of view expressed in each book, however, does not necessarily represent that of the Club. The Sierra Club has some sixty chapters coast to coast, in Canada, Hawaii, and Alaska.

For information about how you may participate in its programs to preserve wilderness and the quality of life, please address inquiries to Sierra Club, 85 Second Street, San Francisco, CA 94105.

Developed and produced by Gary Chassman

EDITIONS

Burlington, Vermont

verve@together.net

Copyright © 2000 by Verve Editions

All photographs copyright © 2000 Daniel J. Cox, unless otherwise credited.
All of Dan's photos are available as fine art prints. Visit his web site at www.naturalexposures.com

Text copyright © 2000 by Rebecca L. Grambo

Published by Sierra Club Books, in conjunction with Crown Publishers, New York, New York. Member of the Crown Publishing Group.

Random House, Inc., New York, Toronto, London, Sydney, Auckland
www.randomhouse.com

SIERRA CLUB, SIERRA CLUB BOOKS, and Sierra Club design logos are registered trademarks of the Sierra Club.

Design by Robert A. Yerks and Jill Eva Schwenderman

Printed in Italy

Library of Congress Cataloging-in-Publication Data is available.

ISBN 0-609-60796-2

10 9 8 7 6 5 4 3 2 1

First edition